Eyewitness
Decade

Edited by Roger Tooth

guardianbooks

Published by Guardian Books 2010
10 9 8 7 6 5 4 3 2 1

First published in Great Britain in 2010 by

Guardian Books
Kings Place, 90 York Way
London N1 9GU

www.guardianbooks.co.uk

A CIP catalogue record for this book is available from the British Library

ISBN 9780852652176

Designed and typeset by Friederike Huber
Production by Simon Rhodes
Printed and bound in China by C&C Offset Printing Co. Ltd

Eyewitness Decade

Wednesday 28 November 2007
Murdo Macleod

Edinburgh gearing up for the festive season with a Ferris wheel and
an ice rink set up beneath the castle.

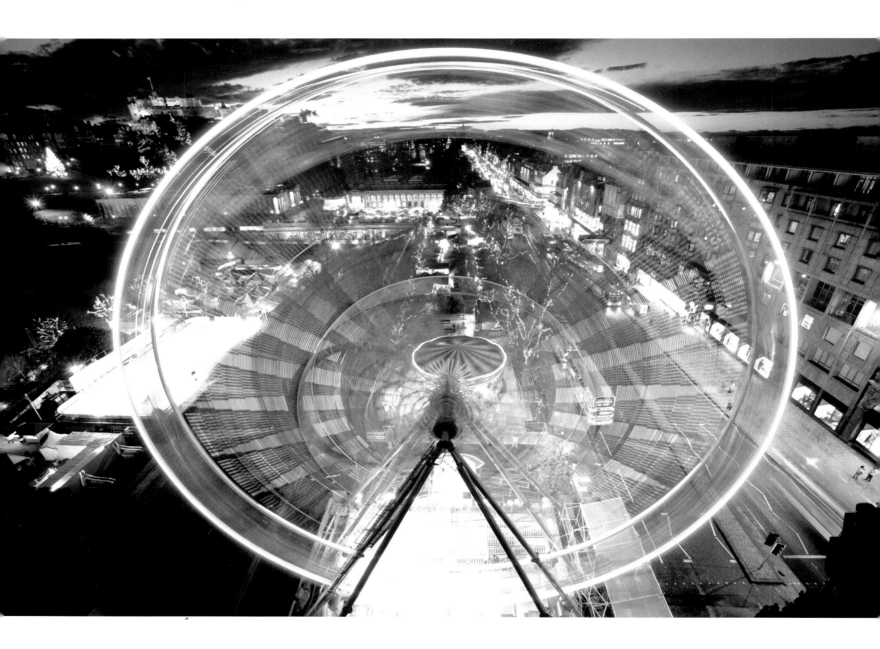

Contents

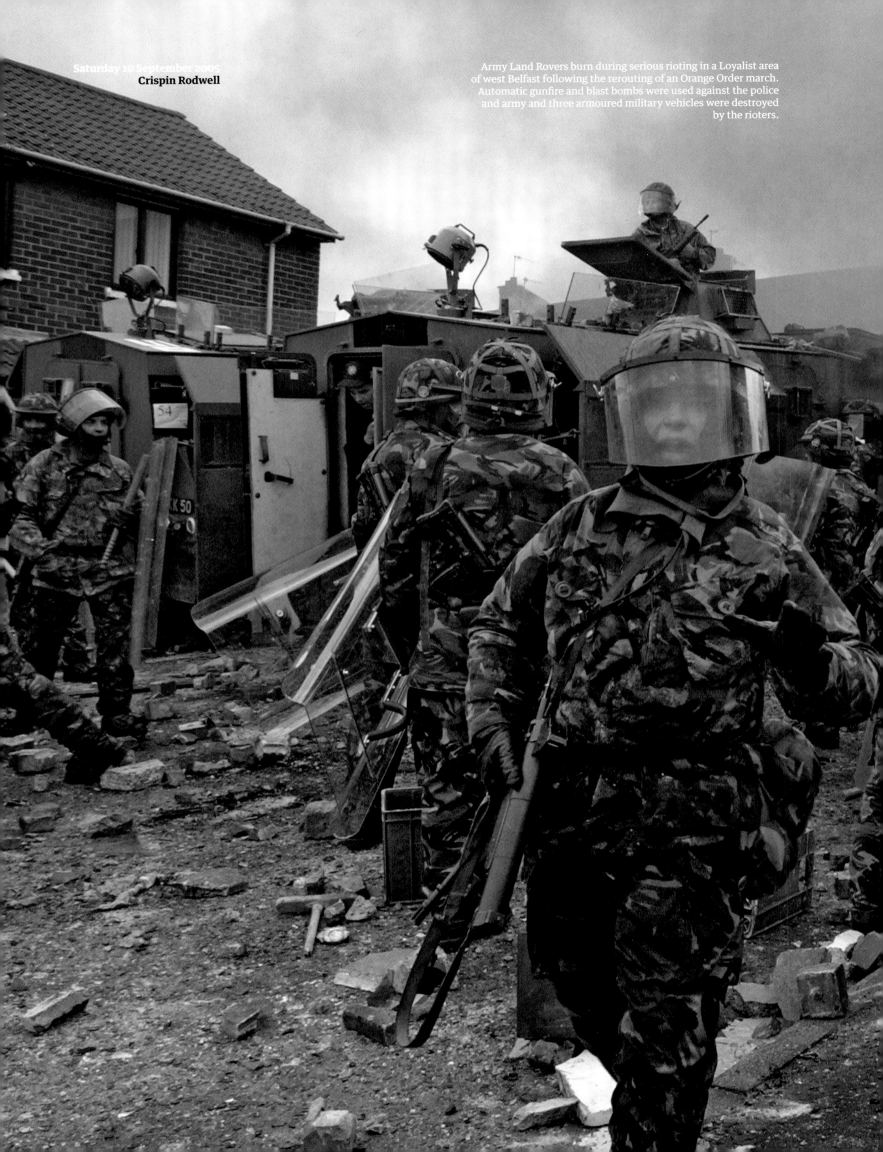

Army Land Rovers burn during serious rioting in a Loyalist area of west Belfast following the rerouting of an Orange Order march. Automatic gunfire and blast bombs were used against the police and army and three armoured military vehicles were destroyed by the rioters.

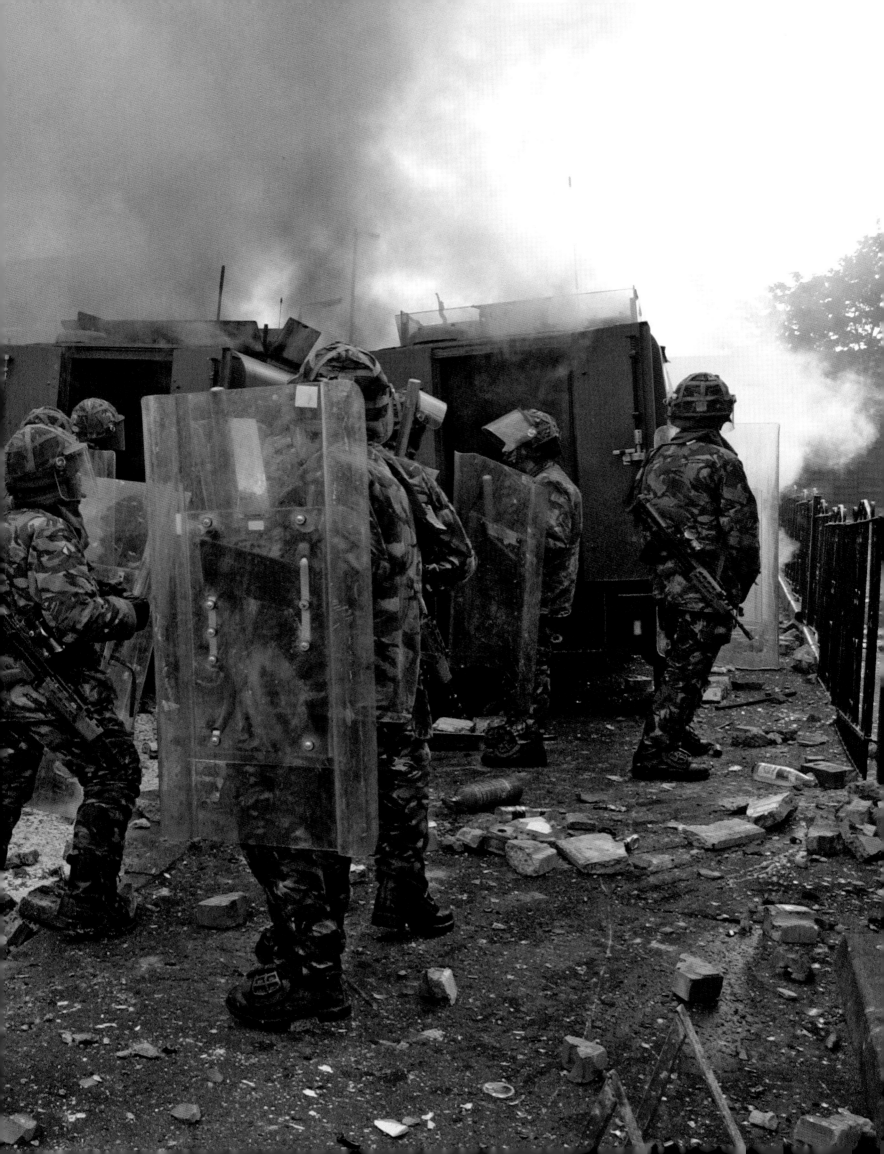

'Erm … so what's in your bottom drawer?' That would be the picture editor's bottom drawer, a mystical place beloved of editors everywhere. My colleagues and I have heard that question far too many times over the course of the last few years, as we have struggled to find the photograph that would have sufficient presence to fill the Eyewitness spread in the *Guardian*. At the end of so many days we somehow managed it, normally without opening the drawer at all.

The *Guardian*'s Eyewitness centre-spread photograph came into being when the paper was redesigned in the Berliner format in 2005. A couple of big decisions had already been made - new, high-quality printing presses had been bought, and the paper was going to be printed in full colour - when Creative Director Mark Porter and Deputy Editor Paul Johnson came up with another: to run one big picture across the two centre pages of the paper three days a week. Porter says, 'We wanted to create the visual equivalent of a piece of in-depth written reportage: something readers could spend time with and lose themselves in. The original intention was not just to have strong images, but also to choose pictures with a lot of detail that would reward sustained examination.' What a great challenge for the picture desk: come up with a photograph that would arrest the readers' attention for more than the few seconds they would normally afford to a news picture.

In the days leading up to the launch of the new, redesigned paper, and after running off a few dummy spreads, we managed to come up with a formula of sorts: the subject had to justify scaling-up. The photograph needed lots of details to pore over. It worked much better if everything was in sharp focus - large out-of-focus areas were ugly. And an ever-changing daily mood was good: some hard news, some 'slice of life' images, a beautiful nature picture, an artwork - whether finished or in the artist's studio.

11 September 2005 - Berliner day - was a quiet Sunday for making the first paper in the new format for Monday morning. Micawber-like, we didn't have a centre spread - we had just been hoping that something would turn up! And it did - Crispin Rodwell's great news picture of riot police back on the streets of Belfast

Roger Tooth is head of photography for the *Guardian*.

popped on to our picture system in the early afternoon and it was a natural. Eyewitness was launched in great style with this image, which remains one of the best centre spreads we have ever run. It had action, sharp details and drama. It was a current news event. It was perfect.

Soon we were running images as diverse as Rachel Whiteread's installation of white plastic boxes in the Tate Modern turbine hall and a Cabinet meeting in session; the appetite for Eyewitness was such that soon we were publishing an Eyewitness centre spread five times a week. We scoured the wire agency images that streamed into the *Guardian*'s offices every day. We came up with our own ideas, such as photographs documenting summer in European cities. Soon, many freelances were saying that they were specifically shooting with Eyewitness in mind.

Artists noticed the space too. Early on, Marc Quinn invited us to photograph him at his Italian stonemasons' workshops in Petrasanta, Tuscany, as he was finishing the astonishing sculpture of Alison Lapper that was destined for the fourth plinth in Trafalgar Square (p. 129). Then there was David Hockney. He soon realised that the *Guardian* would be a great place to display one of his latest works, a study of trees in Woldgate Wood, East Yorkshire, and gave us an exclusive view of him at work on the canvasses (pp. 146-7).

We gradually became more confident in the range of photographs we could include. *Guardian* photographic style for the preceding few years had been, of necessity, strong and simple to survive the vagaries of our old print process. Now that the new *Guardian* printing presses were producing beautiful, clear reproductions day after day, we were able to select complex imagery such as the photograph of the Large Hadron Collider on pp. 142-3. The scale and complexity of the machine is ideal for an Eyewitness spread, and including the worker gives a real sense of the size.

We do reflect the big news events such as the Pakistan earthquake in 2006, and indeed 2010's appalling

quake in Haiti, but Eyewitness is also a great place for photography for its own sake, and we sometimes run images just for the joy of their beauty - Simon Barber's bee, for example (p. 145). The centre spread is a valuable piece of newspaper real estate that can often be used to leaven the rest of the paper's heavy and sombre news. Sometimes we reshoot a familiar scene from a new angle, such as Graeme Robertson's spectacular bird's eye view of the Proms at the Royal Albert Hall (pp. 172-3).

Sometimes we run a selection of pictures, which often looks great, but this does feel a bit like cheating. The single picture is a far more compelling statement, a tremendous vote of confidence in a photograph for its beauty or the strength of its news value. Dan Chung's desolate image of children in the snow following a devastating earthquake in Pakistan (pp. 138-9) and David Levene's fascinating photograph of slums next door to the high-rise buildings of Panama City (pp. 186-7) are both examples of tremendous and courageous photojournalism.

As Eyewitness's reputation has grown, so has its popularity. A pastor serving with a British regiment in Iraq wrote to tell us that *Guardian* Eyewitness spreads were decorating the walls of their barracks. We have heard of schools using the pictures as teaching aids, and some of the spreads have been used in artists' works.

This book is called *Eyewitness Decade*, but of course we introduced the centre spread in 2005. The earlier years are therefore represented here by a group of photographs we have selected with the Eyewitness spread in mind. They are the sort of images that would, in our eyes, 'scale-up'. These images may not always be exactly on the button with the news of the times, but all the main events are there, be it the doomed Concorde or the terrible image of the bombed London bus from July 2005. I hope, in any case, that the selection represents what we have been trying to do with Eyewitness pages all along - the best photography standing alone, published for its own sake.

Only the most churlish could repress a sense of hope as dawn rose on the new millennium in 2000. There were 619 days of hope between 1 January and 9/11 the following year. Those 88 weeks now look like a little bubble of optimism waiting to burst.

Mind you, it was difficult to keep up the hope if you were one of those ill-fated enough to have been invited to spend the midnight hour on 31 December at the Dome in London. Richard Roger's beautiful white tent was to be much over-used as a metaphor for all that was empty and showy about New Labour, then enjoying some sort of high-water mark before the tarnish of Iraq.

A spectacular piece of logistical mis-planning meant that around 20,000 of the supposed great and good had to file through one airport-style security scanner on the night. As the clock edged nearer midnight, there were near riots at Stratford Station as the important personages realised they would be celebrating the new millennium stone-cold sober and in a crush of bodies, scanning the timetable of the Docklands Light Railway for want of any better entertainment.

We got there in the end, just in time for a rather vapid variety performance in front of the Queen who, like everyone that night, must have wanted so much to be somewhere else. If we'd known we were in the physical embodiment of a New Labour metaphor at the time, we'd have recognised the omens. But hope reasserted itself somehow and we got on with the evening, and the century.

A few days later, the stock market suffered its worst one-day fall in history. But there was an explanation for that at the time - the bursting of the dot.com bubble - and financial life soon got back to what passed as normal. A fortnight into the new century, there was much ink spilled over the decision of Jack Straw not to extradite General Pinochet to stand trial for crimes against humanity. Guantanamo Bay, Abu Ghraib, rendition, deniable torture and white phosphorus were all in the future.

At the end of January, Dr Harold Shipman was convicted of killing fifteen of his patients - the trial of the century, they said. Josef Fritz was living quietly

Alan Rusbridger has been editor of the *Guardian* since 1995. Previously he was a reporter, columnist, features editor and the deputy editor of the *Guardian*.

4

in Austria, his daughter imprisoned in his basement. Ian Huntley was working as a barman in Barton upon Humber, a small town near Grimsby. Their own trials lay in the future. I cursed Shipman some years later as my father died an agonising death, with doctors and nurses unwilling to prescribe the morphine that would have eased his passing. They called it the Shipman Effect.

By May, Ken Livingstone was mayor of London, and you would have got very long odds on him eventually being replaced by the chaotic blond-haired Old Etonian who had just taken over as editor of the *Spectator*. Tiger Woods won the British Open in July. You would have got even longer odds on predicting that his career would, within a decade, self-destruct in a tsunami of sex addiction headlines. Not that many people knew what a tsunami was back then.

A rumour circulated that C4 had just signed a deal to import a new TV format which involved locking total strangers in a purpose-built house and filming them night and day. The rumour turned out to be true in July, when *Big Brother* screened for the first time in the UK. How fresh it seemed for, oh, all of two of the twenty-odd series that followed. And what a decade of ever-weirder reality was dished up on television in the years to come.

By September 2000 there were warnings of a very large hole in the ozone layer of the Antarctic: time to save on aerosols. We had another seven or eight years before most people realised it was a little late for that. The Human Rights Act was passed the following month. It seemed like an unequivocally good thing at the time – and still mostly does. However, it wasn't so very long before the government which passed it was apologising for it. But that was after 9/11 and the wholesale attack on civil liberties that followed – not from terrorists but from our own politicians.

And then, on 13 December, the Supreme Court ruled that George Bush had won Florida and would therefore be the next American president. We should have known we were in deep trouble then. But it was another nine months of optimism before the penny finally dropped.

1 January The Millennium Dome opens in Greenwich.

31 January Dr Harold Shipman is convicted of killing fifteen patients.

11 February The Northern Ireland power-sharing government is suspended after the IRA fails to start decommissioning weapons.

9 February Floods in Mozambique leave 500,000 homeless.

3 March Robert Mugabe begins land-grab policies in Zimbabwe.

10 March The dot.com bubble bursts.

4 May A computer virus nicknamed the 'love bug' strikes computers around the world.

4 May Ken Livingstone is elected mayor of London.

6 May The IRA offers to open up its hidden arms dumps to inspection.

7 May Vladimir Putin is sworn in as the second president of modern Russia.

12 May The Tate Modern opens.

23 May After 23 years, Israel pulls out of Lebanon.

6 June The Human Genome Project announces that it has completed the first draft of the entire structure of human DNA.

23 July Tiger Woods wins the British Open.

25 July A Concorde crashes in Paris.

18 July The first series of *Big Brother* airs on Channel 4.

8 September US scientists announce that the hole in the ozone layer over the Antarctic has reached a record size.

2 October The Human Rights Act comes into force in England and Wales.

5 October President Slobodan Milosevic of Serbia is ousted.

7 November The US presidential election begins.

27 November Ten-year-old Damilola Taylor is murdered.

2 December Gordon Brown agrees to wipe out the debt owed to Britain by the world's 41 poorest countries.

11 December The leaders of the EU's 15 member states agree on changes that will pave the way for other countries to join the EU from 2005.

13 December The Supreme Court rules that Bush will be the next president of the USA.

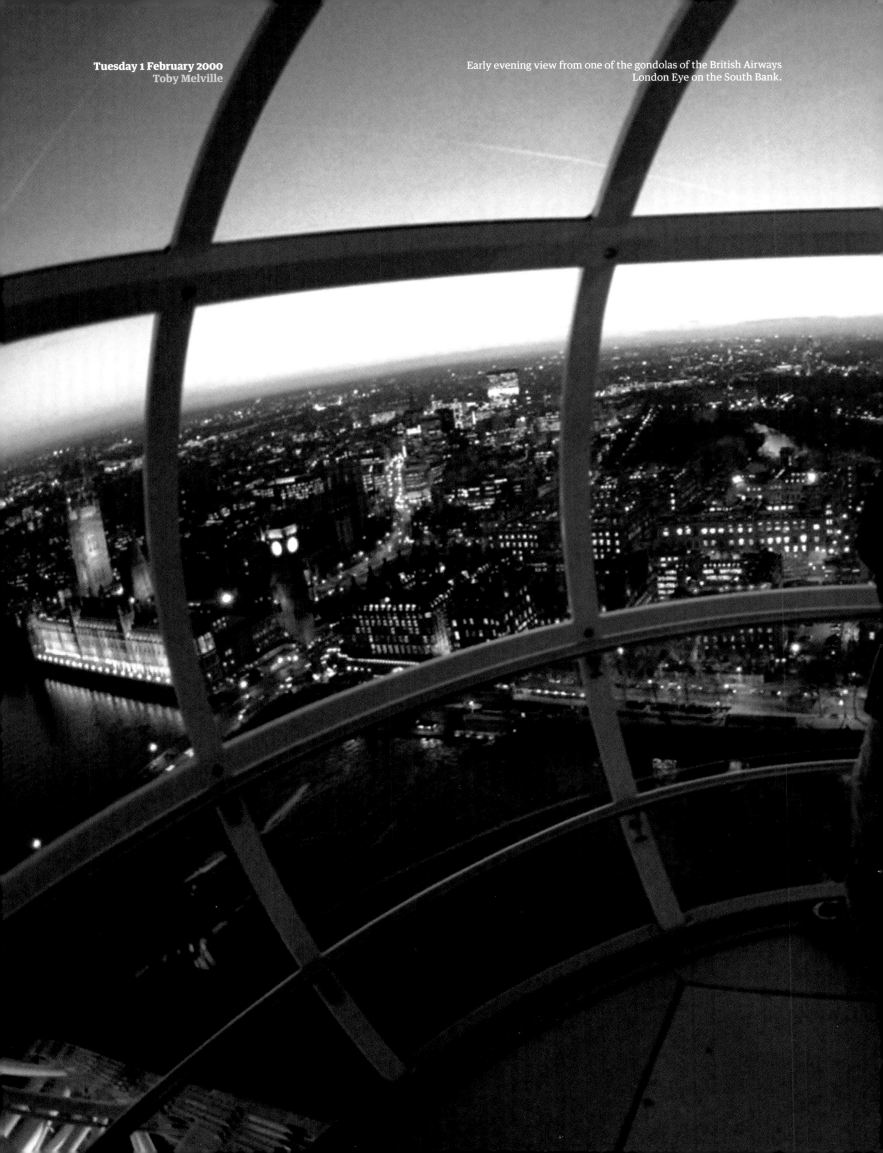

Tuesday 1 February 2000
Toby Melville

Early evening view from one of the gondolas of the British Airways
London Eye on the South Bank.

After the raging Limpopo flood, hundreds of Mozambicans wait for rescue on a roof in the city of Xai-Xai, 200 kilometres north of the capital Maputo.

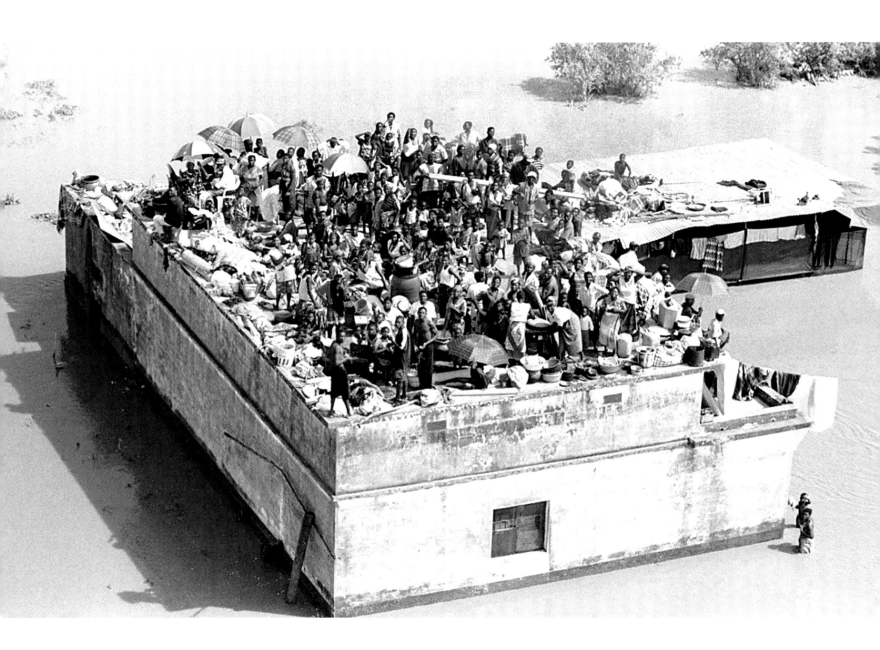

A parched Yorkshire reservoir during the summer's drought.

Wednesday 14 June 2000
Don McPhee

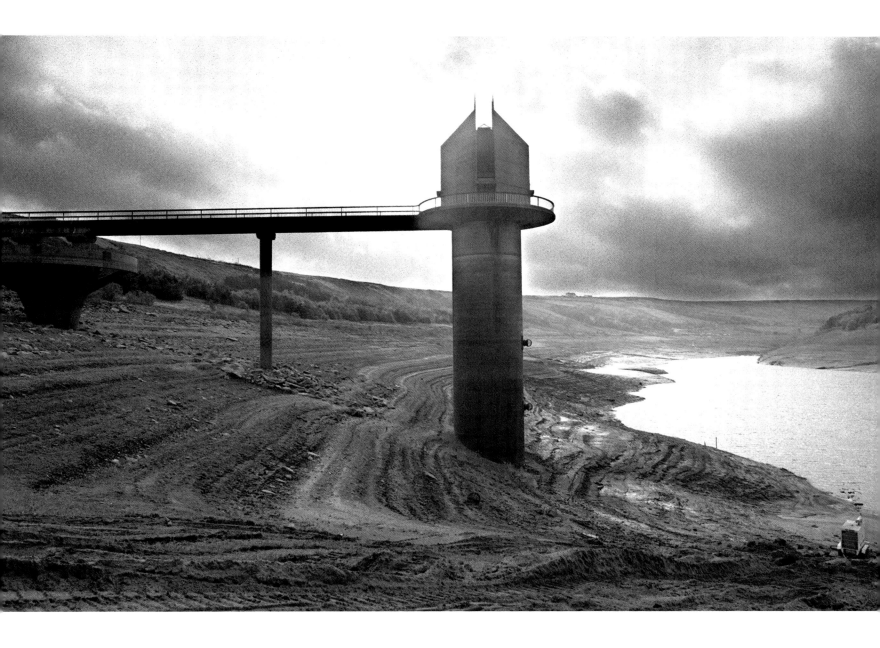

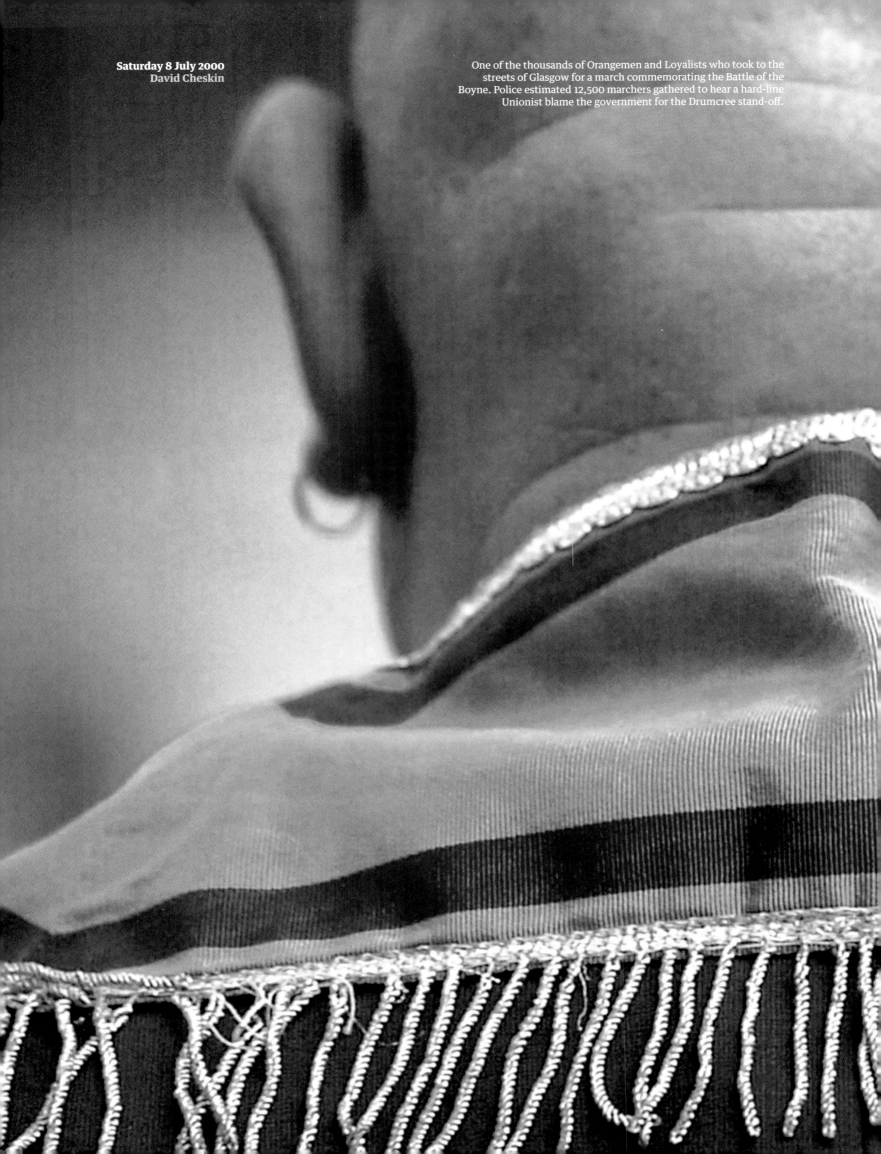

Saturday 8 July 2000
David Cheskin

One of the thousands of Orangemen and Loyalists who took to the streets of Glasgow for a march commemorating the Battle of the Boyne. Police estimated 12,500 marchers gathered to hear a hard-line Unionist blame the government for the Drumcree stand-off.

A Concorde jet taking off in flames before crashing to earth a few minutes later; 113 people died in this accident, the worst in Concorde's history.

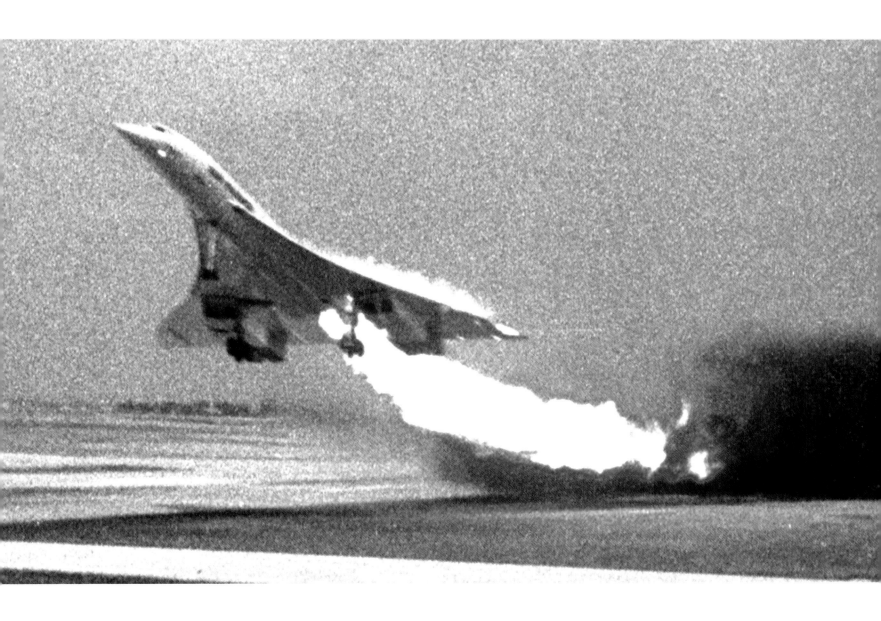

Israeli security officers guard opposition leader Ariel Sharon as he leaves the Temple Mount compound in east Jerusalem's Old City.

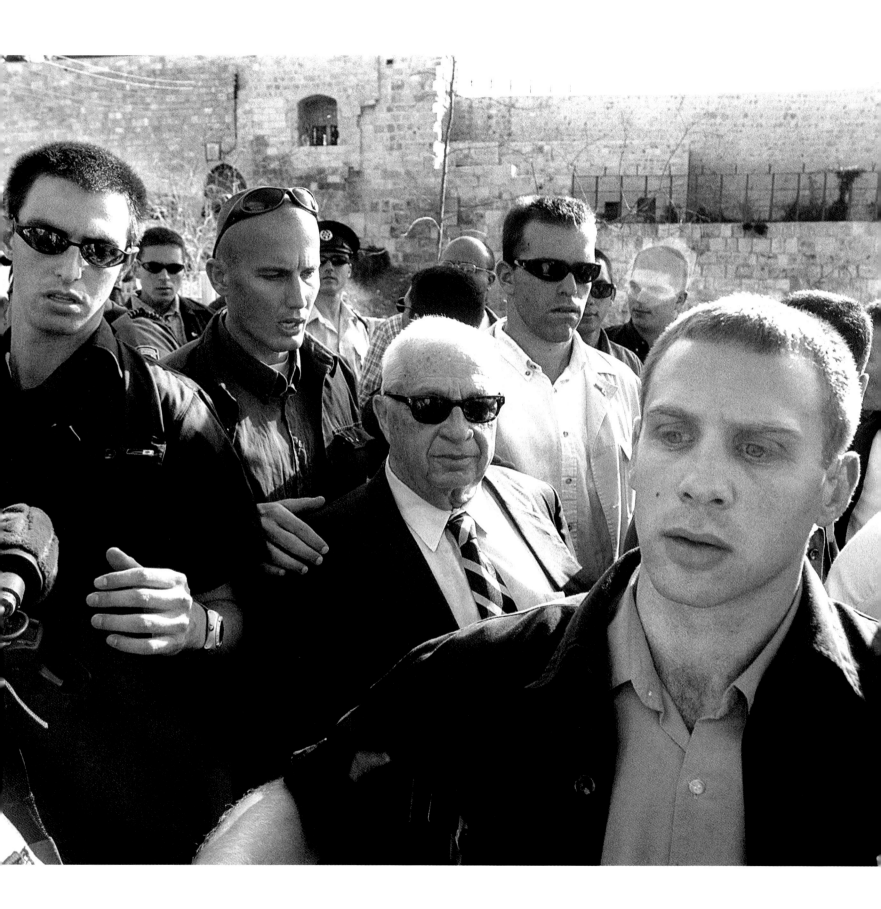

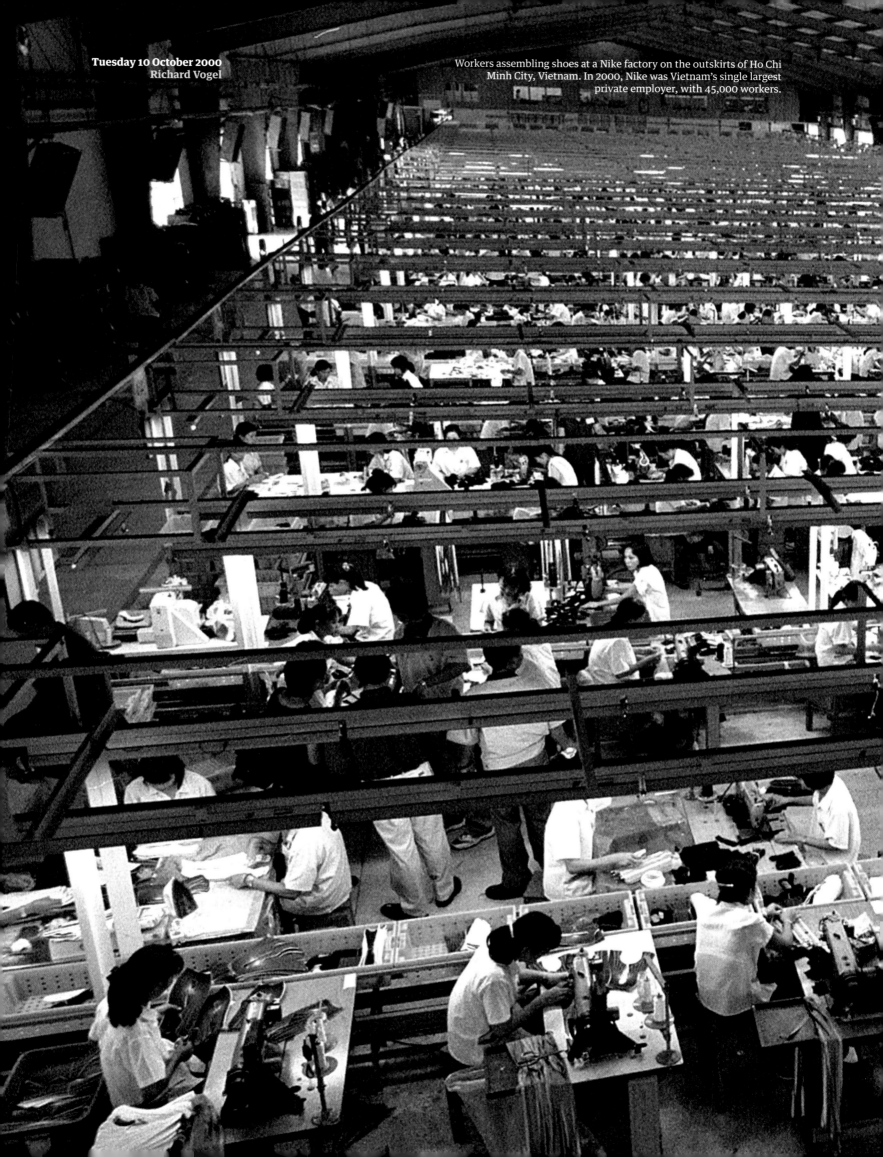

Workers assembling shoes at a Nike factory on the outskirts of Ho Chi Minh City, Vietnam. In 2000, Nike was Vietnam's single largest private employer, with 45,000 workers.

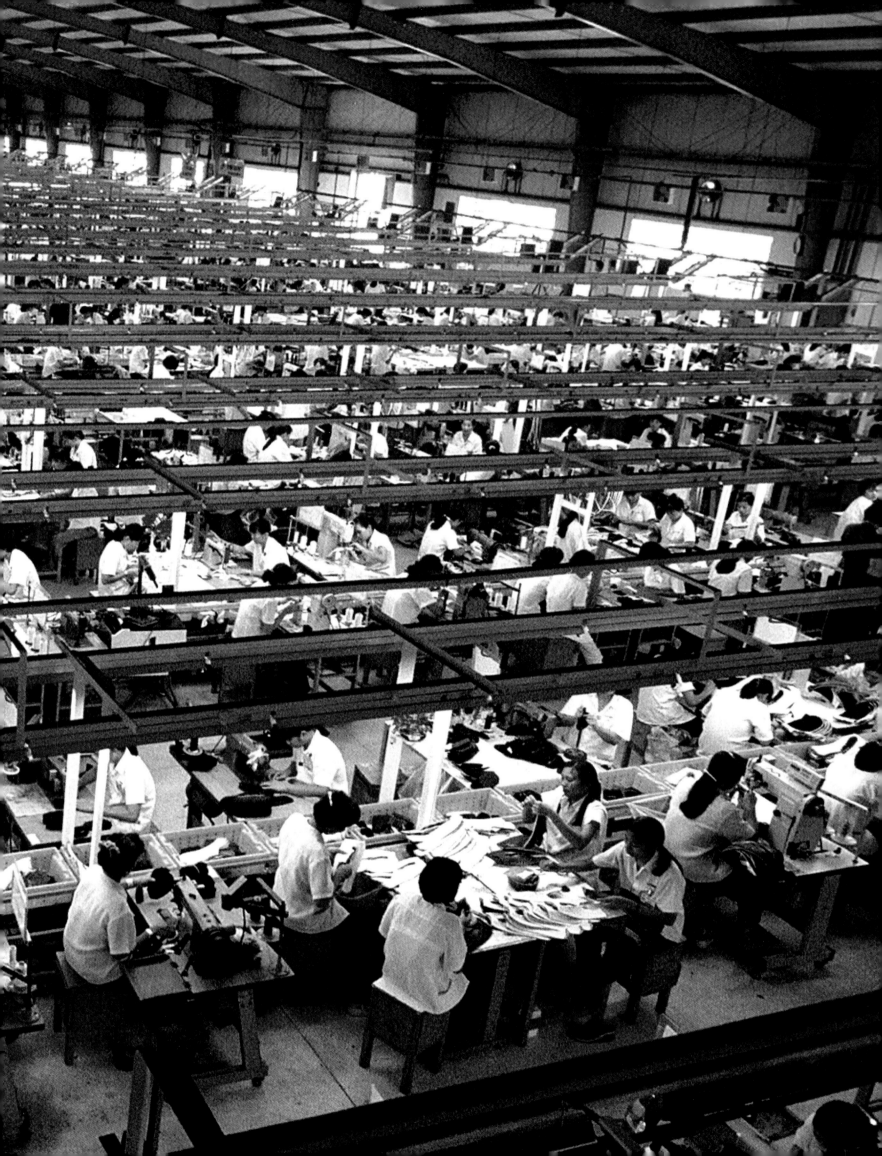

One Canada Square stands sentry over its two younger siblings as they grow at the rate of four storeys a week.

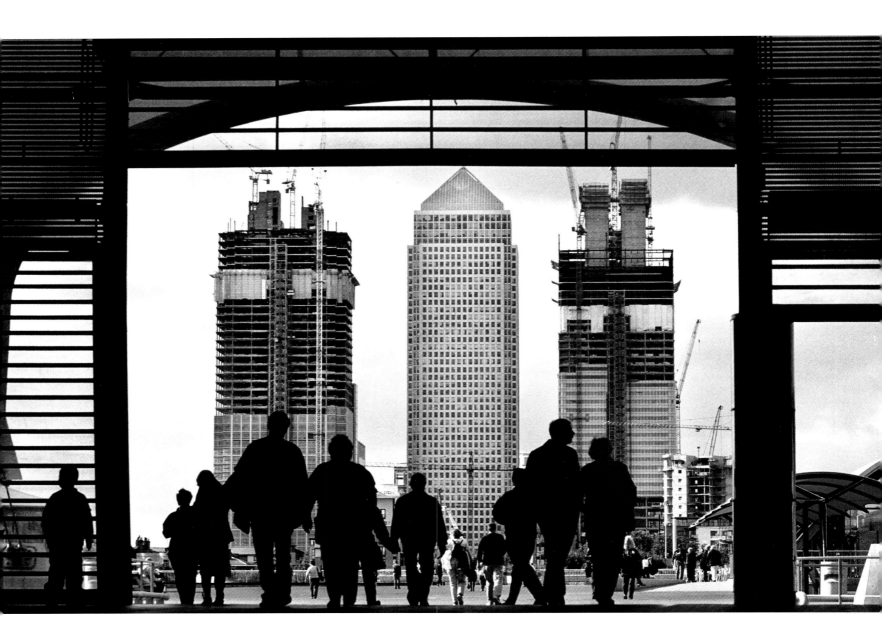

A homeless man bedding down in an underground car park in Cambridge.

Thursday 23 November 2000
Sean Smith

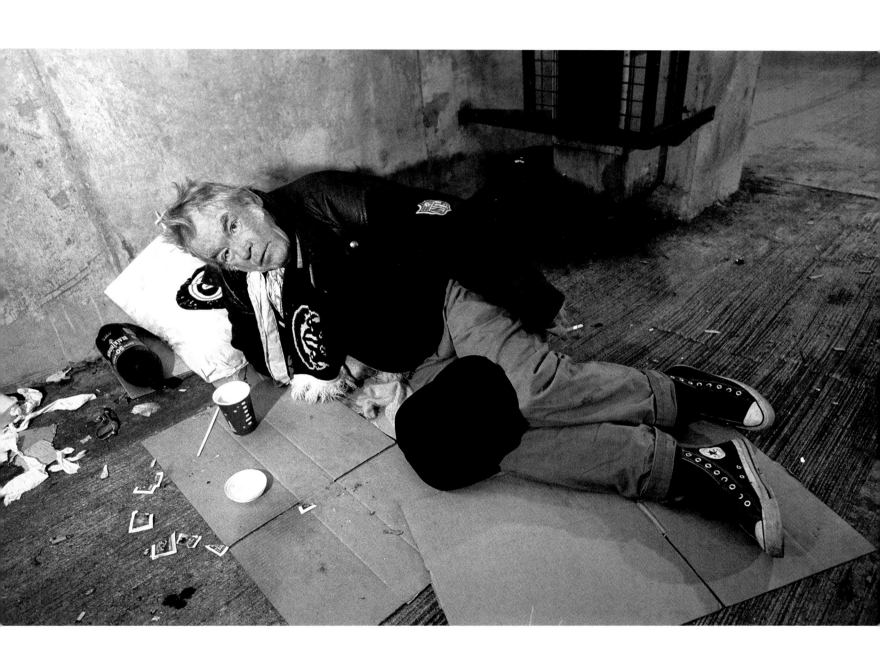

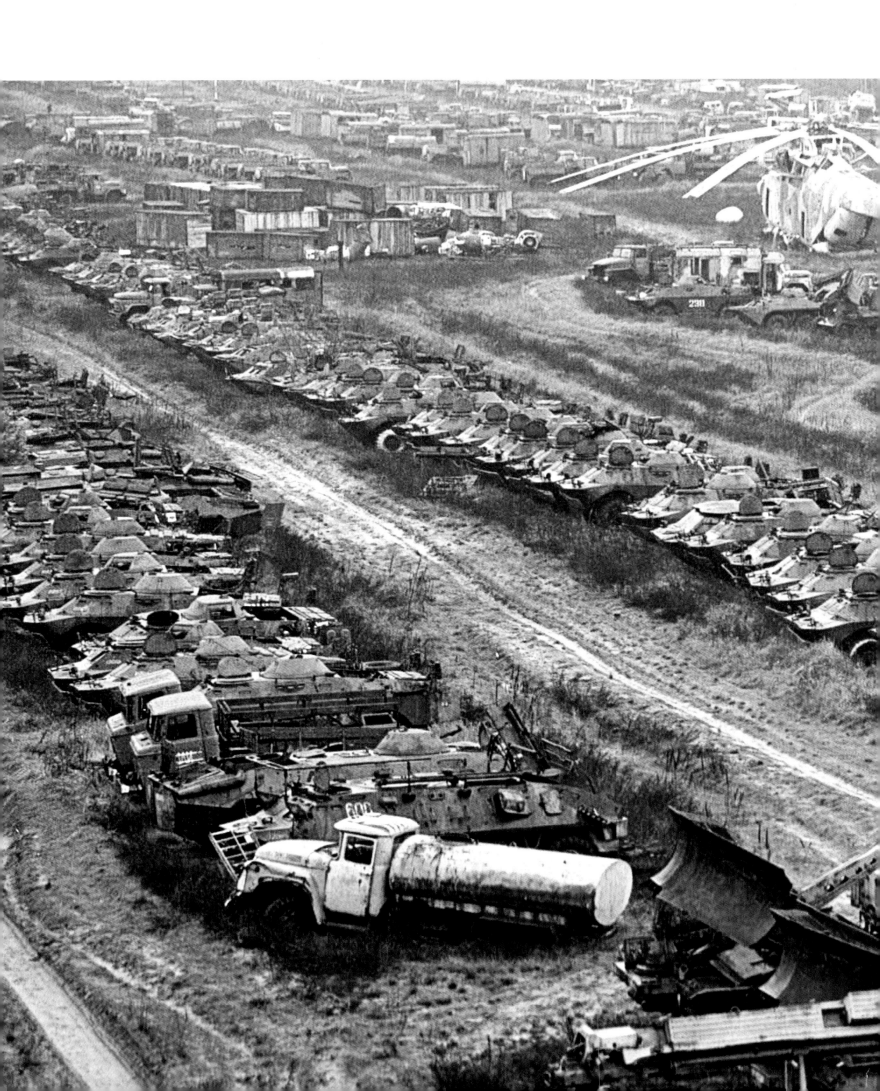

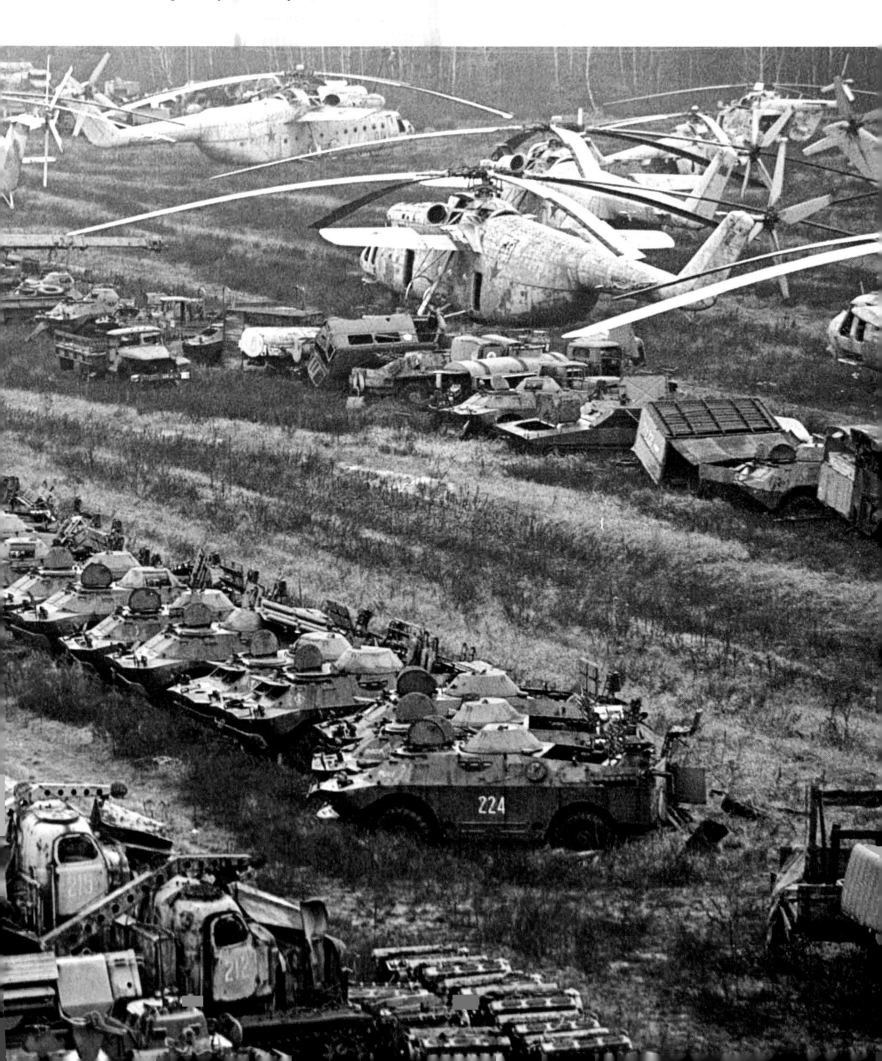

Contaminated military vehicles abandoned in the no-entry zone that surrounds the Chernobyl power plant. The vehicles, 1,350 in total, were used to fight the explosion of 26 April 1986.

Gala Bingo in Tooting, south London. The club, which was originally
a cinema, is a grade I listed building.

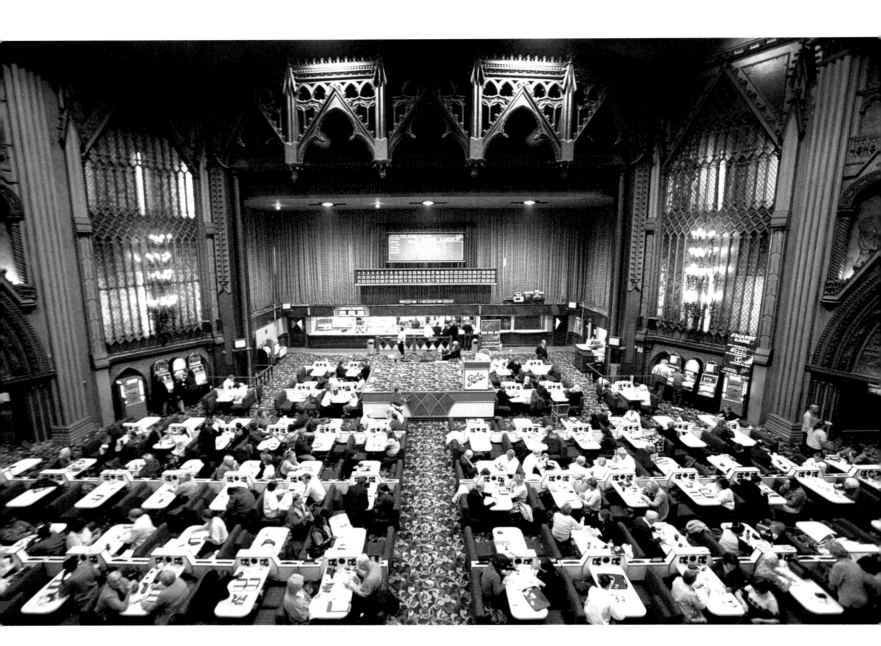

Approximately 4,000 people gather for the funeral of Xhemajl Mustafa in Gllamnik, Kosovo. A journalist and high-ranking member of the moderate LDK party, Mustafa was shot and killed outside his apartment in central Pristina.

Friday 24 November 2000
Andrew Testa

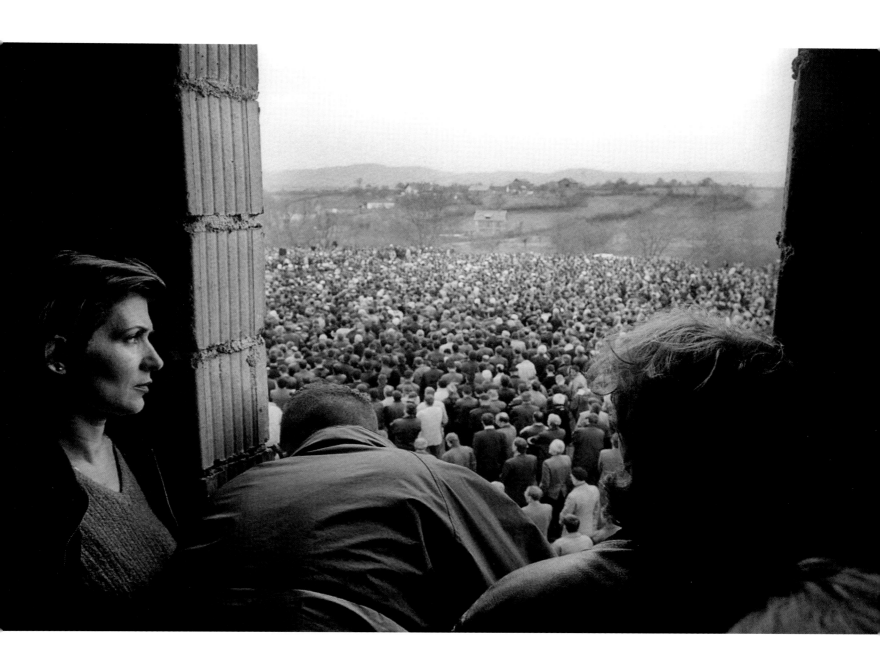

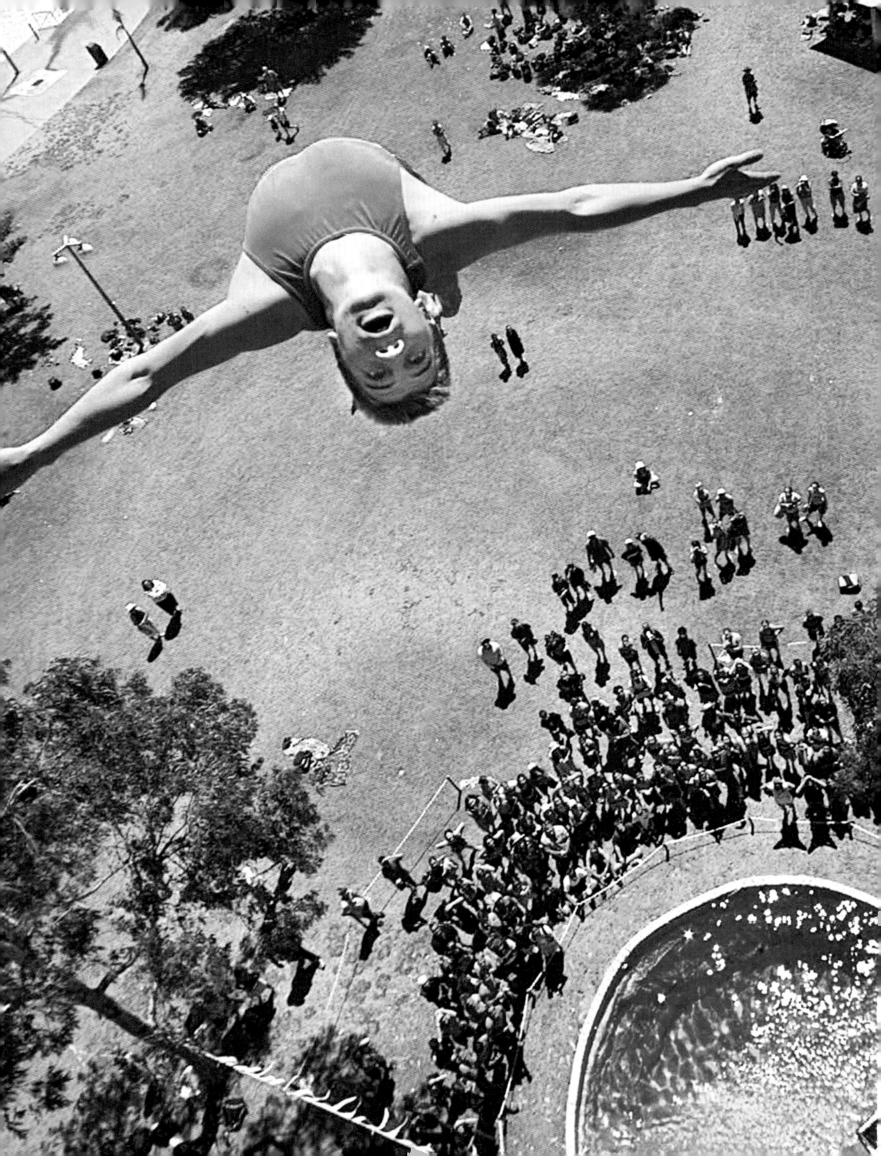

Frenchman Laurent Fischer takes the first plunge from a 30-metre tower erected for the High-Dive Stunt Show in Perth. The conditions were windy, and Laurent took his time considering the dive before taking off. The photographer is Oliver Favre-Bulle, who holds the world high-dive record.

2001

The date that stands out for me in 2001 was 10 September, or 9/10 in US parlance. I had been at lunch with a predecessor as foreign editor of the paper and we'd spent much of the time bemoaning how dull and uneventful the world seemed to have become.

What a difference 24 hours can make. The next day any thoughts of a slow news cycle were thoroughly blasted from our minds with all the force of jetliners crashing into two very tall buildings.

But I'm getting ahead of the story.

It's hard now not to think about the year 2001 without putting it through the mangle of 9/11, but at the time, in those months leading up to it, the world really was a different place. When George Bush was sworn in as 43rd president on 20 January he was not the figure of evil that for many *Guardian* readers he would become, and our photo of him with Condoleezza Rice in the Oval Office did not induce the same chill that it does today.

He still wore the mantle of 'compassionate conservatism', though as the year progressed it wore thin, not least with the announcement in March that the US would refuse to sign up to the Kyoto Protocol on climate change.

Politicians come, politicians go. Just four days after Bush's inauguration, Peter Mandelson moved in the opposite direction, resigning from the UK government for the second time following claims he had inappropriately lobbied for British citizenship for a major Labour donor.

There was more than a touch of déjà vu about Mandelson's departure. But there was nothing familiar about the sequence of events that unfolded from February, incinerating Britain's confidence in both farming and politicians, like the smoke billowing from the burning cattle in our photograph.

I remember the initial bewilderment about foot-and-mouth in the newsroom. Foot-and-what? But within days we were all experts on the subject as the horror of mass culling spread across the countryside.

Ed Pilkington is the *Guardian*'s New York correspondent. He is a former national and foreign editor of the paper, and author of *Beyond the Mother Country*.

Thank heavens May brought a little light relief, though Ronnie Biggs may not have seen his arrest on his return to the UK after 13,068 days on the run in quite that way. Nor would John Prescott, then deputy prime minister, have been able to share in the many jokes that echoed through Farringdon Road when we heard of the swift left hook he had given a farming protester.

That was considerably more exciting than the general election on 7 June, a Labour landslide that had as much drama as setting jelly and consequently the lowest electoral turnout since 1918.

What an uneventful world.

And then that gorgeous, cloudless September day. For all of us, as we watched the attack on the Twin Towers, the Pentagon and the downed plane in Pennsylvania we began with bewilderment, passed through shock and settled in horror. But in the newsroom it quickly morphed into frenzied activity. Not that an outsider would have noticed it. If anything, on huge days like 9/11 the *Guardian* newsroom gets calmer, quieter, more focused. As I sat on the international news desk in the centre of the firestorm, I felt as though the paper had begun to hum like a perfectly attuned Rolls-Royce engine.

I lived in that newsroom for many of the ensuing days and weeks, barely seeing the light of day. Most of the time we were all too busy to step back from it all, though I remember reading Ian McEwan's moving *Guardian* article on the love messages of those trapped in the towers and thinking if I wasn't in an open-plan office I would be bawling like a baby.

No time for that. On to Afghanistan. As foreign editor, the job fell to me to dispatch reporters to cover the story. I was always astonished by the alacrity with which my colleagues would jump at the request. 'Are you up for going to a war zone,' I would ask them, 'where at best your health and at worst your life will be in question, where travelling will be tough, creature comforts non-existent and where you will be separated from your loved ones for nobody knows how long?'

'You bet,' would come the inevitable reply.

12 January Victoria Climbie's carers are found guilty of her murder.

16 January DR Congo president Laurent Kabila is shot.

20 January George W. Bush is sworn in as the 43rd president of the USA.

26 January The state of Gujarat in India is devastated by an earthquake measuring 7.9 on the Richter scale.

31 January Libyan Abdelbaset Ali Mohmed al-Megrahi is found guilty of murdering 270 people in the Lockerbie disaster of December 1988.

19 February A routine inspection at Cheale Meats abattoir in Essex finds signs of foot-and-mouth disease.

22 February Mass rape is judged to be a war crime at the International Criminal Tribunal for the former Yugoslavia.

28 March Bush's administration declares that it will not implement the 1997 Kyoto Protocol.

1 April Former Yugoslav president Slobodan Milosevic is arrested after a siege.

10 April The Netherlands becomes the first country in the world to legalise voluntary euthanasia.

7 May Ronnie Biggs returns to the UK.

16 May Prescott punches a farming protester.

1 June Nepal's royal family is massacred when the heir to the throne, Crown Prince Dipendra, goes on the rampage with a gun.

7 June The general election. Labour wins 412 seats, Conservatives 166, Lib Dems 52. The voter turnout is 59.4%, the lowest since 1918.

11 June Timothy McVeigh is executed for killing 168 people in the 1995 Oklahoma City bombing.

25 June Race violence erupts in Burnley.

2 July Jill Dando's killer is jailed for life.

11 September Two aircraft fly into the twin towers of New York's World Trade Center, another hits the Pentagon, and a fourth crashes in Pennsylvania.

7 October The US and UK launch air attacks against the Taliban in Afghanistan.

7 October Railtrack is declared bankrupt.

23 October The IRA begins decommissioning weapons.

11 December China joins the World Trade Organisation (WTO).

13 December Bush withdraws from the Anti-Ballistic Missile Treaty with Russia - the cornerstone of nuclear deterrence since 1972.

13 December A suicide attack is mounted on the Indian parliament.

One woman was killed and a man critically injured in this landslide at Nefyn, on the remote Lleyn peninsula. Two cars were swept at least 40 feet down towards the sea and left sticking out of the mud as emergency services launched a major rescue operation in the face of the incoming tide.

Tuesday 2 January 2001
North Wales Police

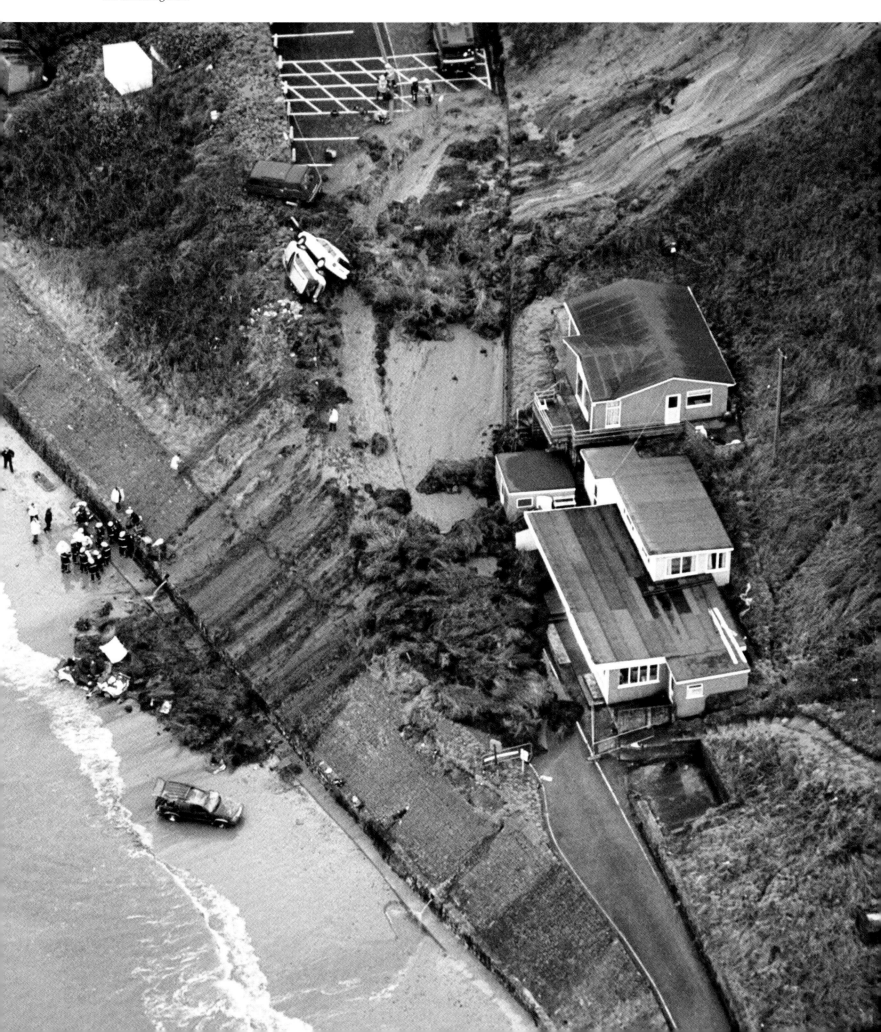

A monkey inside the animal experimentation laboratories at
Huntingdon Life Science.

Tuesday 6 February 2001
Sean Smith

Heavy snow and high winds bring chaos to many parts of Scotland, leaving motorists stranded and thousands of homes without power.

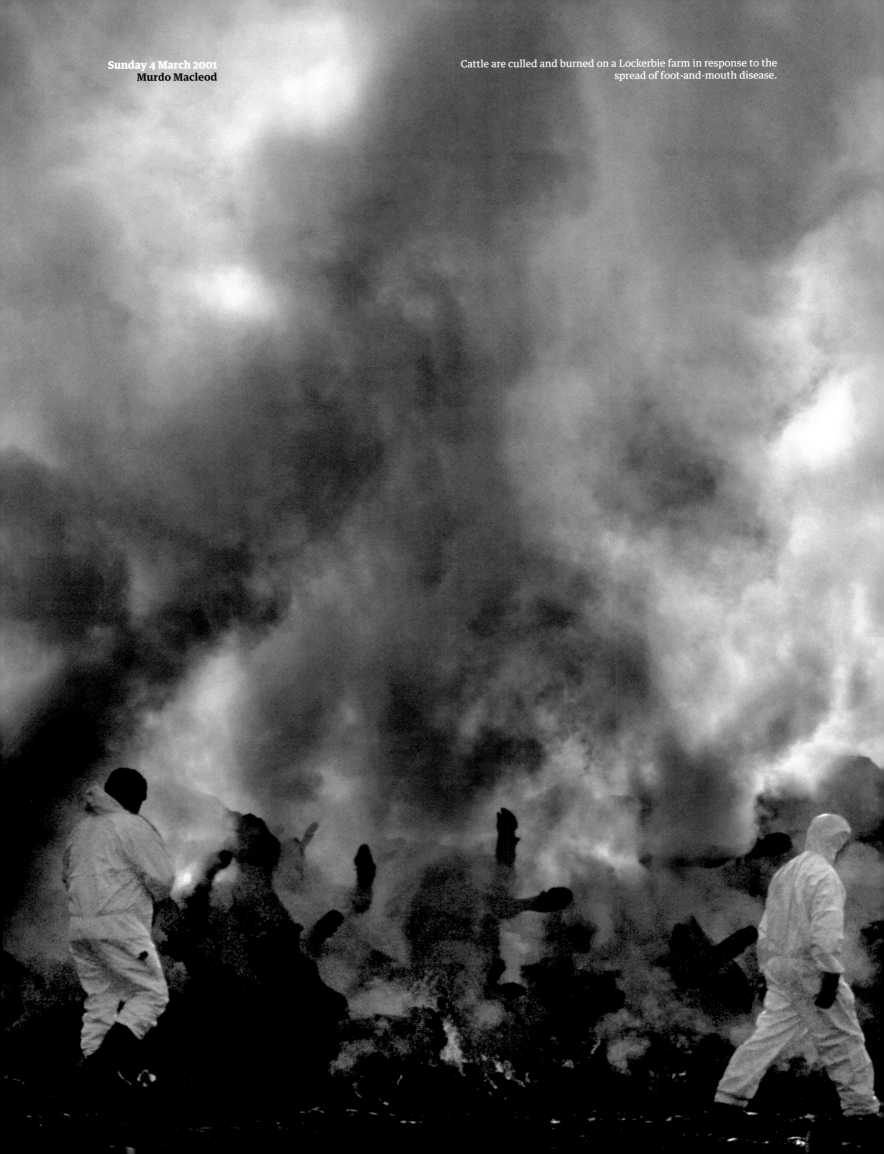

Cattle are culled and burned on a Lockerbie farm in response to the spread of foot-and-mouth disease.

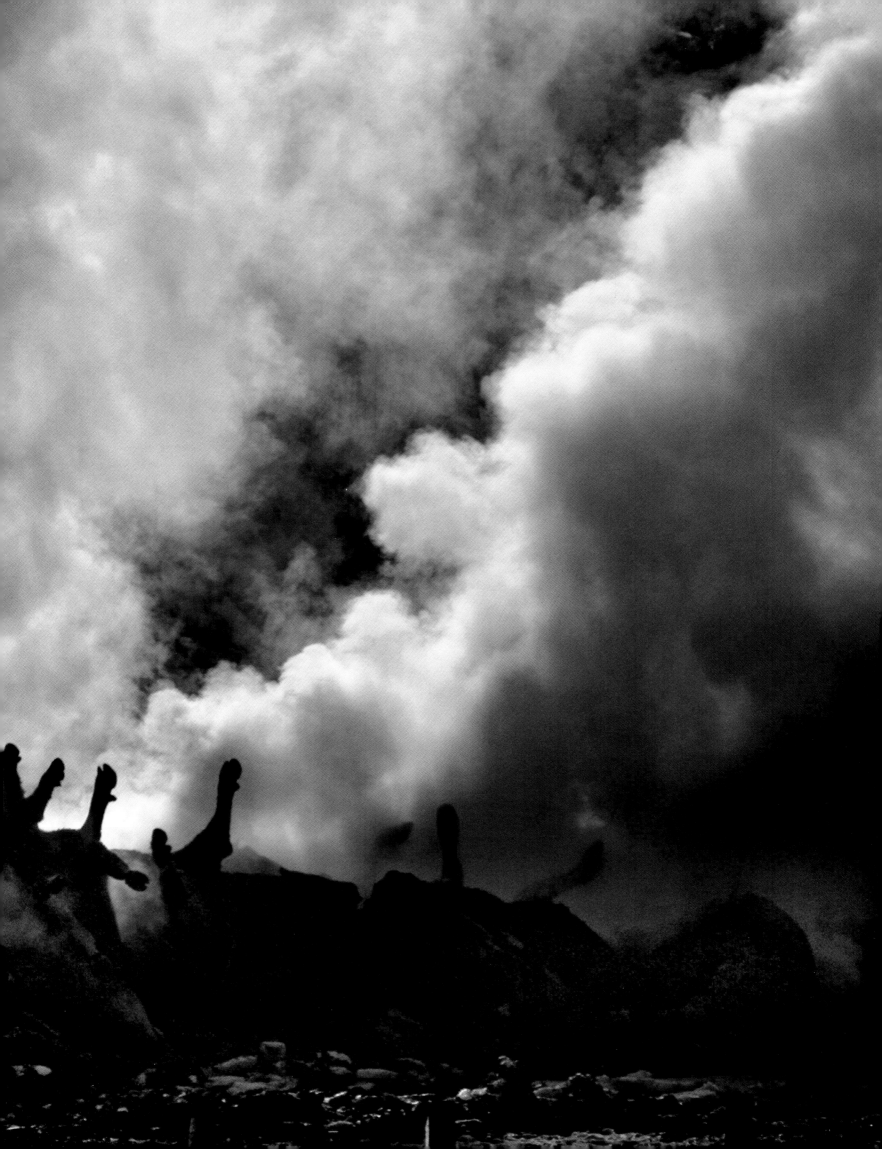

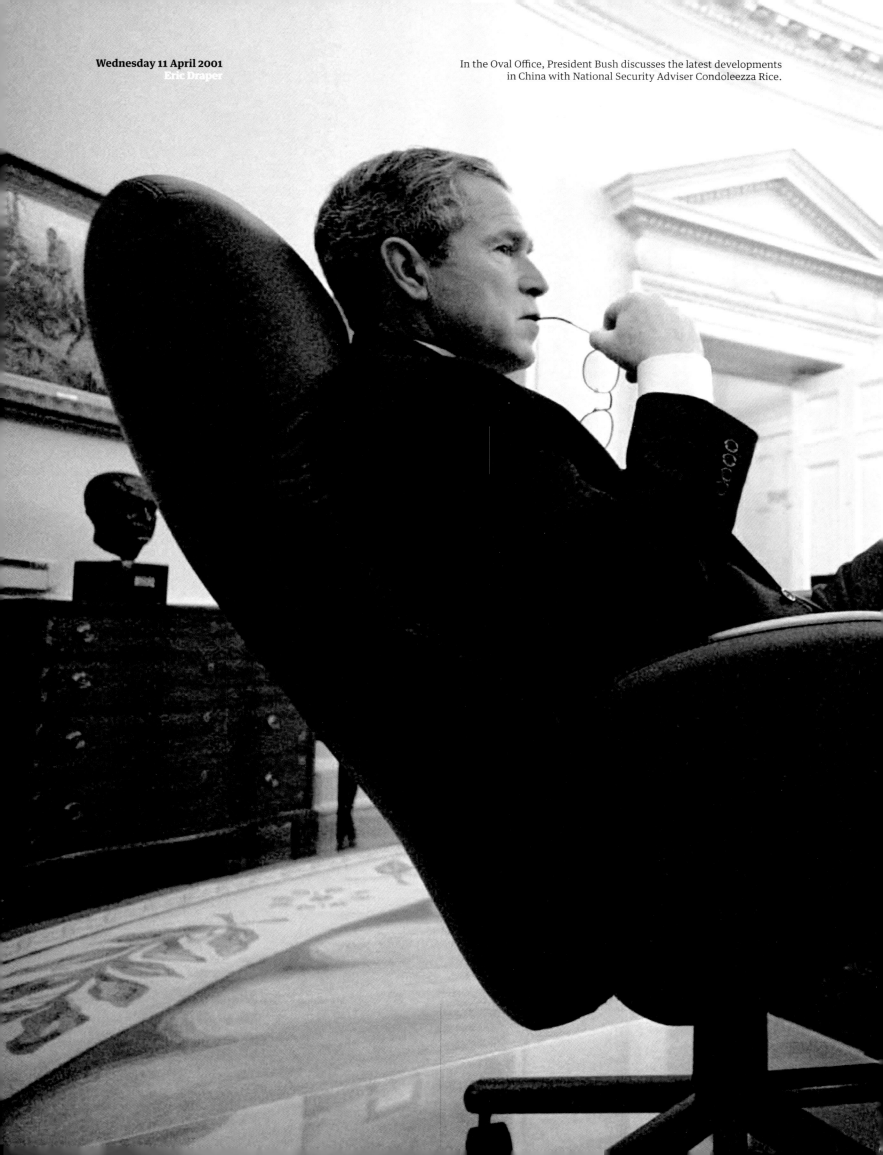

Wednesday 11 April 2001
Eric Draper

In the Oval Office, President Bush discusses the latest developments in China with National Security Adviser Condoleezza Rice.

Rachel Whiteread's sculpture *Monument* on the fourth plinth
in Trafalgar Square.

Wednesday 20 June 2001
Martin Godwin

Wearing ceremonial robes, Baroness Margaret Thatcher sits in the
House of Lords during the State Opening of Parliament.

A worker abseils down one of Big Ben's four clock faces, which are cleaned every 5-6 years.

Monday 20 August 2001
Garry Weaser

The Statue of Liberty seen through the thick smoke that still obscures the lower Manhattan skyline days after the 9/11 terrorist attacks on the World Trade Center.

Saturday 15 September 2001
Dan Loh

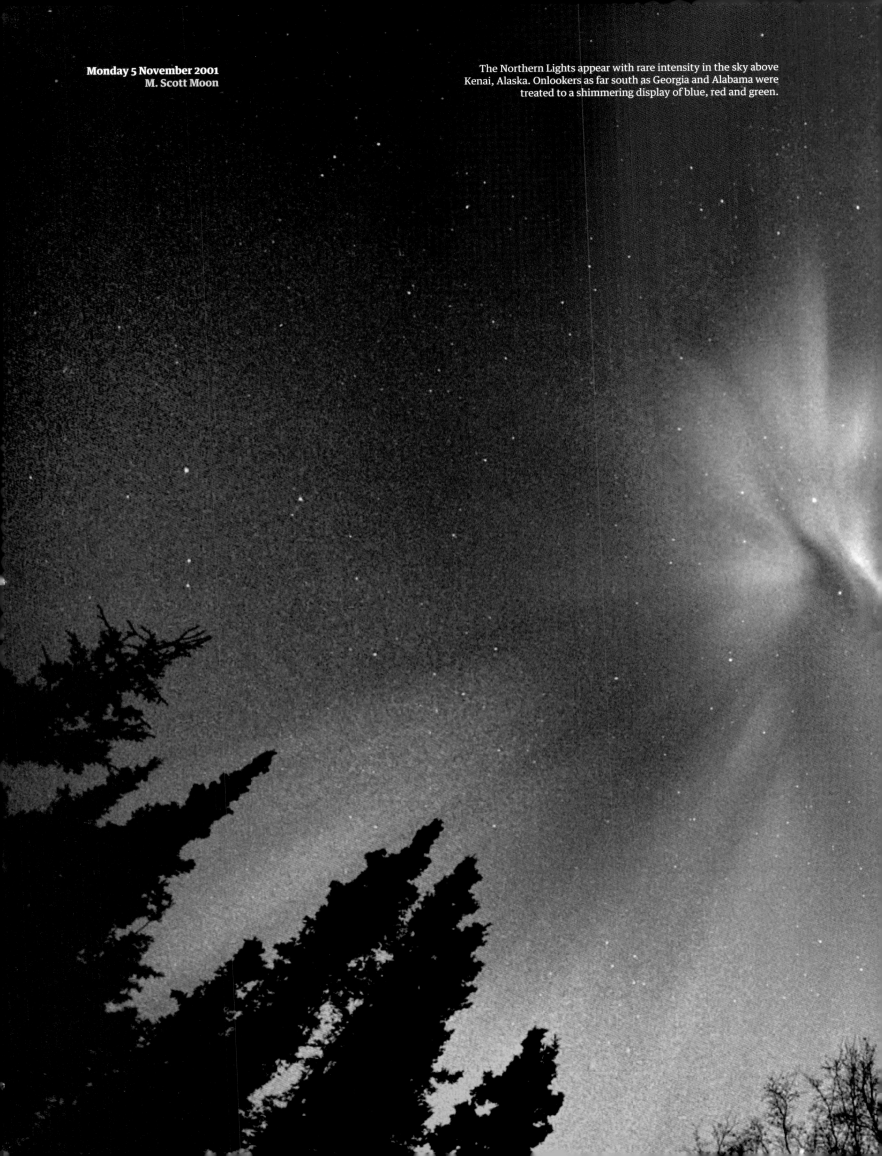

Monday 5 November 2001
M. Scott Moon

The Northern Lights appear with rare intensity in the sky above Kenai, Alaska. Onlookers as far south as Georgia and Alabama were treated to a shimmering display of blue, red and green.

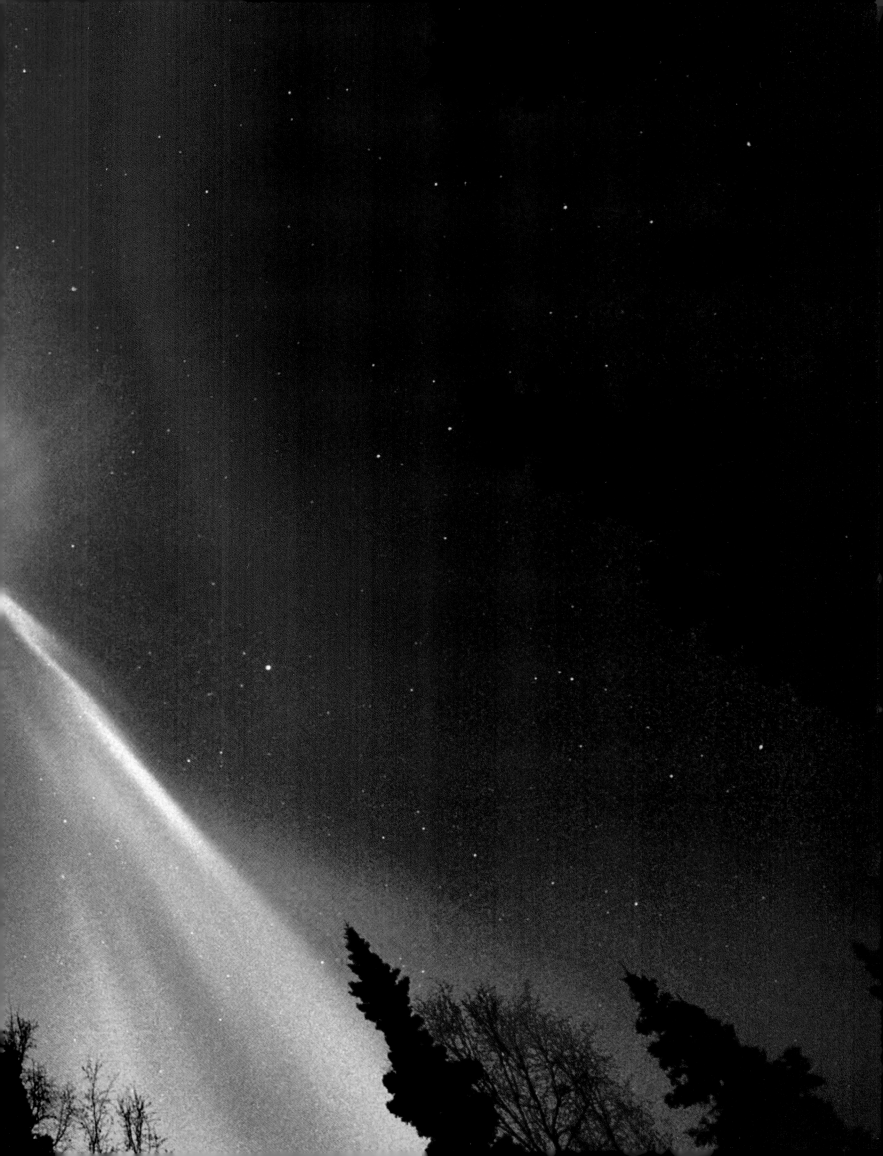

Northern Alliance soldiers watch the US bombing of Taliban positions
from the front line in Khanabad, Afghanistan.

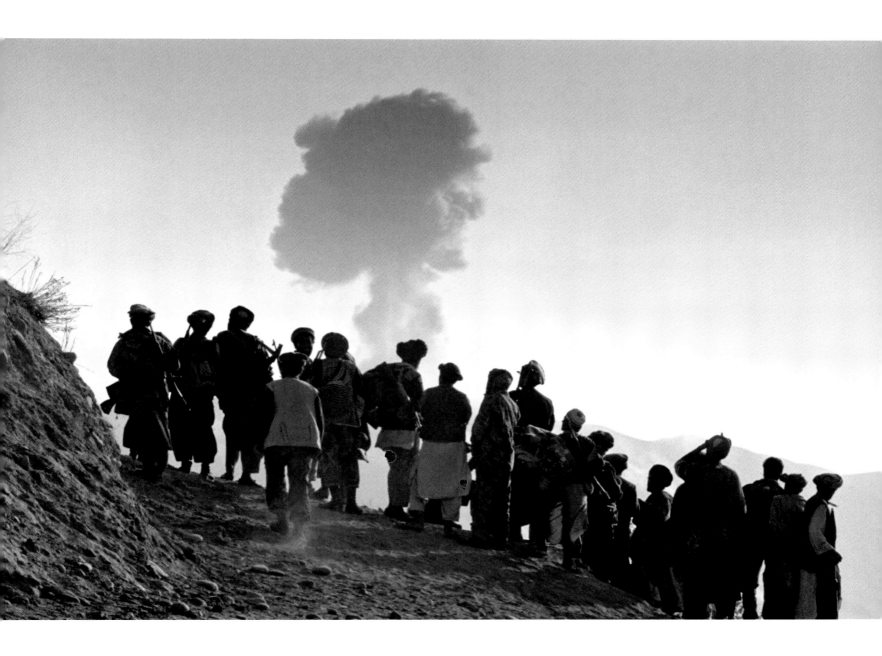

2002

Katharine Viner is deputy editor of the *Guardian*. She joined the paper in 1997 and has worked as a feature writer, editor of *Weekend* magazine and features editor.

US president George Bush set the tone for what would be a grim and ominous year in January with what became known as his 'axis of evil' speech. Iraq, Iran and North Korea were states, he declared, that with their 'terrorist allies' were set on using weapons of mass destruction to threaten world peace. In the wake of global shock and sympathy for the US over the 9/11 attacks, Bush's words laid the ground for a dramatic shift in American foreign policy that would shape the rest of the decade.

After what appeared to be the swift defeat of the Taliban in Afghanistan, the 'war on terror' encompassed extraordinary rendition, torture and imprisonment without trial in Guantanamo and elsewhere. Through-out the year, the ground was prepared for what would prove to be a catastrophic invasion of Iraq, as the UN inspectors began their fruitless hunt for Saddam Hussein's weapons of mass destruction. Meanwhile, the second Palestinian intifada was at its height, as Israel reoccupied the West Bank and Gaza and suicide bombings multiplied against civilian targets in Israel.

The threat of war hung heavily over Britain, too. Tony Blair, re-elected as prime minister the previous year, controversially bound himself ever tighter to the US administration. In April, in Crawford, and in September, at Camp David, he met President Bush, offering full support over Iraq while pressing the case for the UN route and a Palestinian state. His failure to convince on both counts would come back to haunt his government, the Labour Party and Britain for years.

Alarm was also felt at home by the rise of the British National Party. In May, the BNP achieved its best council results since its foundation twenty years earlier, particularly in northern cities, and the party's new focus on Muslims was a taste of things to come. The far right also did well in France: in an almost unimaginable outcome, socialist Lionel Jospin lost to the Front National's Jean-Marie Le Pen in the first round of the presidential election. (In the run-off Le Pen lost to Jacques Chirac in one of the biggest landslides in French history.) Another

anti-Islam politician, Pim Fortuyn, was murdered in Holland by an animal rights activist.

In August, two ten-year-old girls, Holly Wells and Jessica Chapman, were killed by school caretaker Ian Huntley in the Cambridgeshire village of Soham. Their bodies were found after almost two weeks of one of the most highly publicised missing person searches ever seen.

Seven people were killed when a train was derailed at Potters Bar; as many as 180 died when Russian forces pumped poisonous gas into a Moscow theatre where hundreds were being held hostage by Chechen rebels; and Gordon Brown, then chancellor, lost his ten-day-old daughter, Jennifer Jane, who had been born prematurely.

Against such a background, the nation's choices for entertainment look understandably escapist. Yann Martel won the Booker prize with his whimsical, entertaining *Life of Pi*; music from reality shows saturated the charts — Will Young, Gareth Gates, Liberty X — but Ms Dynamite won the Mercury, and The Streets' *Original Pirate Material* was the album of the year. Halle Berry became the first black woman in the history of the Oscars to win the prize for best actress.

400,000 people marched on the capital in favour of hunting, while David Beckham's broken metatarsal in his left foot became a national obsession. It healed in time for the World Cup, but England lost anyway to the eventual champions, Brazil. Manchester hosted a hugely popular Commonwealth Games where England won the men's 4x100m relay despite recording the same time as the Jamaican team.

In the year that saw the introduction of the single currency across swathes of Europe, but not in Britain, the Queen and royal family had something of a resurgence. The Queen Mother and Princess Margaret both died, bringing forth sympathy for the long-serving monarch, and her golden jubilee after 50 years on the throne was celebrated by many. Much was made of the multicultural nature of the crowds.

In such disorientating times, it seems Britain took refuge in the familiar.

1 January The single European currency becomes official in 12 EU member states.

7 January Gordon Brown's ten-day-old daughter dies.

15 January After 11 months, livestock in the UK is declared free of foot-and-mouth disease.

6 February Queen Elizabeth celebrates 50 years as monarch.

9 February Princess Margaret dies at Windsor Castle.

19 March Zimbabwe is suspended from the Commonwealth for a year.

24 March Halle Berry becomes the first black woman to win a best actress Oscar.

30 March The Queen Mother dies aged 101.

10 May A train derails at Potters Bar.

20 May East Timor gains formal independence from Indonesia.

22 June Around 230 are killed and 12,000 made homeless as an earthquake hits Qazvin province in north-west Iran.

1 July The International Criminal Court comes into existence.

4 July Steve Fossett becomes the first man to fly a balloon solo and non-stop around the world.

23 July Rowan Williams is confirmed as the next archbishop of Canterbury.

4 August Ten-year-olds Jessica Chapman and Holly Wells disappear in Soham. Ian Huntley is later charged with their murders.

22 September The Liberty & Livelihood March takes place in London.

24 September Parliament is recalled over the Iraq dossier.

28 September Edwina Currie reveals her four-year affair with John Major.

23 October Chechen rebels hold 500 people hostage in a Moscow theatre; 180 die when Russian forces pump in poisonous gas.

13 November In the first national firefighter strike since 1977, soldiers take over in 'Green Goddesses'.

15 November Myra Hindley dies.

21 November Riots against Miss World in Nigeria leave 105 dead.

25 November UN arms inspectors go to Iraq to search for evidence of weapons of mass destruction.

5 December The decision to close the Sangatte refugee camp is made as part of an Anglo-French immigration agreement.

29 December Brighton's historic West Pier collapses.

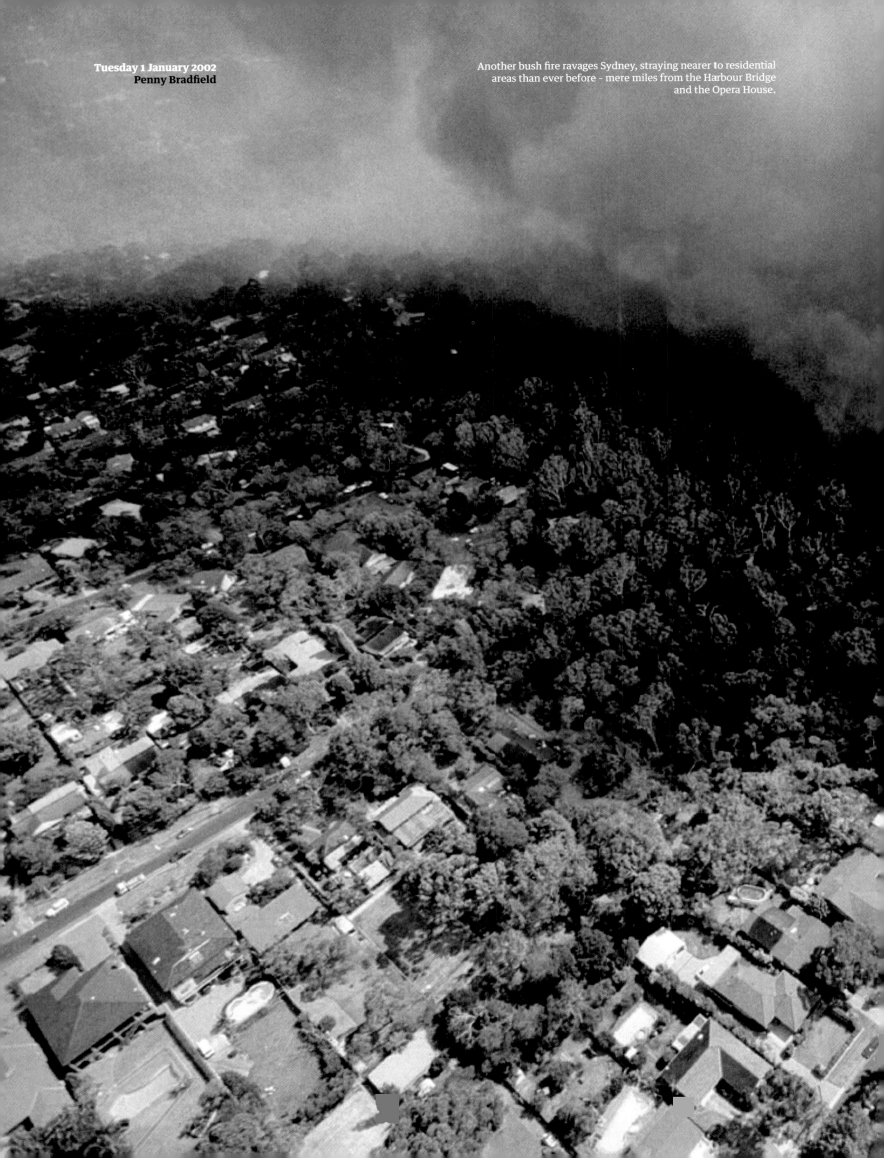

Another bush fire ravages Sydney, straying nearer to residential areas than ever before - mere miles from the Harbour Bridge and the Opera House.

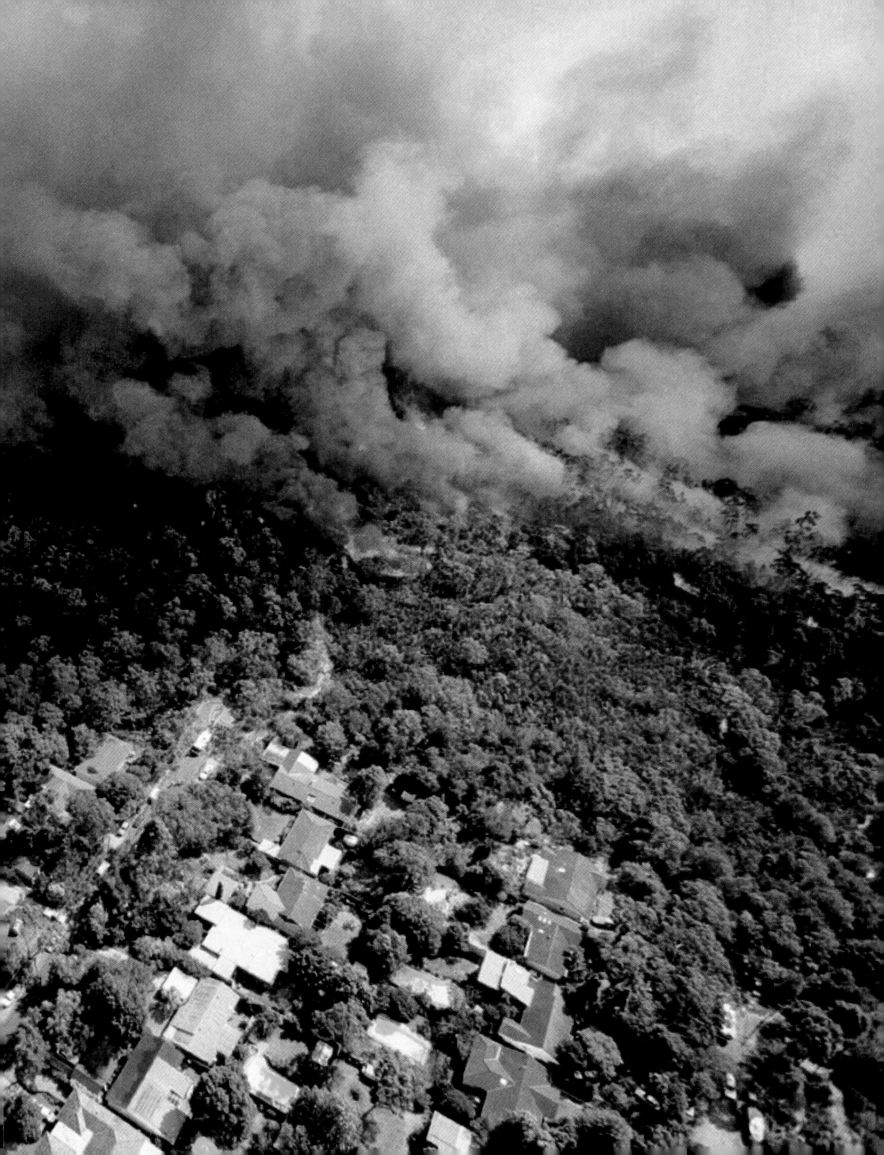

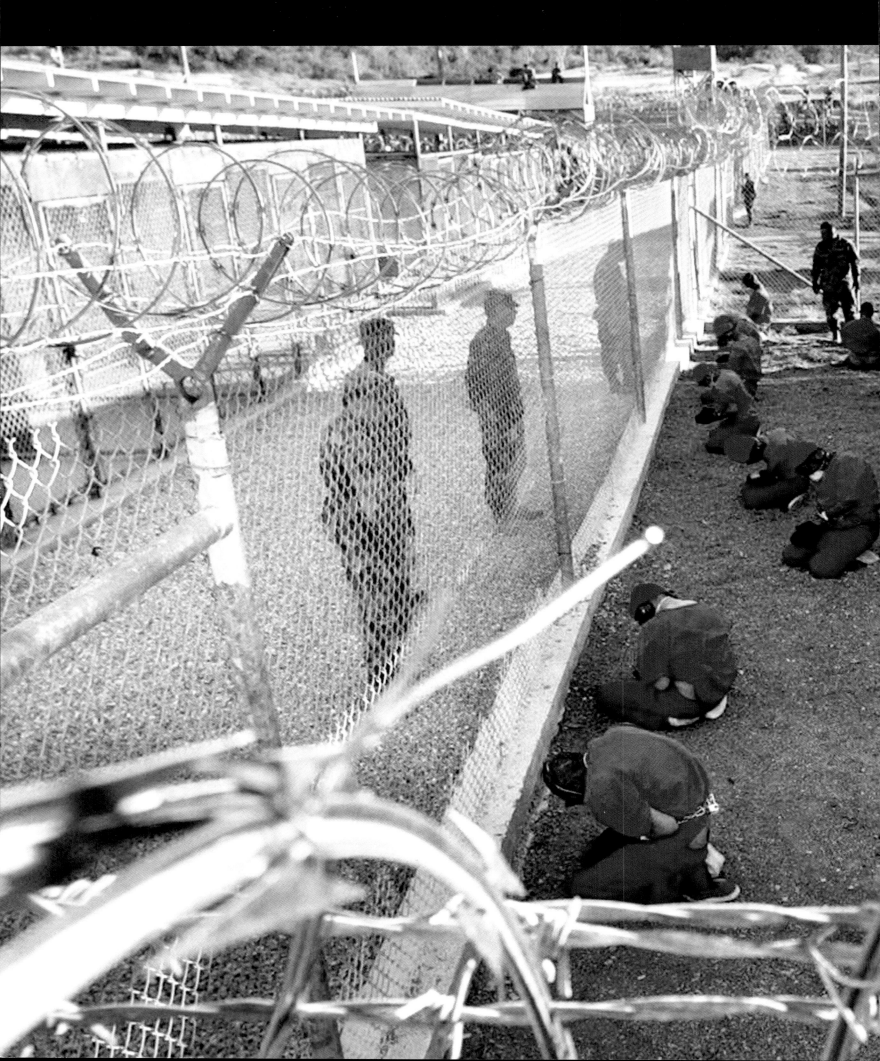

Al-Qaeda and Taliban detainees captured in Afghanistan sit in a holding area while they are being processed for incarceration in Camp X-Ray, Guantanamo Bay.

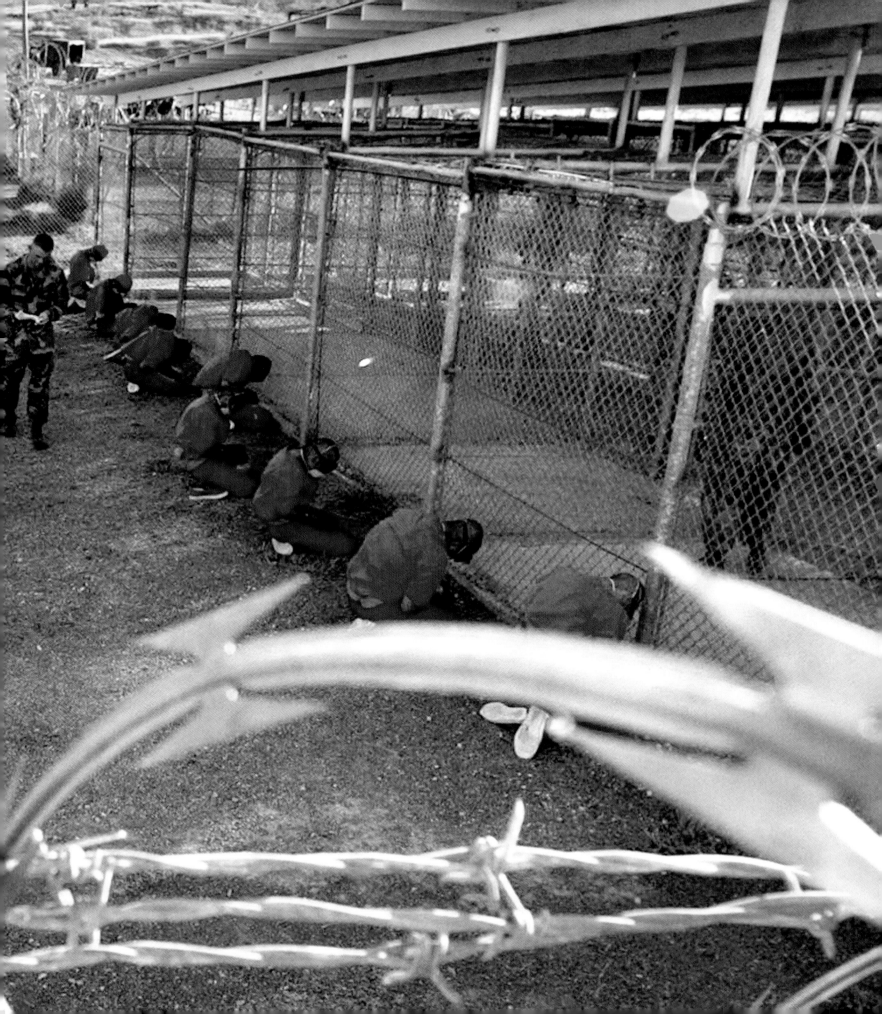

Thursday 14 March 2002
Joerg Sarbach

'Prince Albert', one of the stars of the 'Modern Primitives' freak show,
poses before an event in Goettingen. The 71-year-old former banker
has 350 piercings.

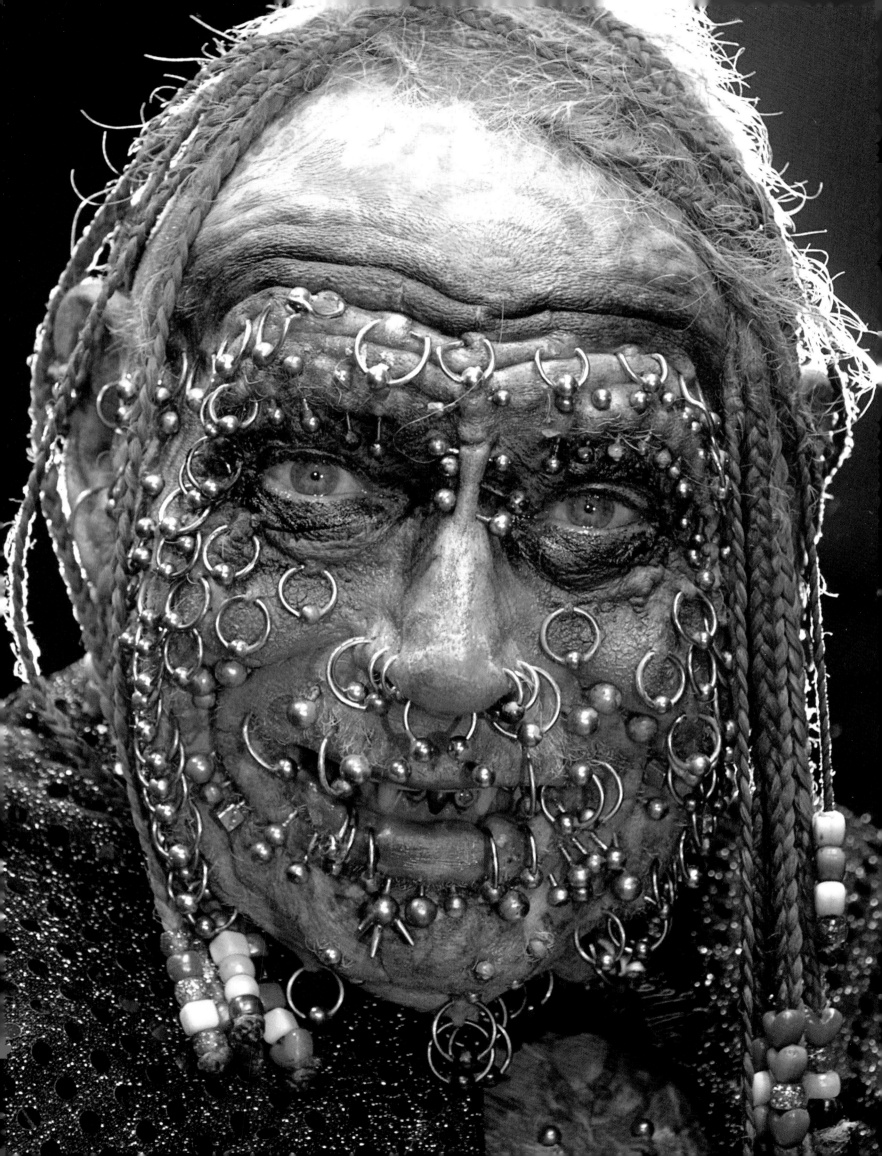

Saturday 30 March 2002
Awad Awad

Scattered shell cases after a street battle in the West Bank between
Israeli and Palestinian forces. The UN Security Council called
for Israeli withdrawal as the siege of PLO leader Yasser Arafat
in his compound in Gaza went into its second day.

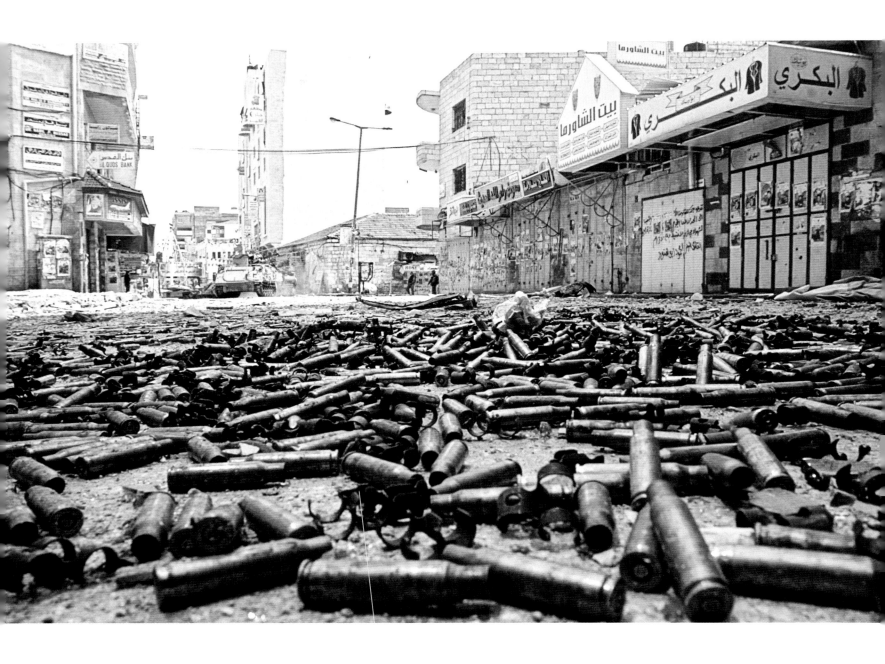

Palestinian men surrender to Israeli Defence Forces in
downtown Ramallah.

Saturday 30 March 2002
Jerome Delay

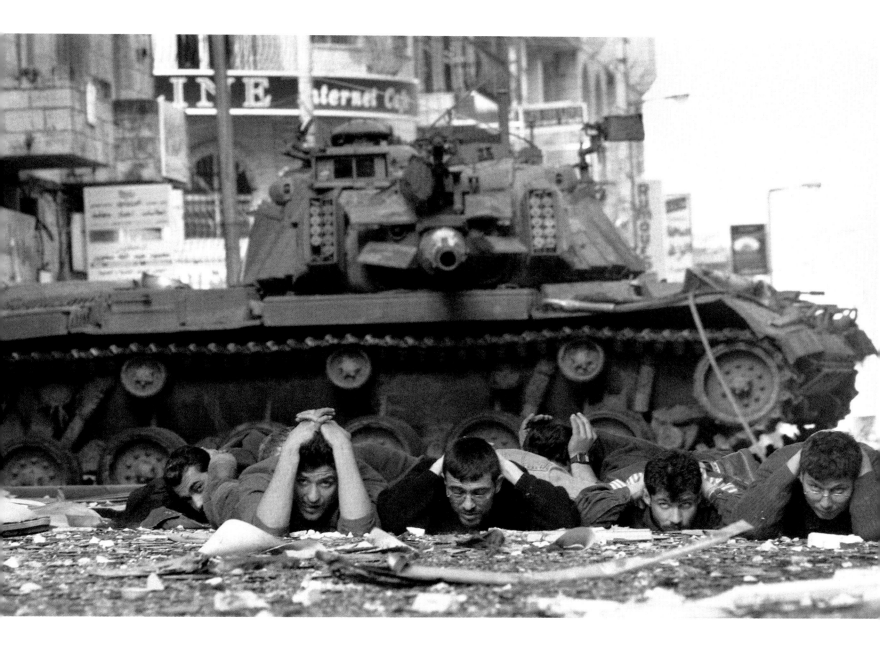

Sunday 7 April 2002
Jeff J. Mitchell

Members of the public queue along the banks of the Thames to pay their last respects to the Queen Mother as she lies in state at Westminster Hall. She died on 30 March, aged 101.

A spectacular ash plume curves out from Mount Etna after a series of earthquakes triggered an eruption. The picture was taken by the ISS-5 crew on board the International Space Station.

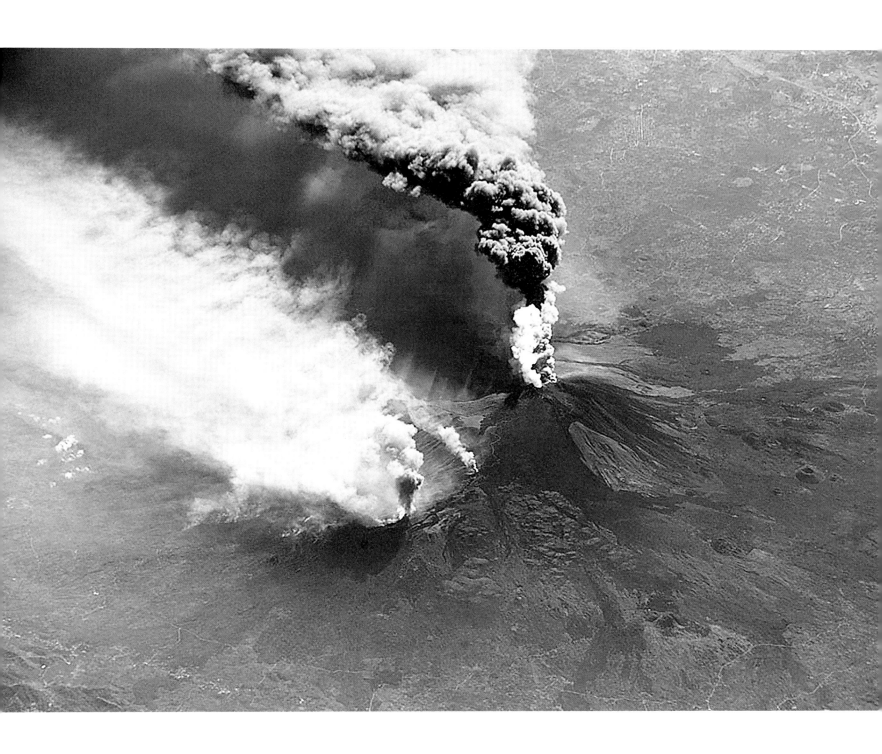

A group of homeless children sleep beneath a footbridge as traffic speeds by in downtown Bangkok. Despite routine police crackdowns on street begging, many continue the practice.

Wednesday 27 November 2002
David Longstreath

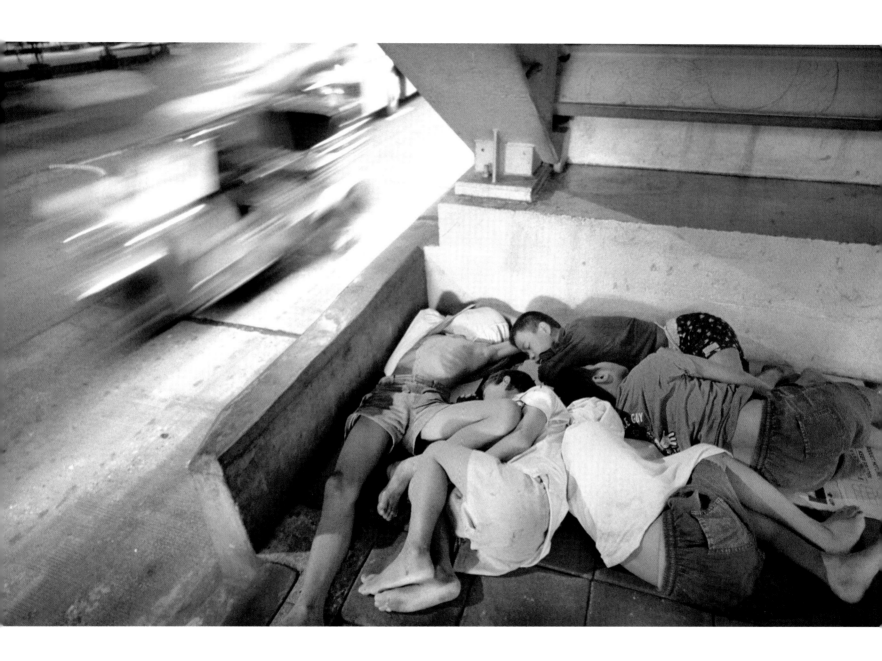

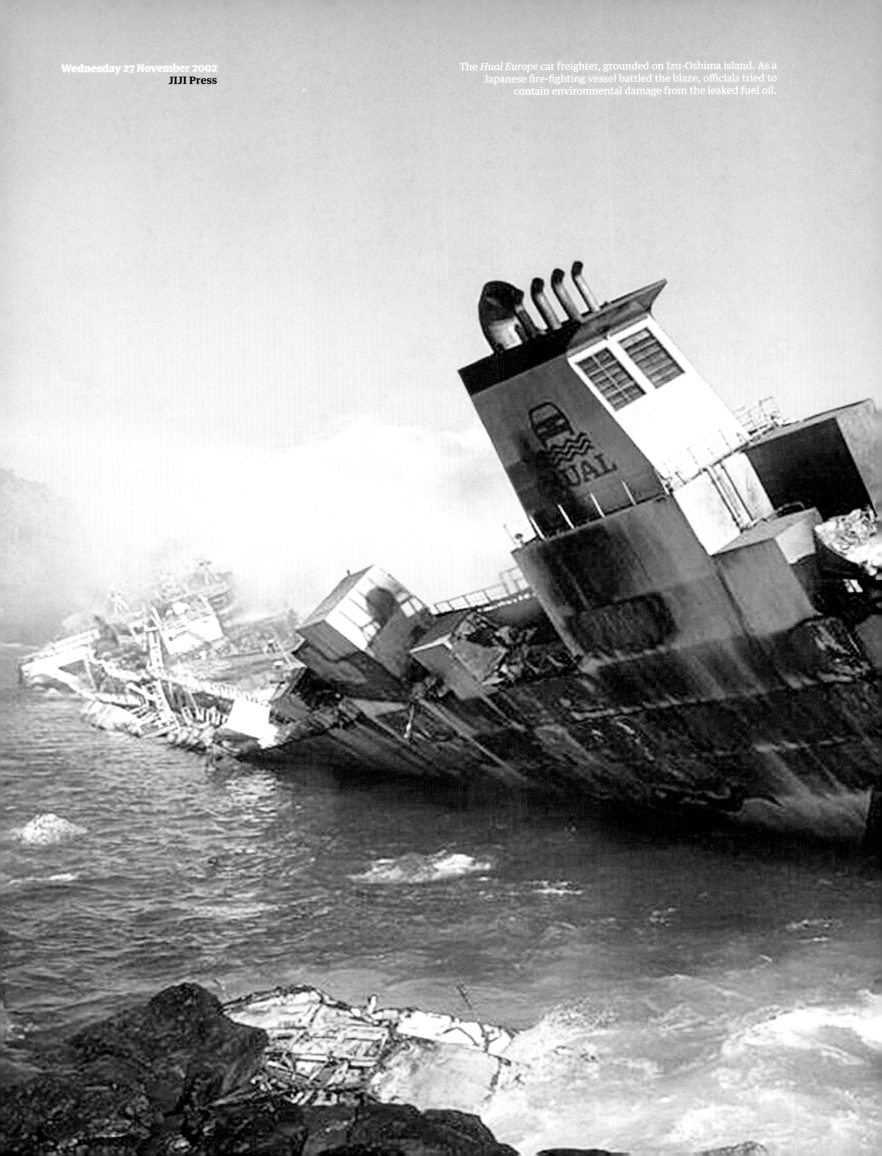

The *Hual Europe* car freighter, grounded on Izu-Oshima island. As a Japanese fire-fighting vessel battled the blaze, officials tried to contain environmental damage from the leaked fuel oil.

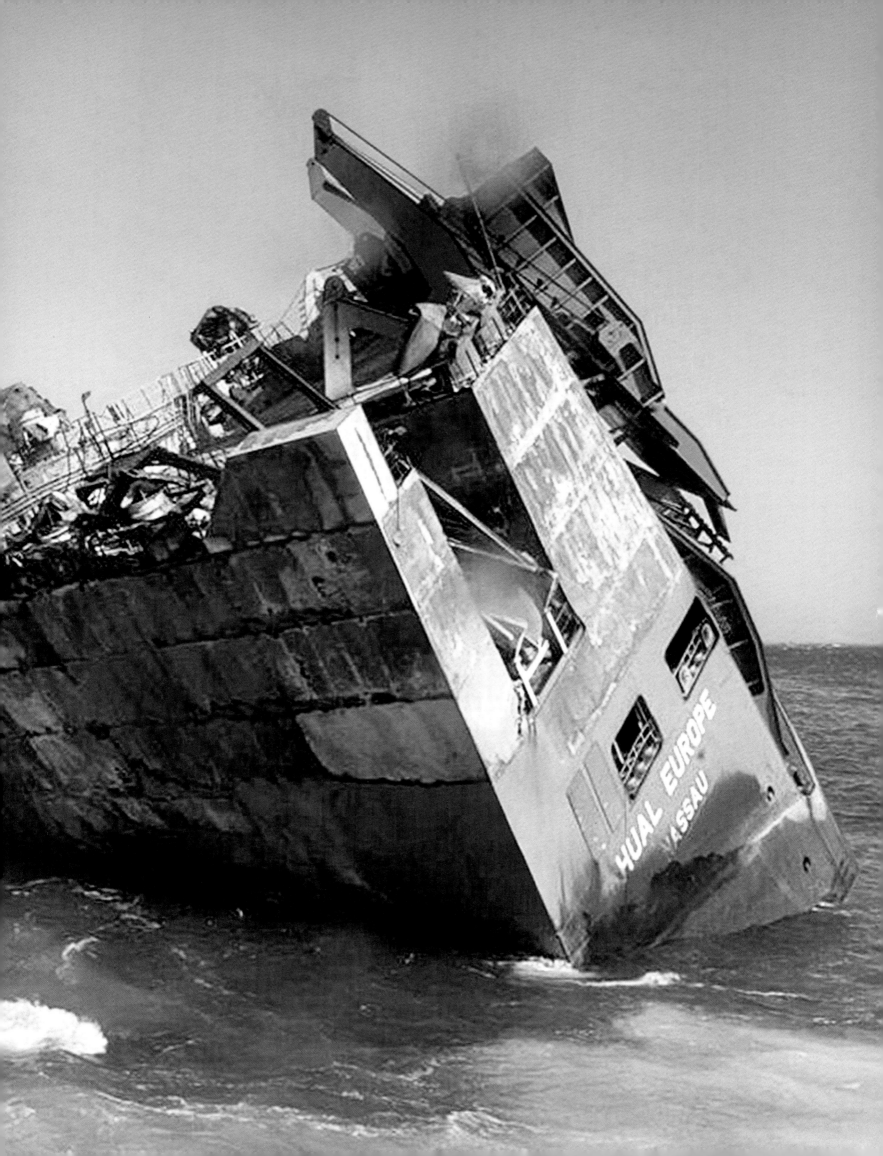

A Powergen worker walks past Scotland's largest wind farm, near Peebles.

Monday 18 November 2002
David Cheskin

A volunteer cleans up at Ons Island, Galicia, after oil leaks from the
sunken tanker *Prestige* devastated Spain's north-western coast.

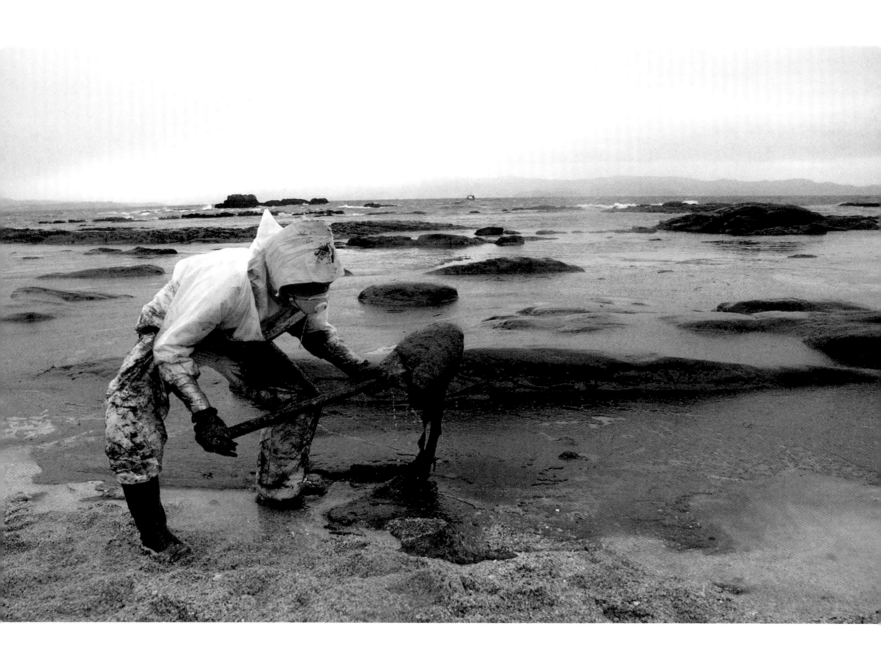

A rainbow forms in the sky over the Grosskrotzenburg
power plant near Frankfurt.

Monday 25 November 2002
Kai Pfaffenbach

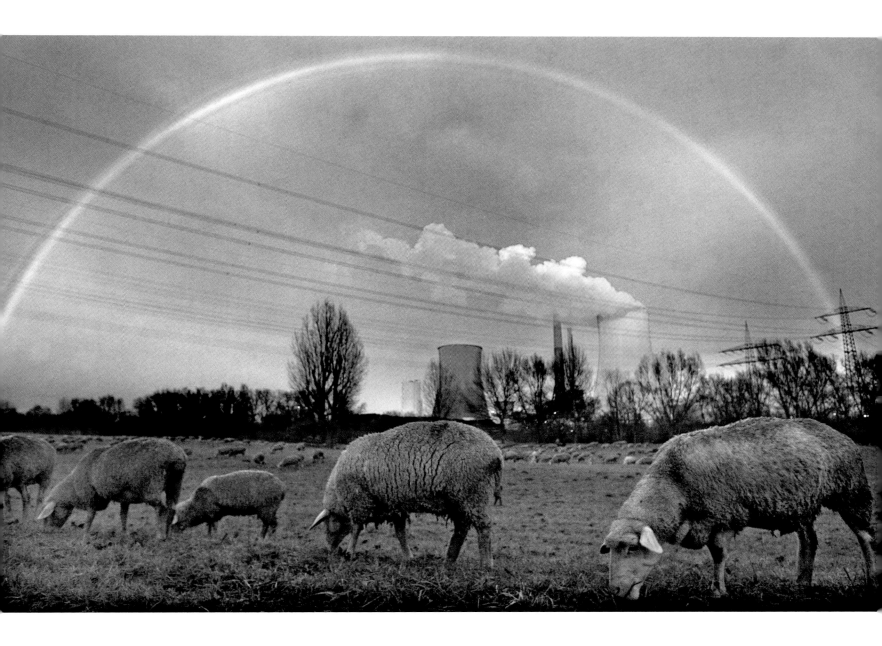

Looking back, 2003 turns out to have been the pivotal year, the year on which the rest of the decade turned. The events of 2001 and 2002 were, we can see now, leading up to what happened in 2003 - and the years that followed were in its shadow.

What happened was, of course, the invasion of Iraq. The memoirs and insider accounts now tell us that this project was on the agenda of the Bush administration within hours of 9/11 (if not before), and so the period after 11 September 2001 was dominated by preparation for the removal of Saddam. But by the start of 2003, that preparation - political, diplomatic, military - had grown intense and feverish, drowning out almost everything else. Each day seemed to bring another plea for action by Tony Blair, another crucial manoeuvre at the UN, another leaked glimpse of the machinations of the Bush White House. I remember the *Guardian* newsroom growing hushed during the key moments, colleagues gathering around a TV set to watch Blair make his most stirring case to the House of Commons or a studiedly unexcitable Hans Blix present his latest findings to the Security Council.

One doesn't have to rely on hindsight to say that, even at the time, war felt utterly inevitable. We reported the prime minister saying that, even at this late hour, it was still possible for Saddam to save himself. But as we watched US and British troops piling into the region, establishing an enormous military presence there, almost no one imagined they would turn around and go home. Even when a million Britons, maybe more, filled the streets of London in February to oppose the invasion - the largest demonstration anyone had ever seen in this country - it still seemed obvious that the spring of 2003 was to be a season of war.

At first, it seemed like it might be a short affair. There was the shock-and-awe fireworks display, tempered only by the delusional briefings of 'Comical Ali' (Iraqi Information Minister Mohammed Saeed al-Sahaf), telling reporters that Saddam was putting up heroic resistance. Then suddenly we were provided with the image that the war's prosecutors hoped would define

Jonathan Freedland is an award-winning journalist and broadcaster. He has been a columnist at the *Guardian* since 1997 and was named Columnist of the Year in the 2002 *What the Papers Say* awards. He has written two books.

the invasion: the toppling of an oversized statue of the dictator in Baghdad's Paradise Square, laid low with the help of US troops and revealed, poetically, as hollow inside.

But though the war started in 2003, it did not end in 2003. It did not proceed as advertised – a short, sharp shock with the boys back home in time for the Fourth of July. George W. Bush donned his flight suit in early May to make a telegenic landing on an aircraft carrier, declaring 'Mission Accomplished', but the mission had not been accomplished. In fact, it had barely begun. The clearest warning came from the refusal of Saddam himself to follow the script: he eluded capture until the last days of 2003.

There was a clue, too, to the long shadow the war was set to cast over the rest of the decade. David Kelly was outed and died in that baking-hot summer of 2003, triggering the Hutton inquiry that began sitting later that year. It was an early warning that the debate that had raged before the invasion would not recede; in some ways, it would only grow more intense. And it continues still.

Of course, normal life went on. Musicians kept playing. Who knows, perhaps the historians of the future will say that the truly revolutionary event of 2003 did not take place in the Gulf but inside a computer, when iTunes was launched – a development that has reshaped the music industry, and may do the same for books and for the entire business of media and entertainment.

Politics went on too. Iain Duncan Smith branded himself 'the quiet man': trouble was, the country wasn't listening, so the Conservative Party shut him up for good. Michael Howard took his place, setting in train the eventual succession of Howard's protégé, David Cameron.

There will be countless other memories of 2003, people remembering the year for the birth of a child or the death of a friend. But in the public sphere, it will live on as a start date - for a war that has still not ended.

1 January Four teenage girls are shot dead in Birmingham.

5 January A ricin plot is uncovered when police raid a flat in north London.

30 January 'Shoe bomber' Richard Reid is jailed for life.

1 February The *Columbia* shuttle disintegrates as it re-enters the earth's atmosphere, killing all its seven astronauts.

15 February One million people take to the streets in London to protest war in Iraq.

15 March SARS is confirmed as a 'worldwide health threat'.

20 March The Iraq war begins.

28 April iTunes is launched.

30 April The US publishes a Middle East peace roadmap.

29 May Andrew Gilligan reports that the Iraq dossier has been copied from a PhD thesis and 'sexed up' with a 45-minute claim.

1 June A heatwave across Europe results in droughts and forest fires.

18 July The body of missing Iraq expert Dr David Kelly is found in woodland not far from his home in Oxfordshire.

20 July The BBC admits Kelly was the main source for the report by Andrew Gilligan into the government's 'sexed up' Iraq dossier.

3 August The Anglican Church in America approves gay bishop Reverend Canon Gene Robinson.

11 September The Swedish foreign minister Anna Lindh dies of stab injuries after being attacked in a department store.

8 October Arnold Schwarzenegger is elected governor of California.

15 October China sends its first man into space.

24 October Concorde lands for the last time.

31 October Prime Minister Mahathir of Malaysia steps down after 22 years in office.

20 November Michael Jackson is arrested on child molestation charges. He is later found not guilty.

22 November England wins the Rugby World Cup.

10 December Angela Cannings is cleared of murdering her two baby sons.

14 December Saddam Hussein is captured by US soldiers.

17 December Ian Huntley is found guilty of murdering Soham schoolgirls Holly Wells and Jessica Chapman.

25 December The British-built Mars space probe, *Beagle 2*, disappears.

Locals from the Ashdown Forest area, East Sussex, stage a naked anti-war protest in the freezing weather.

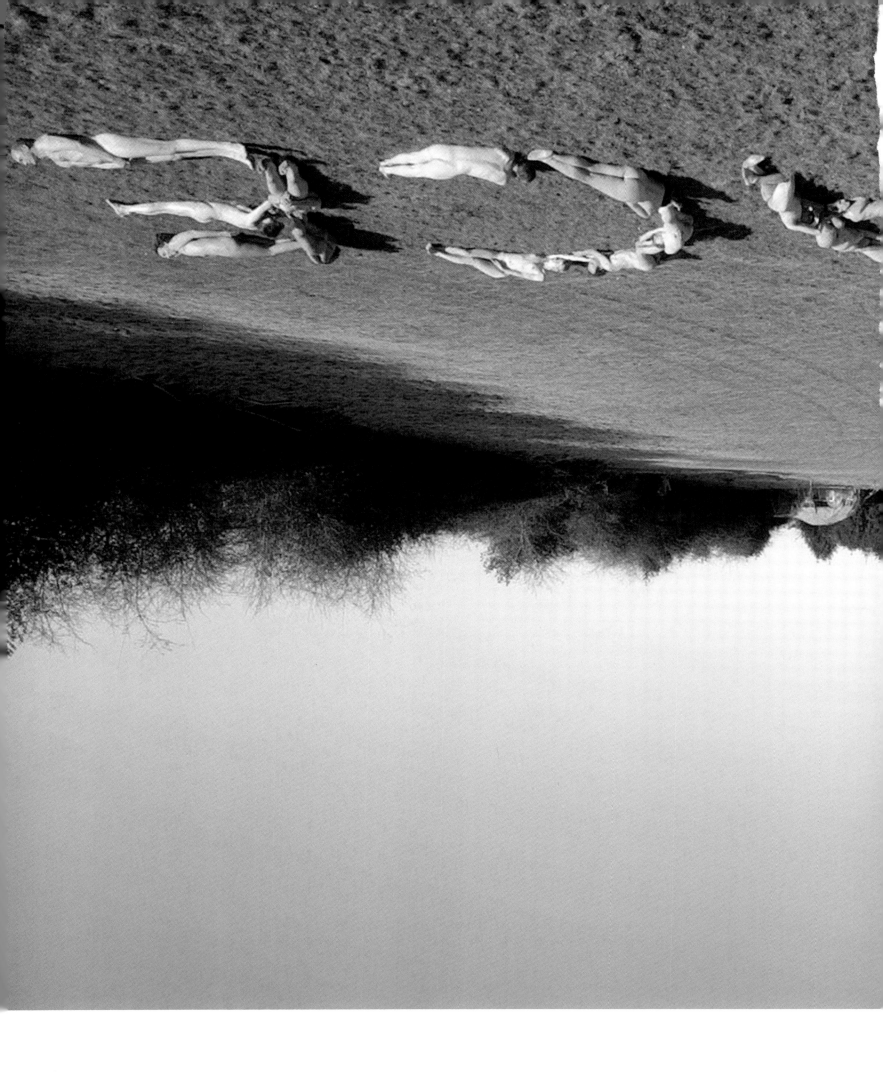

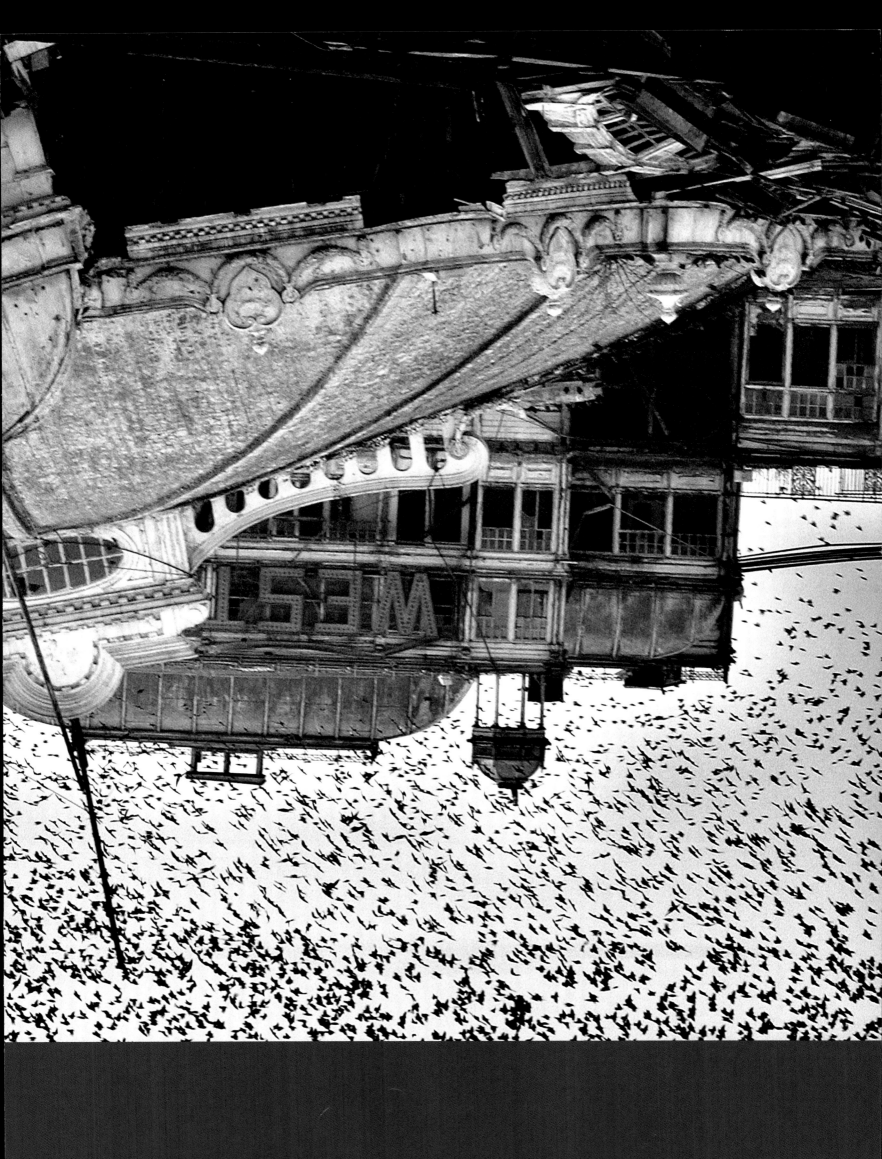

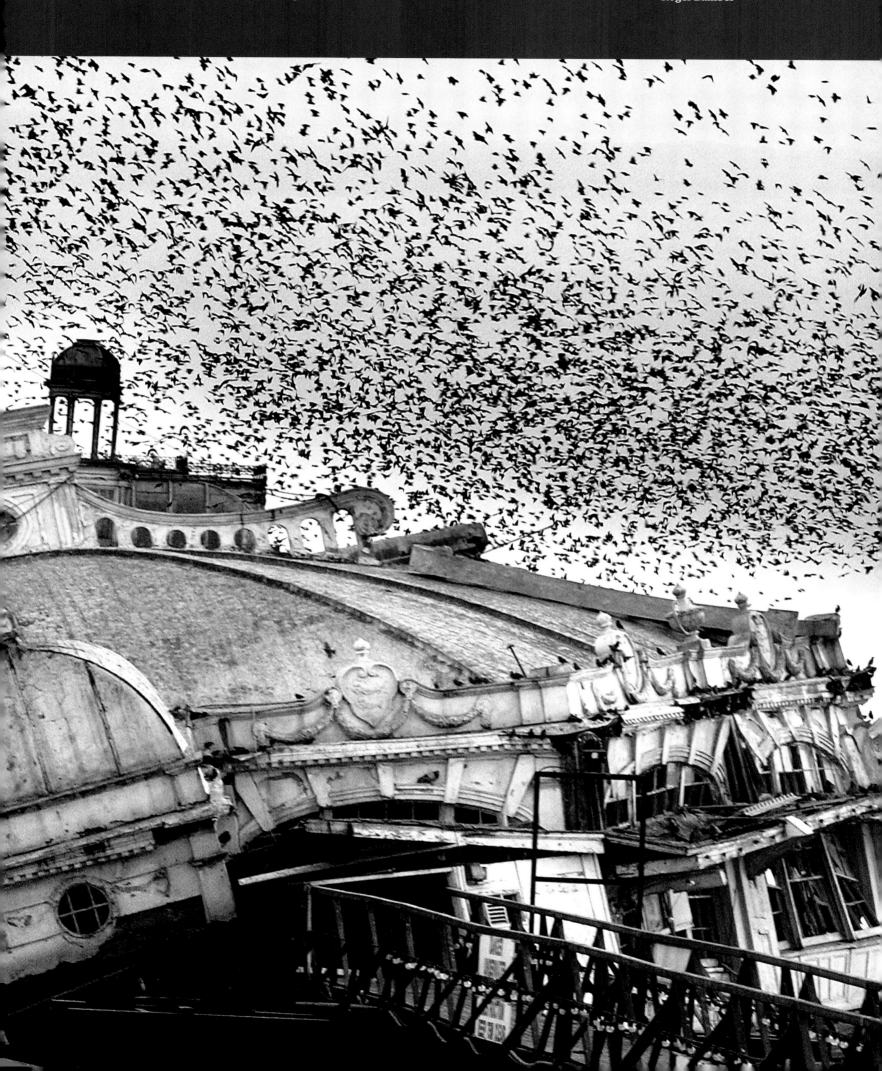

The collapsing Concert Hall of the grade I-listed West Pier in Brighton, and some of the 50,000 starlings that roost there.

Wednesday 26 February 2003
Roger Bamber

93-year-old Cuban music legend Compay Segundo sings the famous
song 'Chan Chan' at the opening of the Habanos International Cigar
Festival in Havana.

Friday 29 February 2003
Rafael Perez

Sunday 23 March 2003
Sean Smith

A child in the civilian neighbourhood of al-Qadissiya recovers a rabbit
from the wreckage of a US bombing raid in Baghdad. Military action
against Iraq commenced on 20 March.

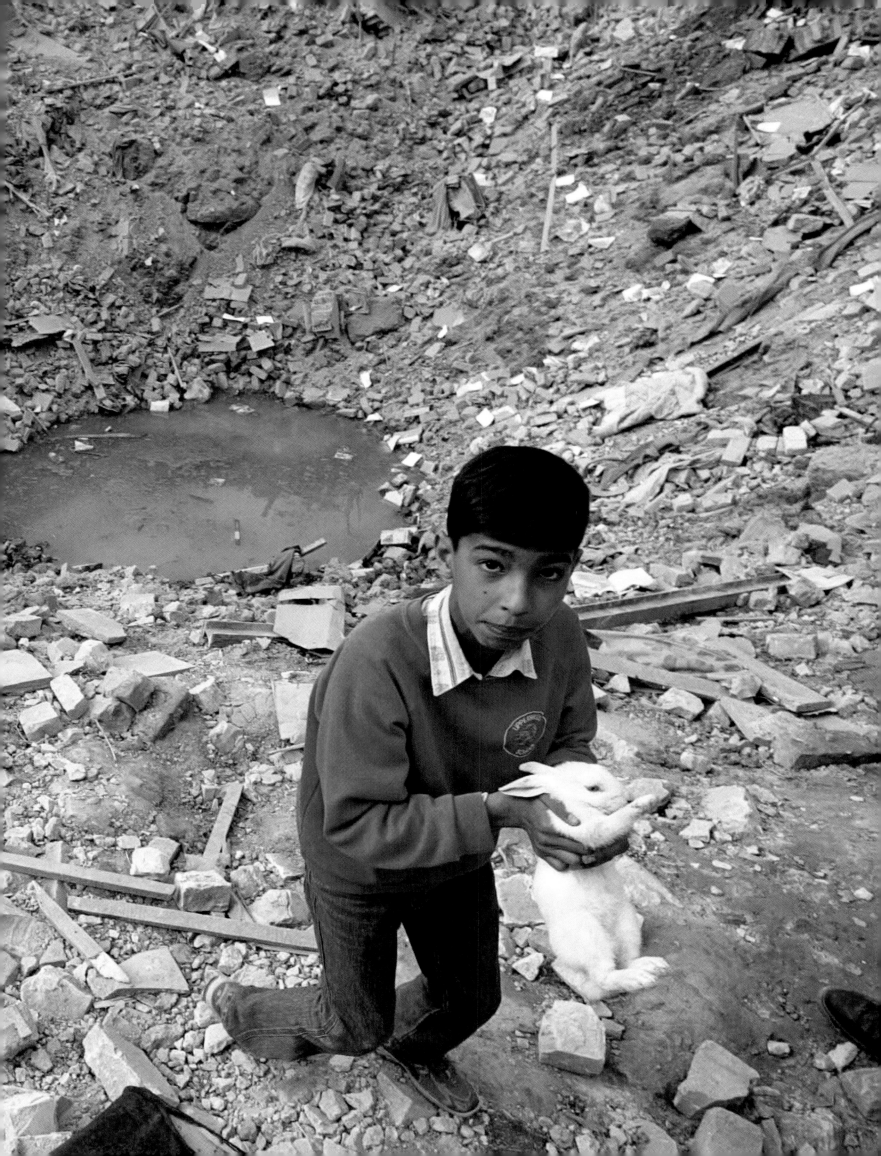

Despite the disruption, street life goes on in Baghdad.

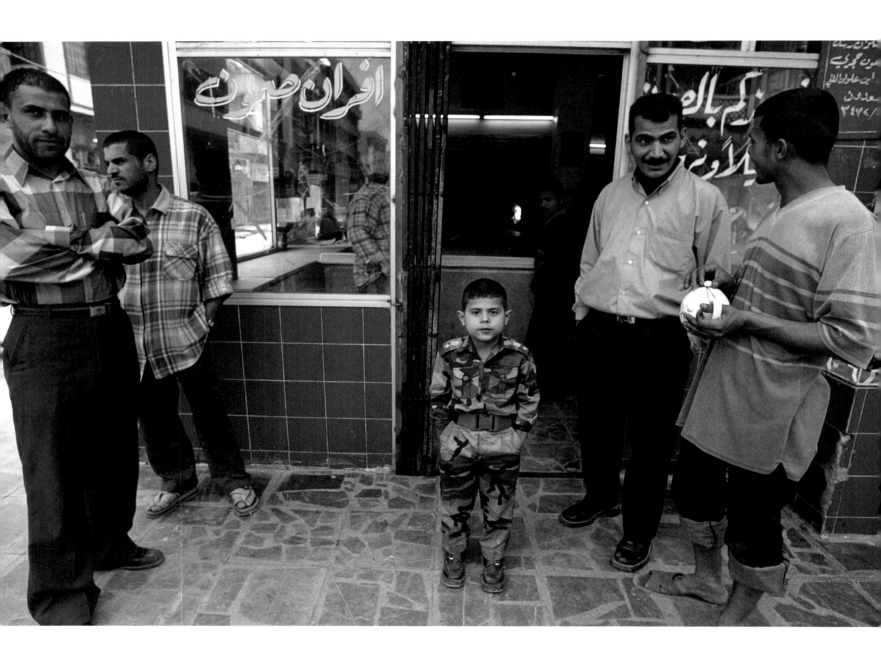

Families leaving Basra cross a bridge manned by British soldiers.

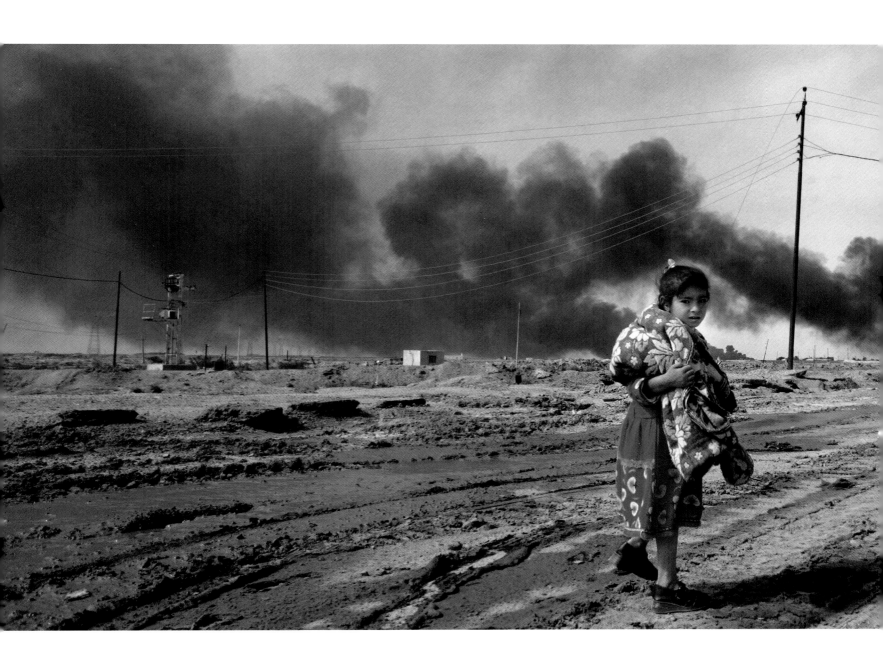

Iraqi civilians and US soldiers pull down a statue of Saddam Hussein in downtown Baghdad.

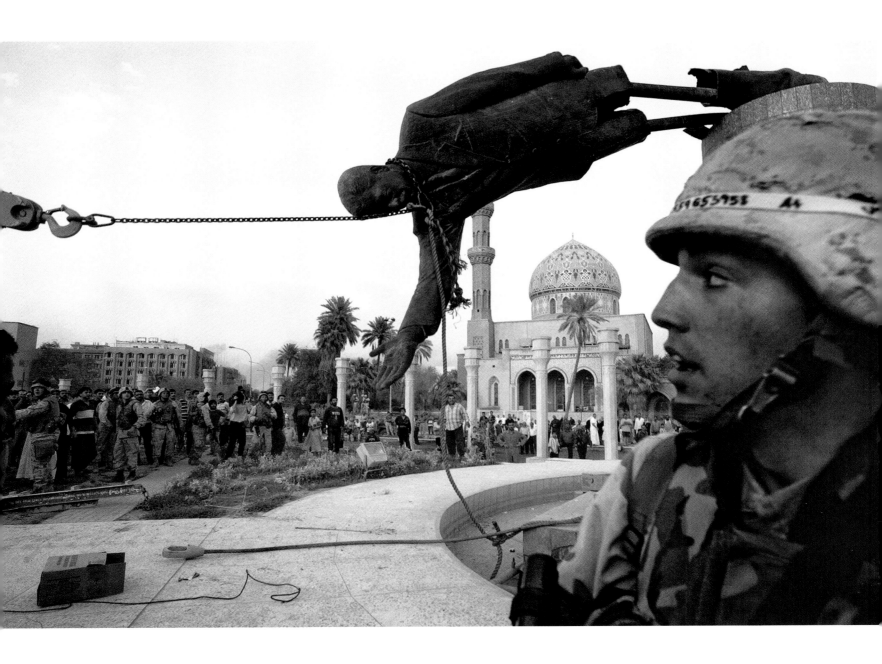

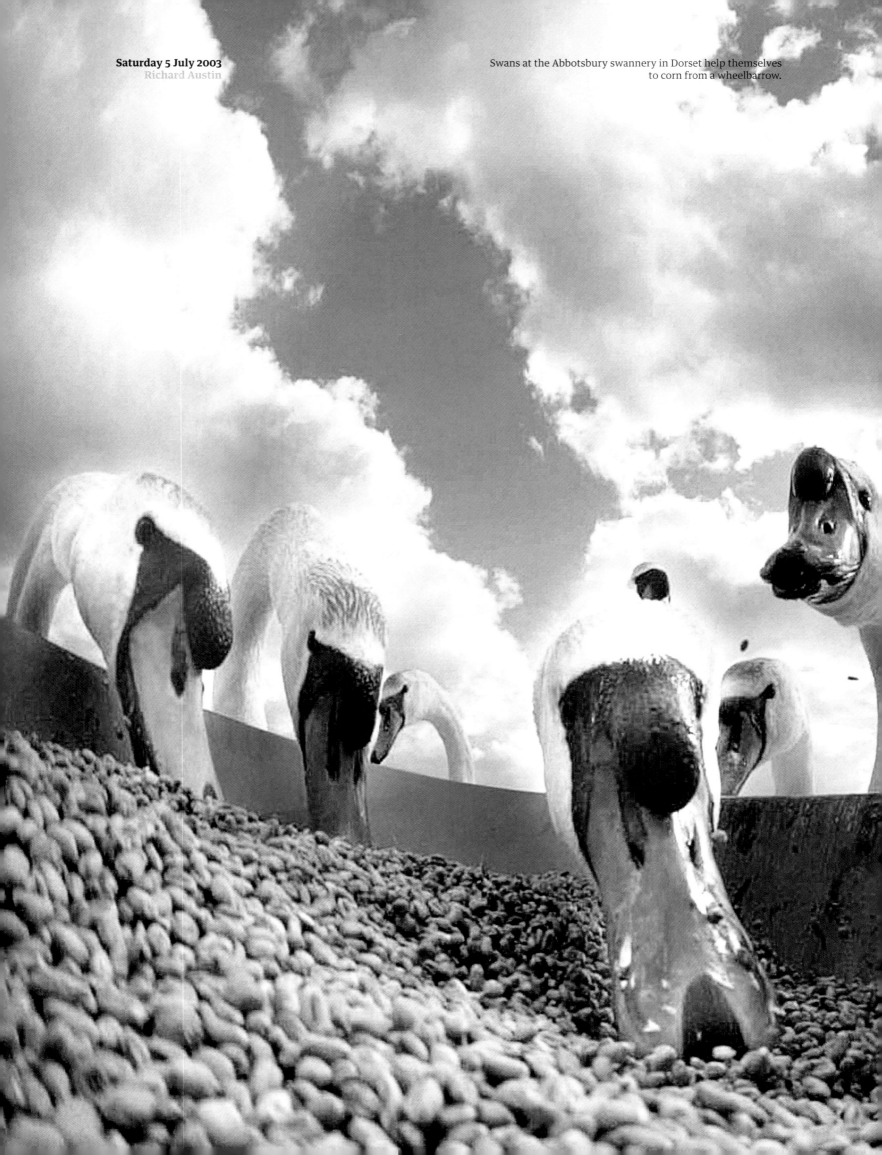

Swans at the Abbotsbury swannery in Dorset help themselves
to corn from a wheelbarrow.

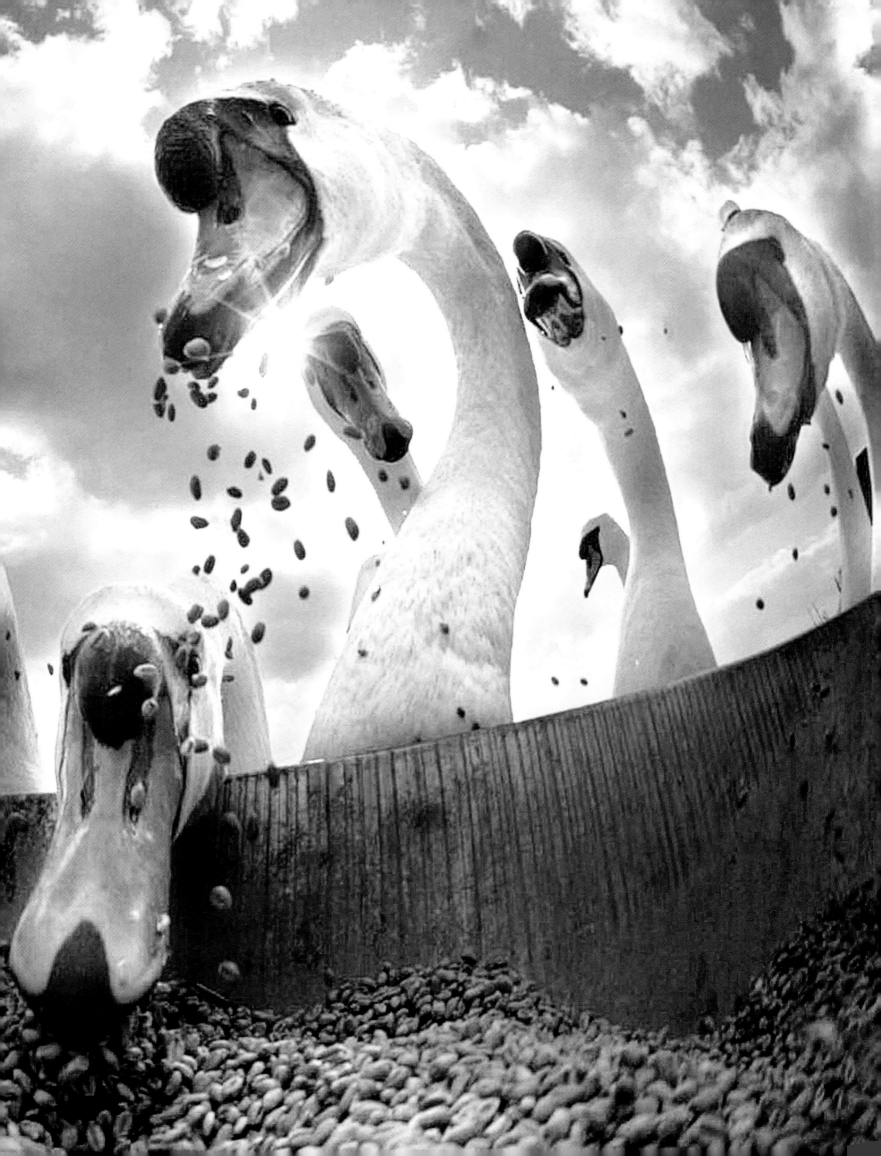

A Liberian militia commander who has just fired a rocket-propelled grenade at rebel forces in Monrovia during fierce fighting in the city. Government forces succeeded in driving back the rebels in a civil war that cost over 200,000 lives.

Sunday 20 July 2003
Chris Hondros

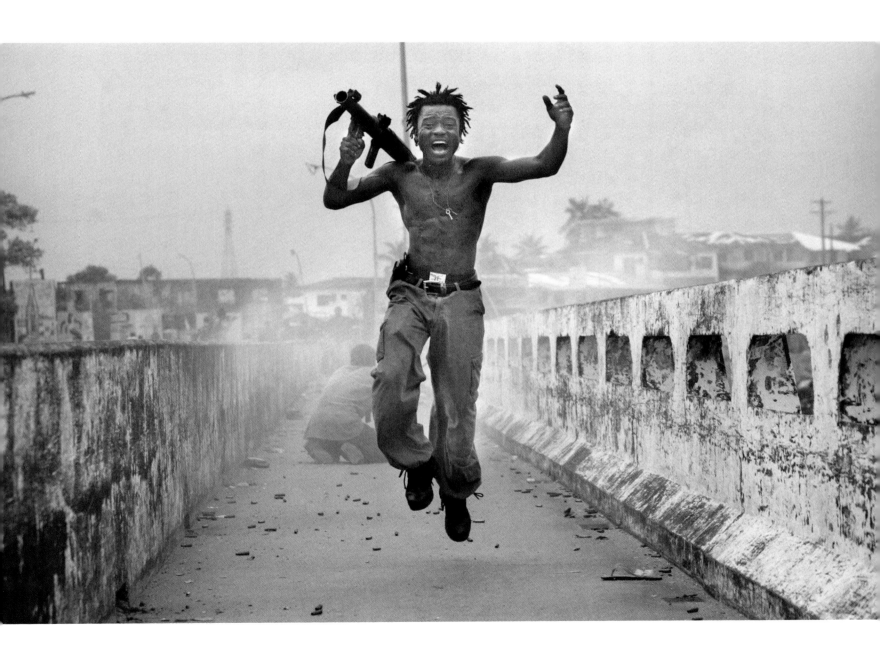

Birmingham's new Selfridges illuminated at night for the first time; 15,000 spun aluminium discs were used in the construction of this futuristic building.

The historic fortress of Bam after it was flattened by an earthquake.
A team of Italian archaeologists and architects travelled to Iran to
begin a delicate restoration project on the structure, parts of which
date back 2,000 years.

Saturday 27 December 2003
Hasan Sarbakhshian

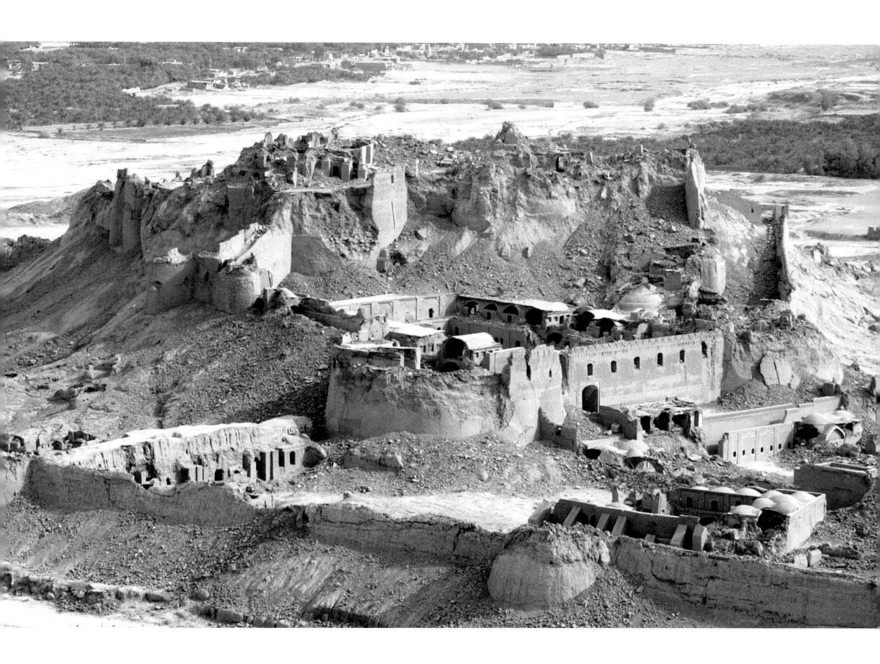

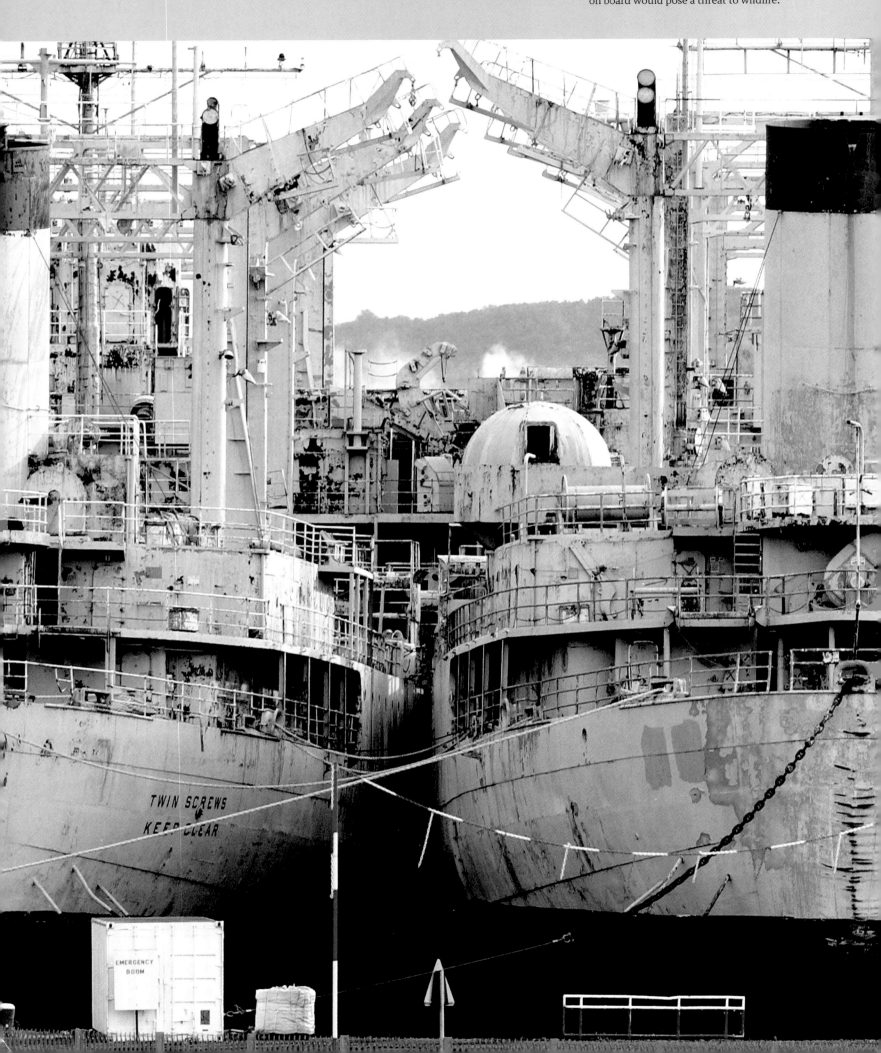

One of a fleet of controversial 'ghost ships' arrives at the Able UK yard in Hartlepool. The firm had a contract to dismantle the thirteen former US Navy vessels, but environmental groups feared chemicals on board would pose a threat to wildlife.

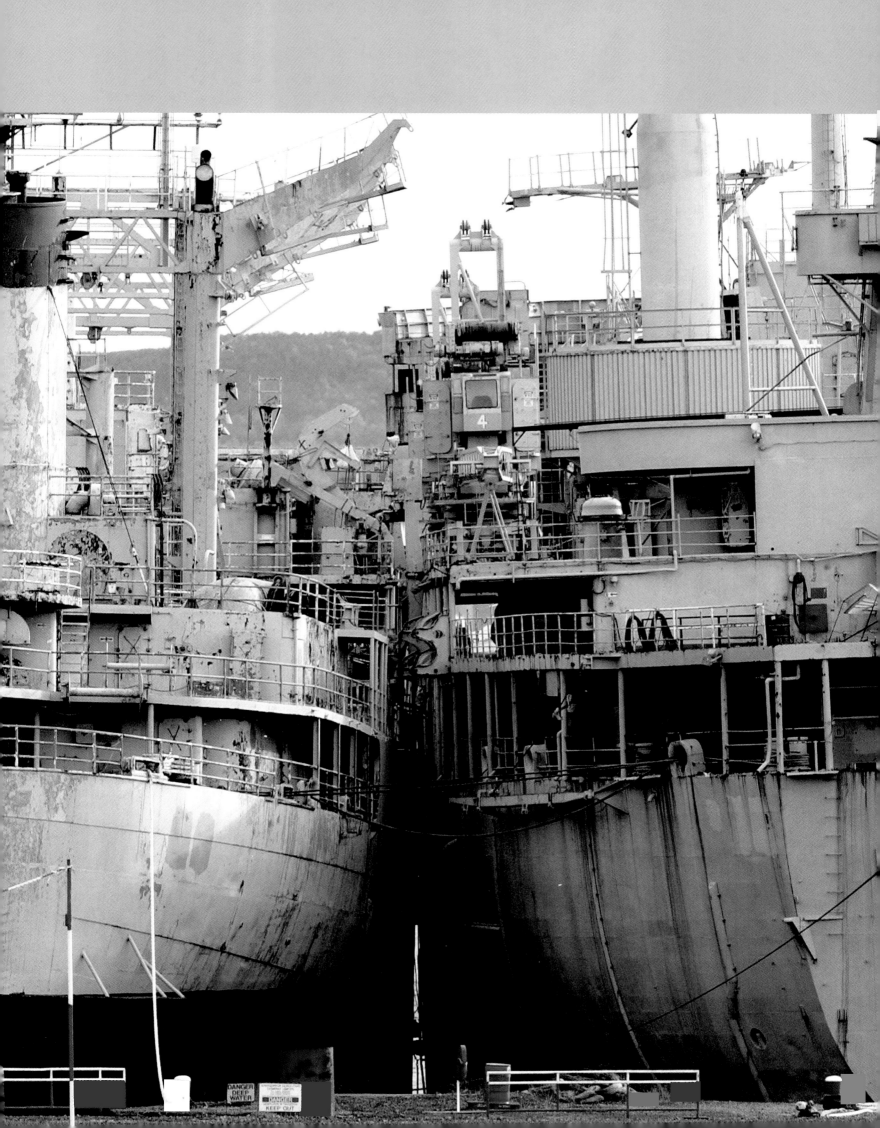

DANGER
DEEP
WATER

DANGER
KEEP OUT

2004

It was a year most remembered for its last few apocalyptic days. As Christians in the West slept off their Christmas excesses, deep under the Indian Ocean the earth heaved and cracked, unleashing a monstrous wave of destruction. First reports of the tsunami, broadcast on Boxing Day bulletins, were cautious: it was unclear how many were dead or how much had been destroyed. By the time the year turned, five days later, the appalling scale of the disaster had revealed itself. Waves up to 100 feet high had smashed against the coastlines of fourteen countries, killing nearly 230,000 people and obliterating towns and villages. The wall of water reached some places within fifteen minutes of the earthquake; it took seven hours to cross the vast sea to villages on the Somalian shore.

Those who understood the warning signs knew that the sea being sucked back into itself heralded a high-speed rush of unimaginable quantities of water moving with extraordinary force. A few managed to scramble to higher ground; most simply didn't stand a chance. People, animals, buildings, trees – all were torn from the ground and swept into the vortex. One-third of the dead were children, least able to escape the surge. As the waters receded, it became apparent that there was little luck in being a survivor: the loss of loved ones, homes, livelihoods, crops and communities was soon joined by the threat of disease and hunger.

The world, shocked at the TV images being broadcast round the clock, put its hand in its pocket to help; $7bn was donated by governments, but ordinary citizens outdid their leaders. In the UK, £330m was given to charitable appeals as pensioners dug into their life savings and children offered up their pocket money.

It was the worst tsunami in recorded history, a tragedy on an almost incalculable scale. But it was a natural disaster: unpredicted, unpredictable and with no one (save for the shoddy builders whose constructions collapsed at the first tremor) to blame.

Destruction of a different, man-made kind was evident throughout 2004, as it was for so many years of that decade. The fall-out from 9/11 was still reverberating. Iraq continued its slide into bloody chaos with the first video decapitation of a Westerner, regular suicide bombings, the partitioning of cities and provinces on

Harriet Sherwood became the *Guardian*'s foreign editor in 2003, and head of international news in 2008. Between 1998 and 2003, she was the *Guardian*'s home editor.

sectarian religious grounds, the shocking abuse of prisoners at Abu Ghraib, the flight of anyone who had a chance of escape. Somewhere on this spectrum of desperation were the increasing risks faced by the media in reporting what was happening in post-Saddam, post-invasion Iraq. We agonised over calculating the importance of the story against the safety of our reporters.

The repercussions of the West's Iraq adventure rippled beyond the Middle East. In March, the theatre of war transferred to commuter rail stations in Spain. A series of rush-hour bombs killed 191 people and injured 1,800 more. The Spanish prime minister, Jose Maria Aznar, had been an enthusiastic cheerleader for President George Bush over Iraq; three days after the terrorist attacks, Aznar was ejected from government in a general election.

Many in Europe hoped the same verdict would be delivered on Bush himself later in the year. Despite John Kerry's wooden campaign, it was a close race, and on the night of 2 November it seemed as though the Bush family might be destined to produce two one-term presidents. Amid disputed results and calls for recounts, Kerry refused to concede until the next morning when the key state of Ohio declared for the incumbent, and the world reconciled itself to four more Bush years.

Acts of violence were not confined to Al-Qaeda and its franchisees. On the first day of the new school year in Beslan, a small town in North Ossetia, militant separatists took 1,100 people hostage, including 777 children. For three days, anguished parents waited outside the school where their children had been herded into a gym in which live explosives were strung above their heads. On the third day, Russian security forces stormed the building, triggering explosions, fire and chaotic gunfights - all carried out live on television. Around 330 hostages, including 186 children, were killed.

It wasn't all bad: in Ireland, smokers fulminated and pledged defiance in the face of the world's first ban on smoking in the workplace, which included public houses. In the event, they fell into line without so much as a cough or splutter; cigarette sales fell by just under 60% and within a year thousands had quit for good.

3 January Two US space probes land successfully on Mars.

28 January The Hutton Report is published, leading to the resignation of Greg Dyke on 29 January.

2 February Israeli PM Ariel Sharon announces he will remove all Jewish settlements in Gaza.

5 February Twenty-three Chinese immigrants picking cockles die on Morecambe beach.

11 March Bombings in Madrid kill 201. Three days later the socialist party wins the Spanish election.

29 March The Republic of Ireland becomes the first country in the world to introduce a nationwide ban on smoking in the workplace.

29 March NATO welcomes seven new members: Bulgaria, Estonia, Latvia, Lithuania, Romania, Slovakia, and Slovenia.

29 April Graphic photographs emerge of cruelty and mistreatment of Iraqis by US forces at Abu Ghraib.

1 May Ten new member states join the EU.

5 June Ronald Reagan dies at the age of 93.

21 June *SpaceShipOne* (SS-1) becomes the world's first crewed commercial craft in space.

1 July Marlon Brando dies.

4 July Greece beats Portugal 1-0 to win Euro 2004.

14 July The Butler inquiry into Iraq criticises the flawed quality of the intelligence about Iraqi weapon capabilities.

6 August The Barclay twins buy the *Telegraph*.

3 September The Beslan school siege ends, causing 331 deaths.

8 October Kidnapped engineer Ken Bigley is beheaded in Iraq.

10 October John Peel dies.

2 November Bush beats John Kerry and is re-elected.

6 November Kidnapped aid worker Margaret Hassan is killed in Iraq.

11 November Arafat dies.

18 November The Parliament Act is used to pass a ban on hunting into law.

18 November The Civil Partnerships Act receives royal assent.

15 December David Blunkett steps down amidst rumours of a love child.

26 December An earthquake measuring 9.3 on the Richter scale occurs off the coast of Sumatra. It results in a tsunami which kills thousands in countries including Indonesia, the Maldives and Sri Lanka.

A Stealth Bomber flies overhead during the pre-game national anthem at the Rose Bowl in Pasadena, California.

Supporters surround Greg Dyke as he returns to Television Centre in White City after resigning as the BBC's Director General. Dyke left his post over Lord Hutton's stern rebuke of the corporation's Iraq reporting.

Thursday 29 January 2004
Toby Melville

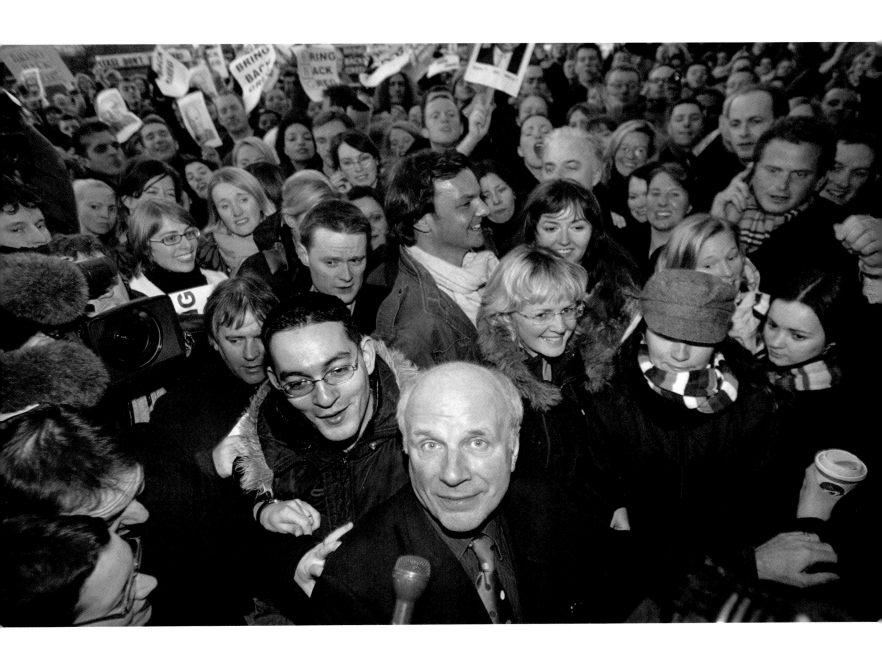

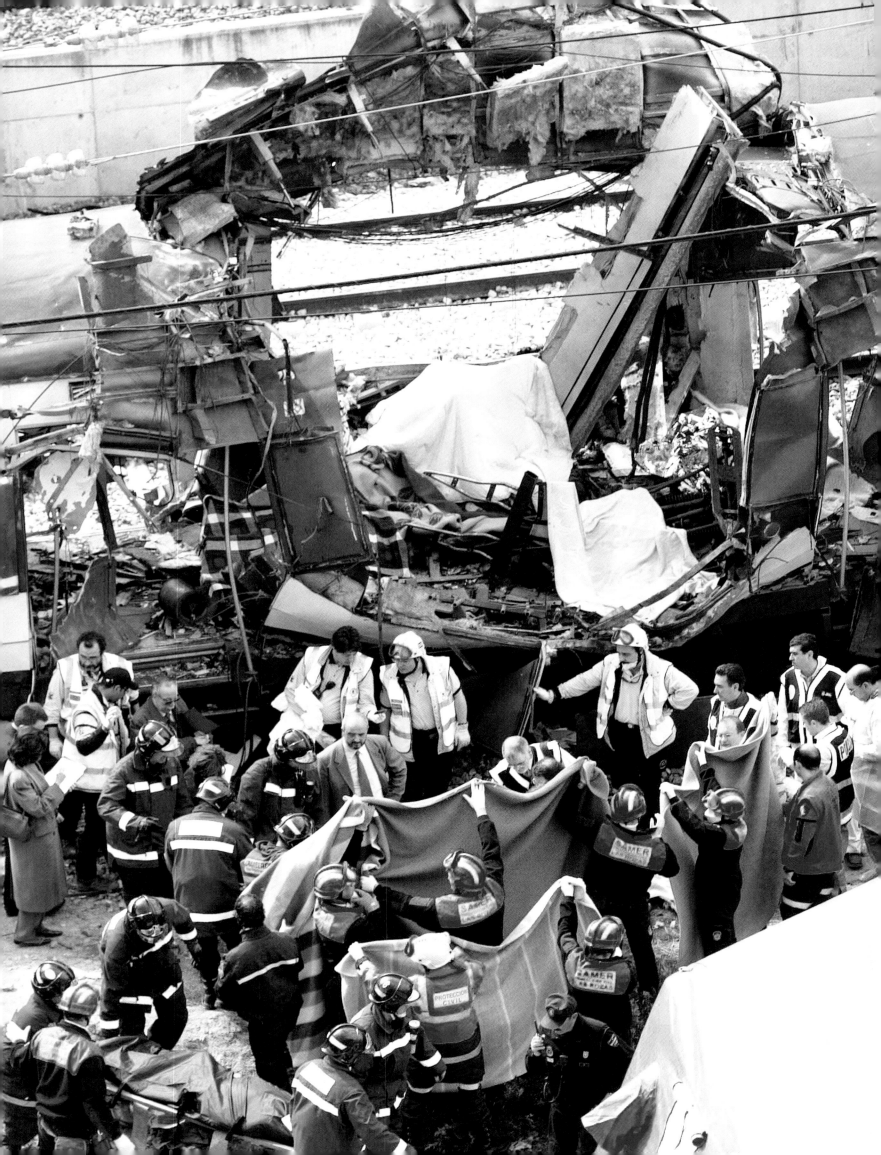

Bodies are evacuated after near-simultaneous explosions on three trains in Madrid. At least 131 people were killed and 400 injured in blasts that appeared to be a coordinated attack staged just 72 hours ahead of Spanish general elections.

Thursday 11 March 2004
Christophe Simon

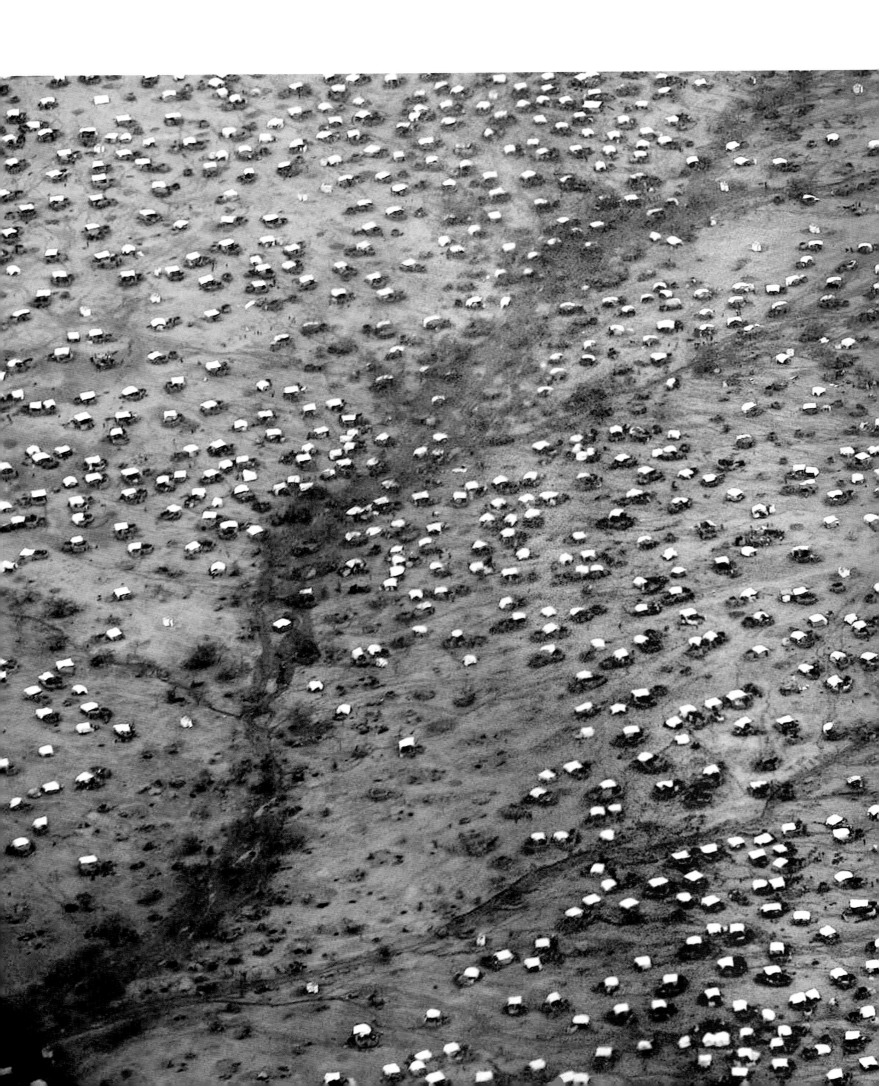

A Sudanese refugee camp in Eastern Chad. Around 200,000 people
from the Darfur region fled after attacks by Sudanese rebels.

Tuesday 29 June 2004
Thomas Coex

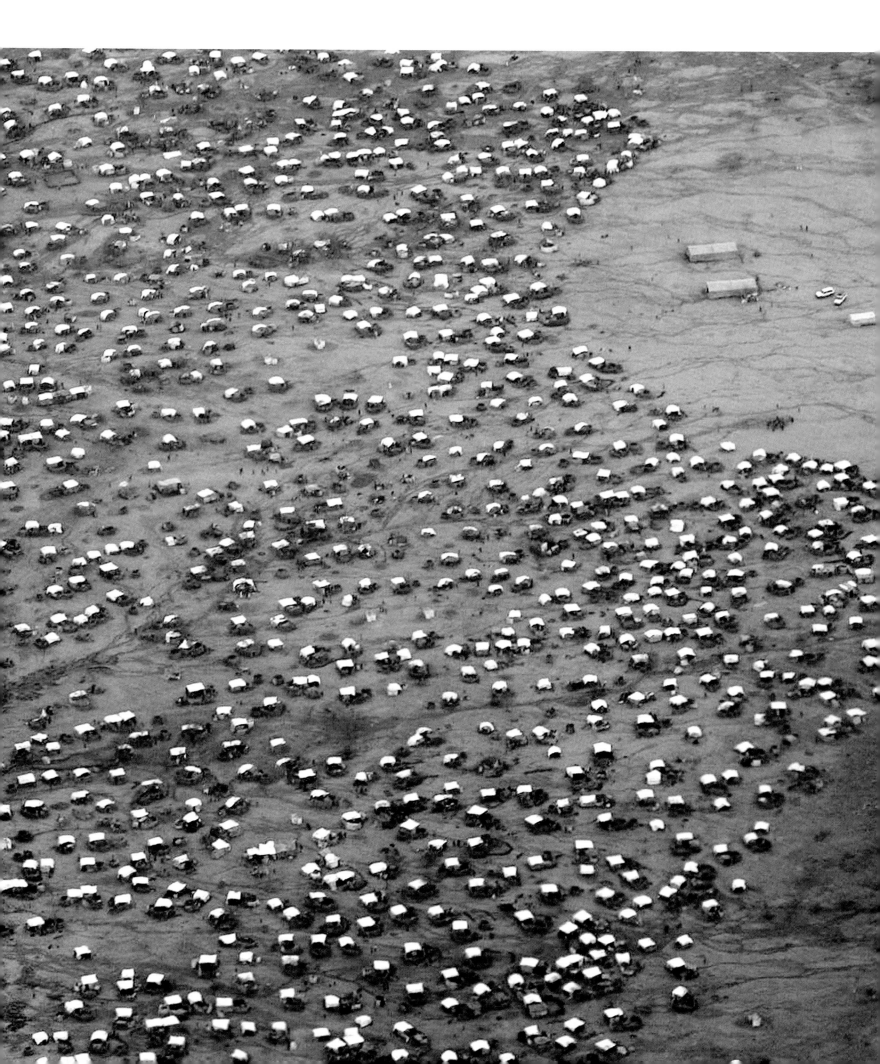

Iraq's deposed dictator Saddam Hussein in shackles on the day of his Iraqi special tribunal hearing. He faced charges leading to a trial for war crimes and genocide.

Among the hostages freed by special forces from a besieged school in
Beslan, a boy cries. The three-day stand-off with Chechen rebels
ended in a series of explosions and intensive shooting.

Thursday 23 September 2004
James Quinton

Models backstage at London Fashion Week getting ready for
the Tristan Webber show.

Lance Corporal James Blake Miller, photographed as his Marine unit mounted an assault on the insurgent stronghold of Fallujah. The image was published on the front pages of more than 150 newspapers and Miller, a country boy from Kentucky, became an icon of the war.

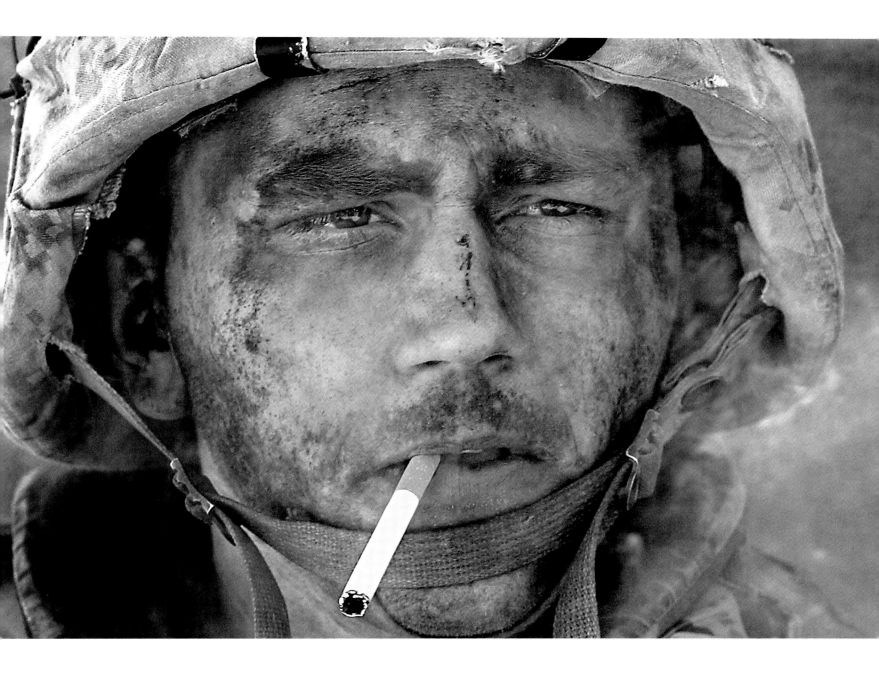

The coffin of Yasser Arafat is transported across the crowds in the Muqaata compound in Ramallah. The Palestinian leader died in a hospital in Paris at the age of 75.

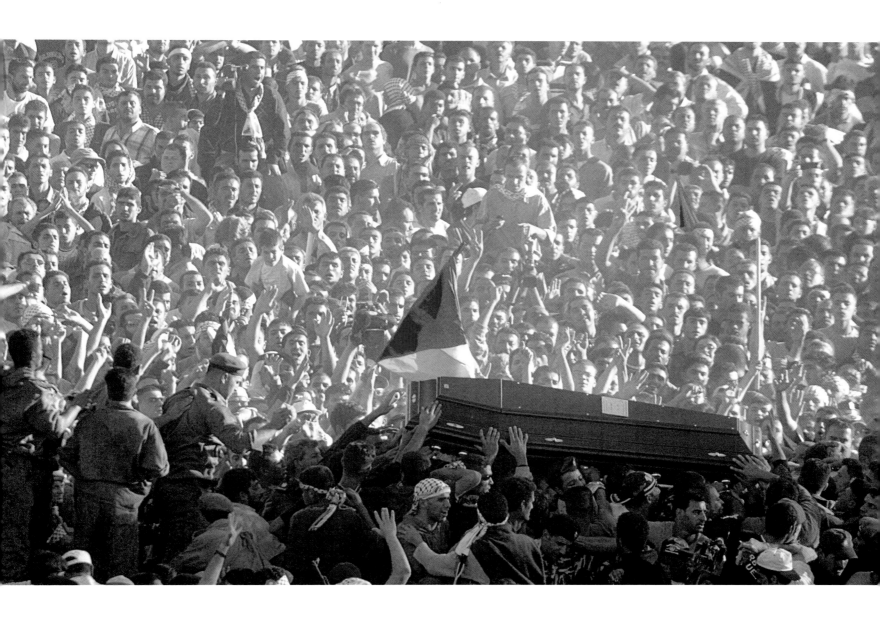

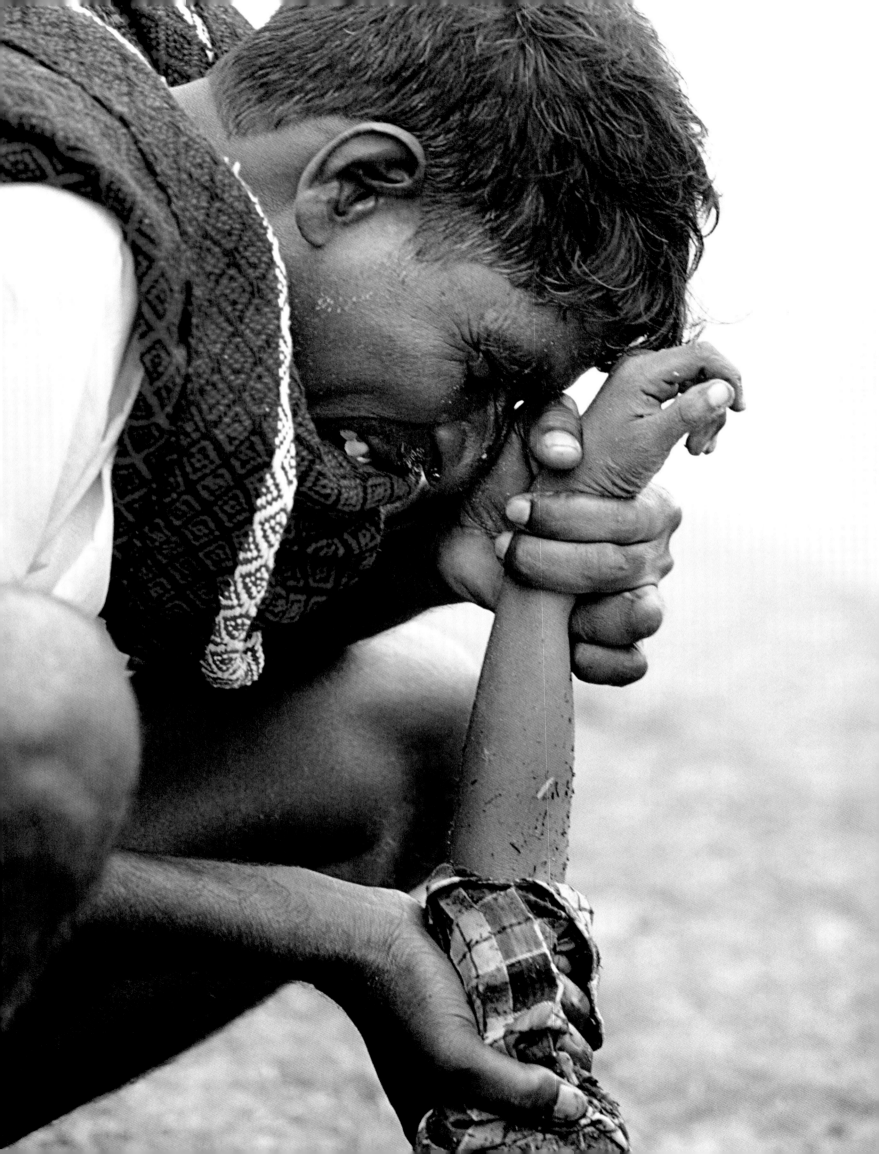

An Indian man cries as he holds the hand of his eight-year-old son, who was killed when the devastating tsunami of 26 December hit Cuddalore in south India.

Monday 27 December 2004
Arko Datta

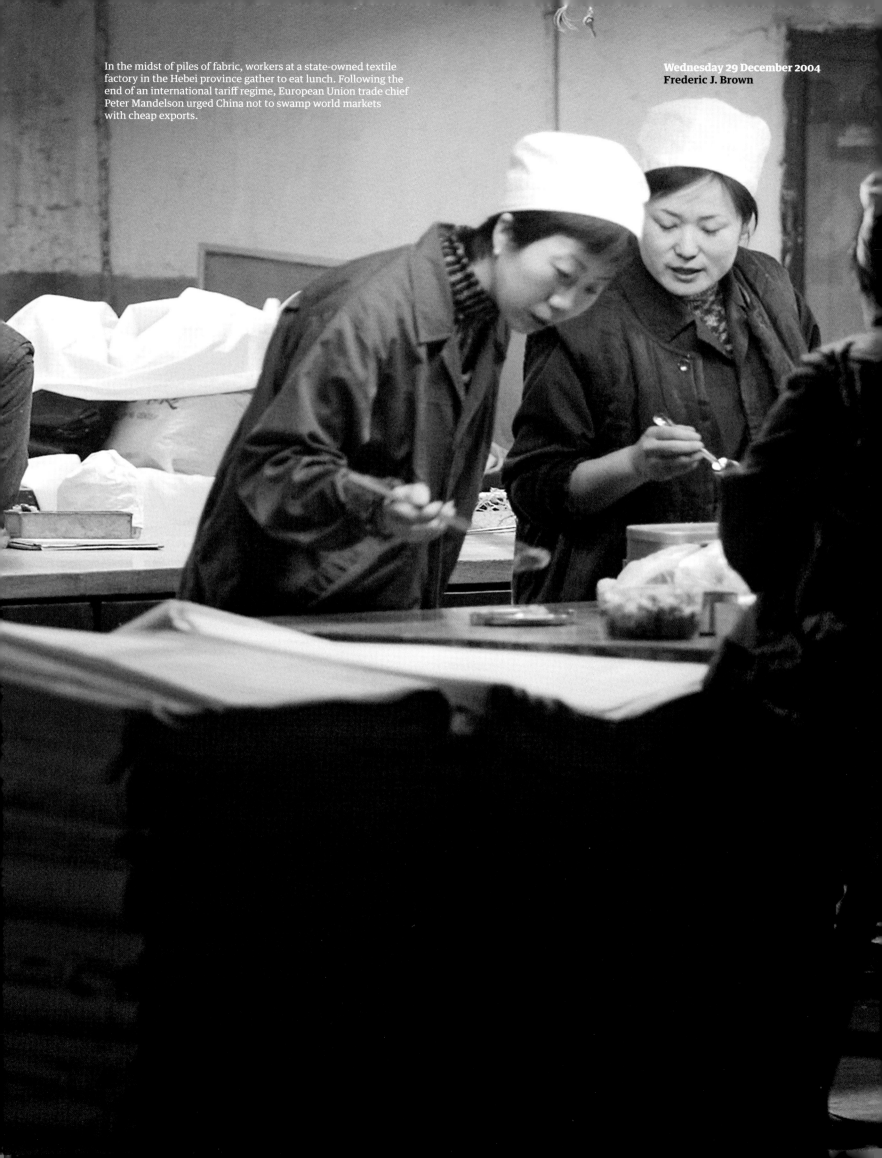

In the midst of piles of fabric, workers at a state-owned textile factory in the Hebei province gather to eat lunch. Following the end of an international tariff regime, European Union trade chief Peter Mandelson urged China not to swamp world markets with cheap exports.

Wednesday 29 December 2004
Frederic J. Brown

In Trafalgar Square, the crowd went wild. Banners and balloons were waved by the thousands who had squeezed in around Nelson's Column. Red, white and blue confetti was shot out of cannons, the Red Arrows swooped overhead, the smoke trail, again, red white and blue. 'It's not often in this job that you punch the air, do a little jig and embrace the person next to you,' said Tony Blair. London had beaten Paris to the 2012 Olympics, breezing past Madrid, New York and Moscow on the way. 'London is an open, multi-racial, multi-religious, multi-cultural city and rather proud of it,' said the PM. 'People of all races and nationalities mix in with each other and mix in with each other well.'

Twenty-one hours later, the first of the four bombs went off. Three of the devices were detonated on underground trains, ripping through the crowded rush-hour carriages. A fourth blew the top off a bus in the centre of the city. Fifty-six people were killed and more than 800 injured in the most lethal terror attack on mainland Britain ever. Over the next few days the country gradually learned that there is no identikit fit for a suicide bomber, and that discontent and alienation can be nurtured within our own communities. Three of the bombers were from Yorkshire, the other had grown up there. One was a carpet fitter, another a teaching assistant, another a sports science graduate. The youngest, 18, was a talented cricketer.

And there was to be another, indirect victim. On 22 July, Brazilian electrician Jean Charles de Menezes was shot seven times in the head at point-blank range as he sat in a train at Stockwell tube station. Police said they had mistaken him for a wanted terrorist and that his manner, clothing and aggressive movements all contributed to the shooting. An inquest jury rejected all that, but no charges were ever brought.

2005 was not a year of great change or transition. The decisive influences had come before – most notably the invasion of Iraq – and ruptures with the past were yet to appear.

Those who believed class warfare was alive in Britain enjoyed the fox-hunting ban, even given that the law provided for the trailing of an artificial scent and for the flushing out of the fox so long as, when flushed out, the animal would be shot or killed by birds of prey rather than savaged by hounds. Equally, police had said enforcement was not a priority.

We said farewell to Pope John Paul II, a non-Italian, radical authoritarian who travelled the world and was

Paul Johnson is deputy editor of *Guardian* News and Media, and head of sport. He was a member of the award-winning teams that investigated the 'cash for questions' scandal and the inquiry into former cabinet minister Jonathan Aitken. As assistant editor and then deputy editor, he played a leading role in the *Guardian*'s transformation into the Berliner format in 2005.

media aware but who rigorously defended conservative orthodoxy. He was replaced by Pope Benedict XVI, a non-Italian, rigorous defender of the conservative orthodoxy.

We saw the birth of YouTube, with the first video – 'Me at the zoo' – nineteen seconds long and featuring one of the founders. Now it is a phenomenon with a billion views a day worldwide. And the birth, too, of the *Guardian* Berliner, the first newspaper of its kind in the UK.

In late August, Hurricane Katrina came in across Florida at speeds of up to 135mph, veering suddenly to pass over New Orleans just hours after an order was given to clear the city. The levees burst and at least 1,800 were killed. Thousands were rescued from rooftops, but many drowned in their attics. Five years on, accusations that the poorest were left to fend for themselves remain.

In the UK, Tony Blair became the first ever Labour leader to win three general elections in a row – a victory achieved with the lowest-ever share of the popular vote. Michael Howard resigned and Charles Kennedy said the Liberal Democrats were the future, before being ousted. As the fall-out continued, David Cameron exploited his age (39) and his style (no-notes speaking) to defeat the favourite David Davis for the Conservative leadership.

In Iraq, a form of democracy stuttered forward, with elections for the National Assembly. In October the two-thousandth US serviceman was killed, while figures for the year estimated 14,842 Iraqi civilians dead. A CBS poll showed that 55% of Americans thought they should have stayed out of the war, with 59% wanting their troops home as soon as possible.

Back to Trafalgar Square, nine weeks on from the Olympic carnival, and England, having beaten Australia for the first time in 18 years, had won the Ashes. The two stand-out players, Flintoff and Pietersen, were described as looking like giants atop a dinky bus. Pietersen, not exactly cut from the cloth of England cricketers of old, is from Pietermaritzburg, South Africa, and has lip, ego, bling (a £50,000 ear stud), as well as a haircut fashioned after the colouring of a skunk. The dark glasses could not hide the fact that most of the players had been on a 24-hour bender. 'It's been a long night,' said captain Michael Vaughan. 'We celebrated in true English fashion.'

1 January The Freedom of Information Act becomes law.

7 February Ellen MacArthur completes her record-breaking single-handed voyage around the world.

14 February Former Lebanese prime minister Rafik Hariri is killed in west Beirut.

16 February The Kyoto protocol comes into force.

3 April Pope John Paul II dies at the age of 84. Ratzinger is elected on 19 April.

8 April With no bid forthcoming, Rover collapses with 5,000 job losses.

9 April Charles and Camilla marry.

18 April The Fat Duck in Bray is declared the best restaurant in the world.

22 April Would-be shoe-bomber Saajid Badat gets 13 years for plotting to blow up a passenger plane.

23 April YouTube is launched.

26 April Syria announces all its troops have withdrawn from Lebanon.

2 May Insurance company AIG admits to £2bn of accounting errors and restates its earnings over five years. Boss Maurice 'Hank' Greenberg is forced out.

6 May Tony Blair wins a historic third term.

2 July Live 8 concerts are held in the G8 states and Africa.

7 July 56 people, including the bombers, die in the London bombing attacks.

22 July Jean Charles de Menezes is shot.

23 July Bomb attacks in Sharm el-Sheikh, Egypt, kill 88 people.

28 July The IRA announces a formal end to the armed struggle.

28 August Hurricane Katrina hits the southern coast of the US, reaching New Orleans on 29 August.

11 September The last Israeli troops leave Gaza.

12 September England wins the Ashes.

30 September A Danish newspaper publishes Muhammed cartoons, leading to uproar in the Muslim world.

1 October Bombings in Bali claim 26 lives.

8 October An earthquake in Pakistan kills over 1,000 people.

19 October Saddam Hussein goes on trial, facing charges of crimes against humanity.

29 October Delhi bombings kill 62 people and injure 210.

9 November Emergency powers come into force in over 30 French towns and cities following urban youth riots.

6 December David Cameron becomes the new leader of the Conservative Party.

15 December Iraqis vote for the first, full-term government and parliament since the US-led invasion.

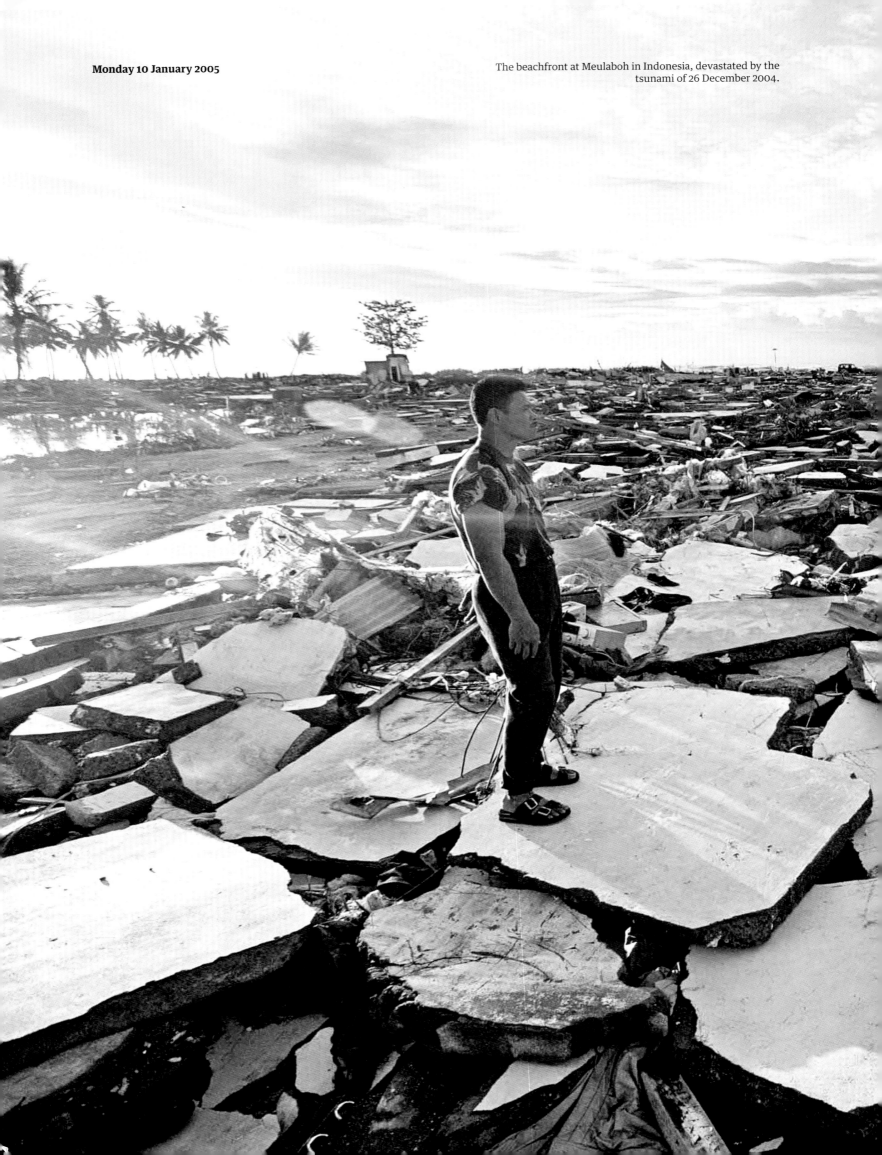

The beachfront at Meulaboh in Indonesia, devastated by the
tsunami of 26 December 2004.

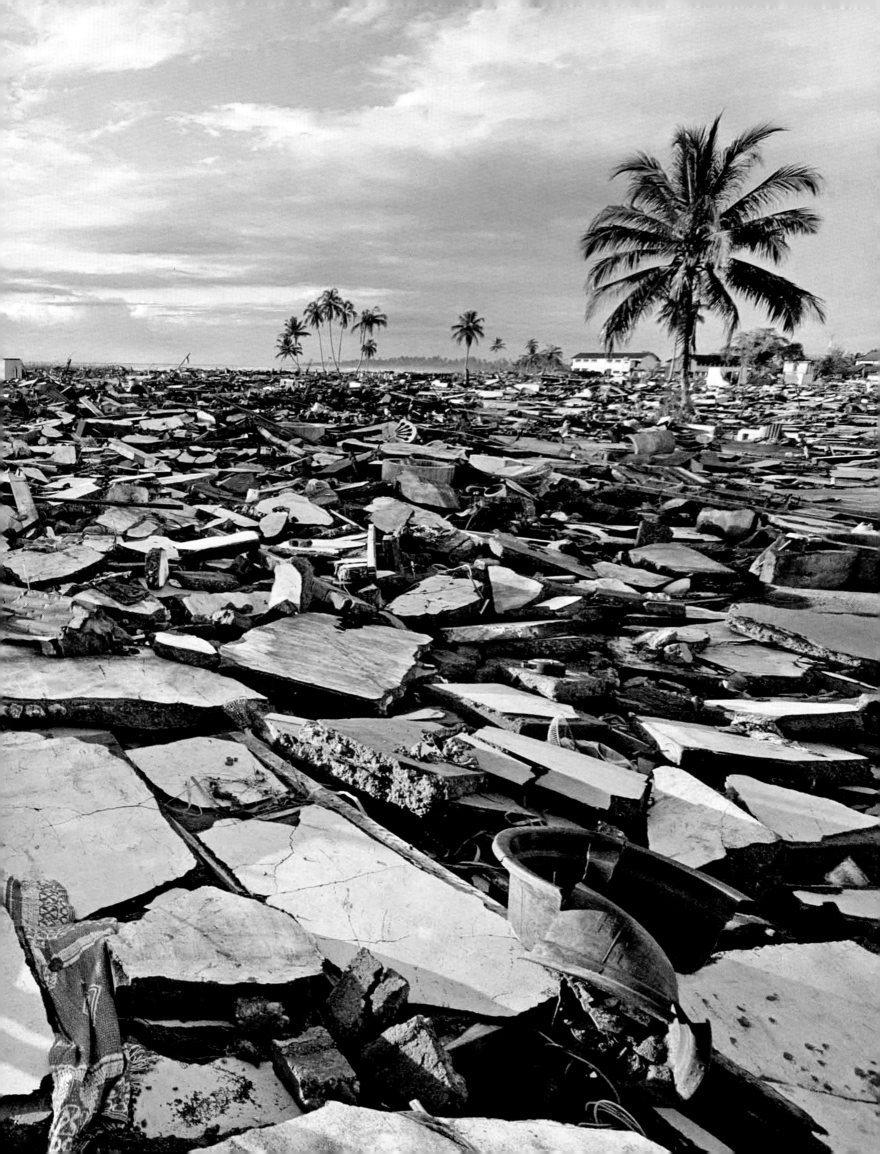

Model Naomi Campbell on the catwalk during the Julien Macdonald show at London Fashion Week.

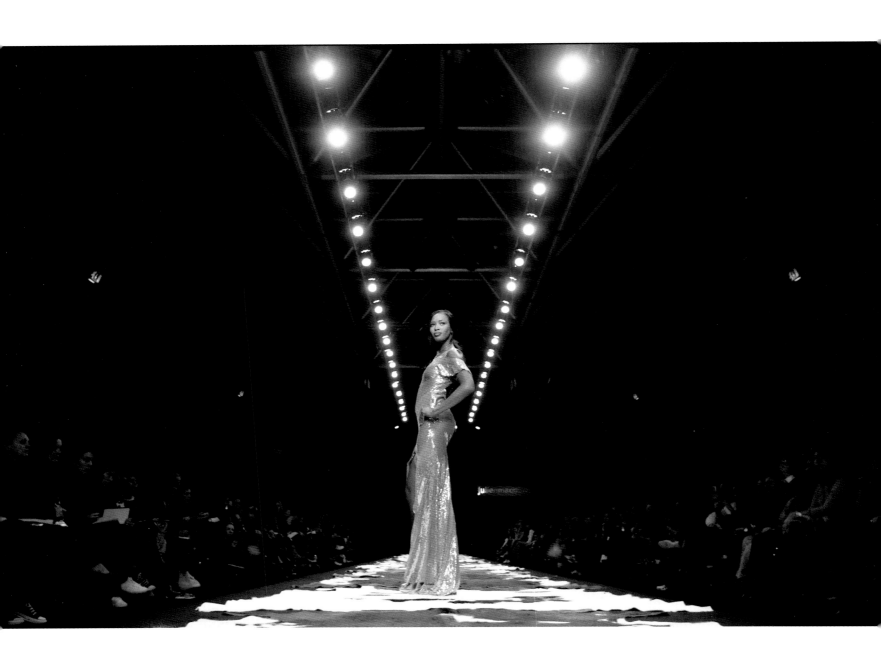

Award-winning image of a gardener shovelling snow from a path in
the gardens of Chateau Wackerbarth in Radebeul near Dresden.

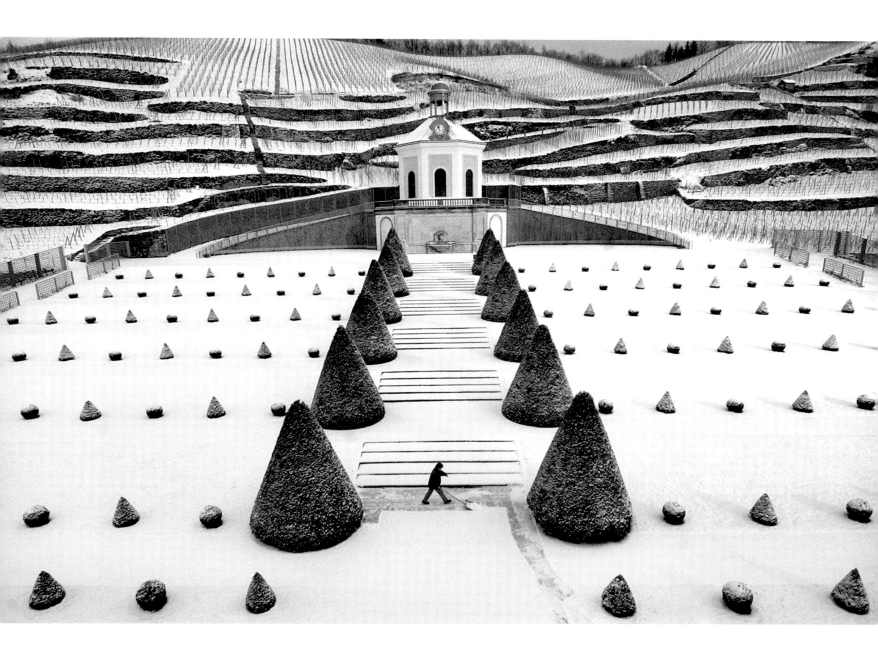

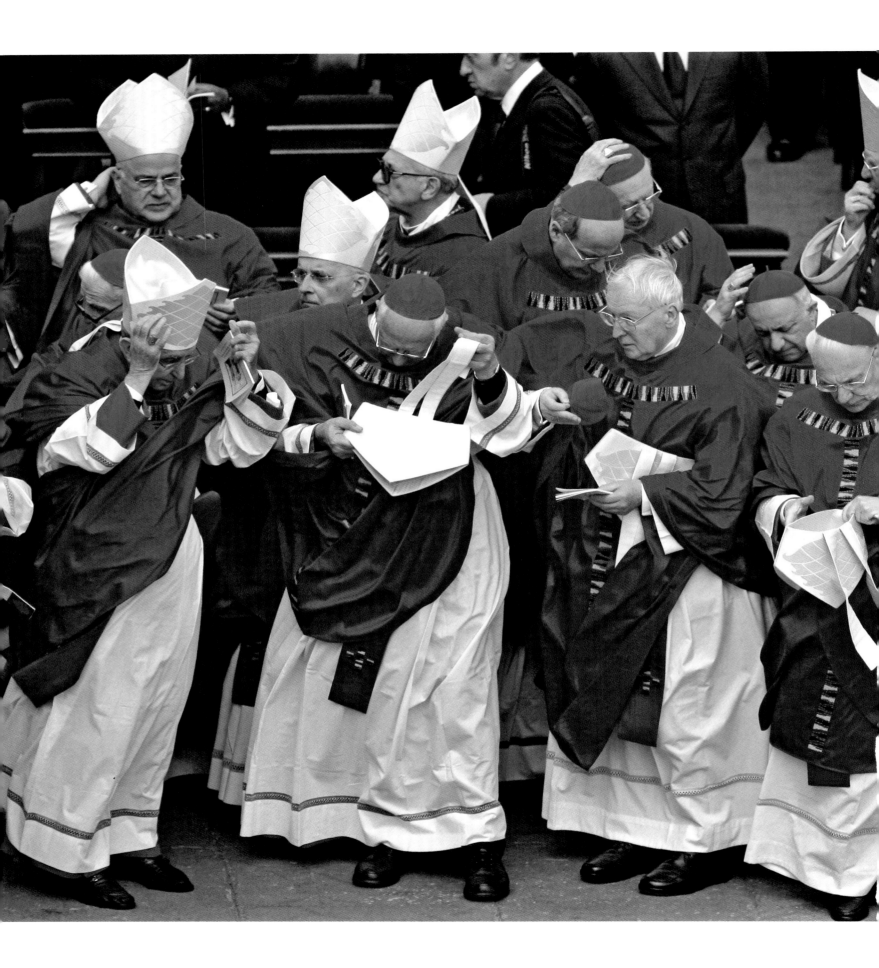

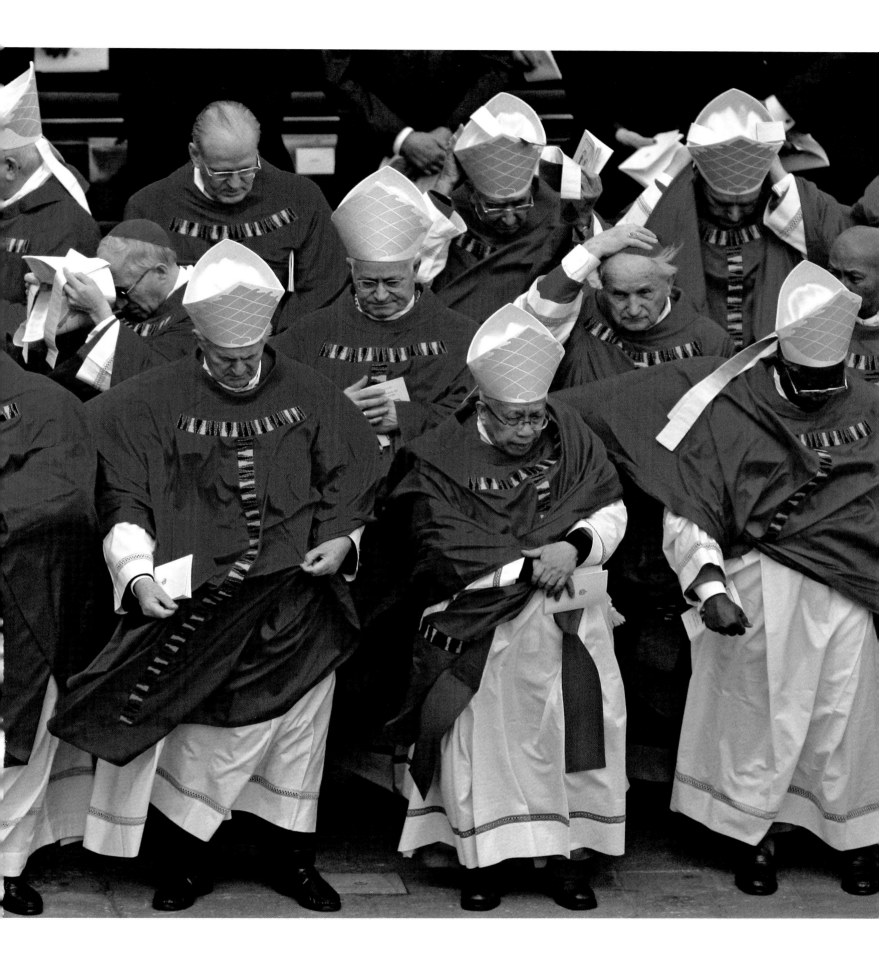

Cardinals hold on to their mitres as the wind blows through the Vatican during the funeral of Pope John Paul II. He died on 2 April.

A destroyed number 30 bus in Tavistock Square, central London.
Terrorist bombs tore through the double-decker and three
underground trains on 7/7.

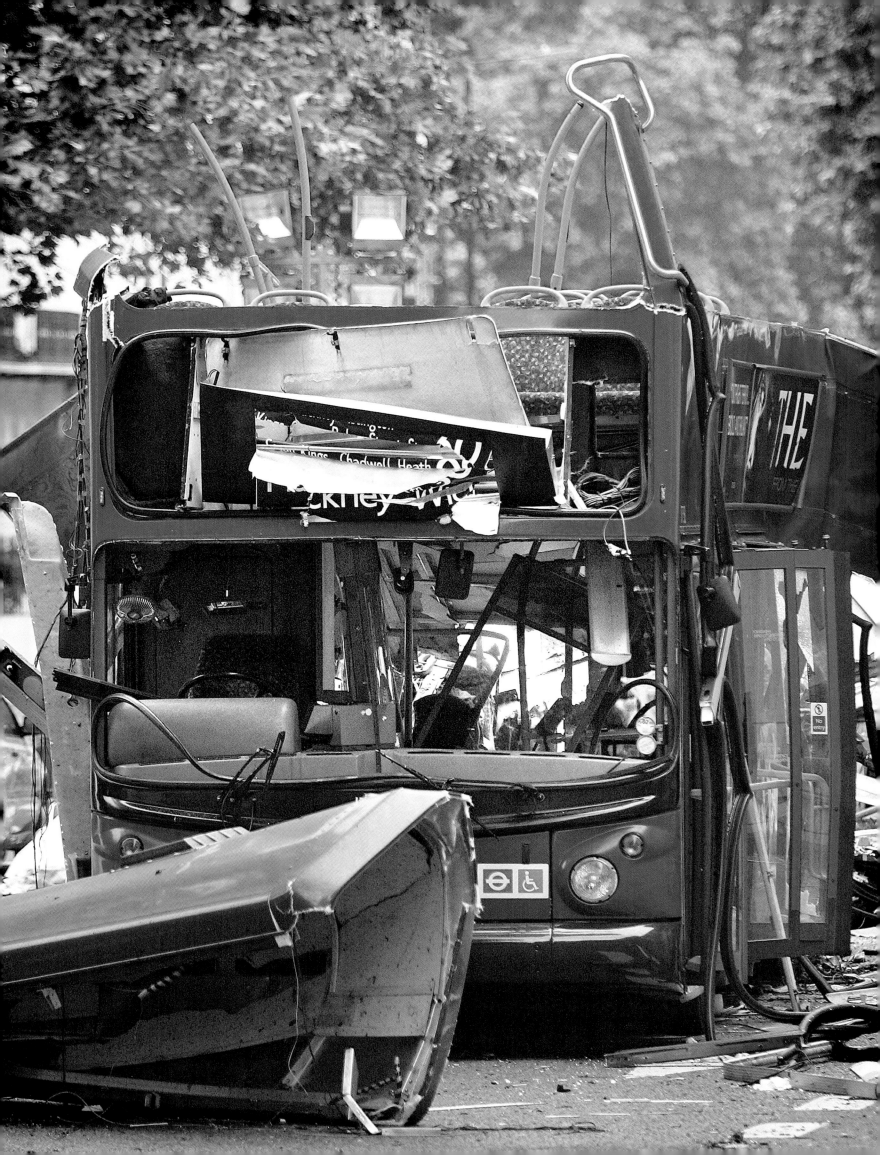

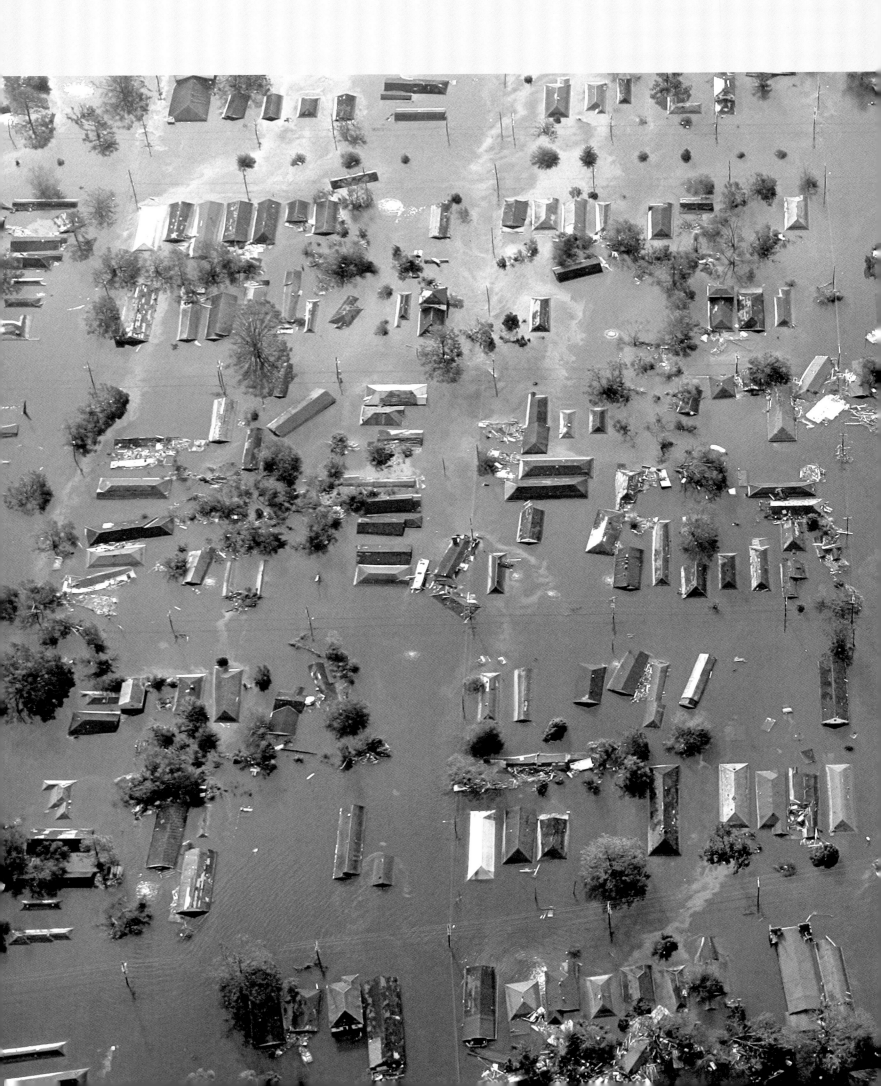

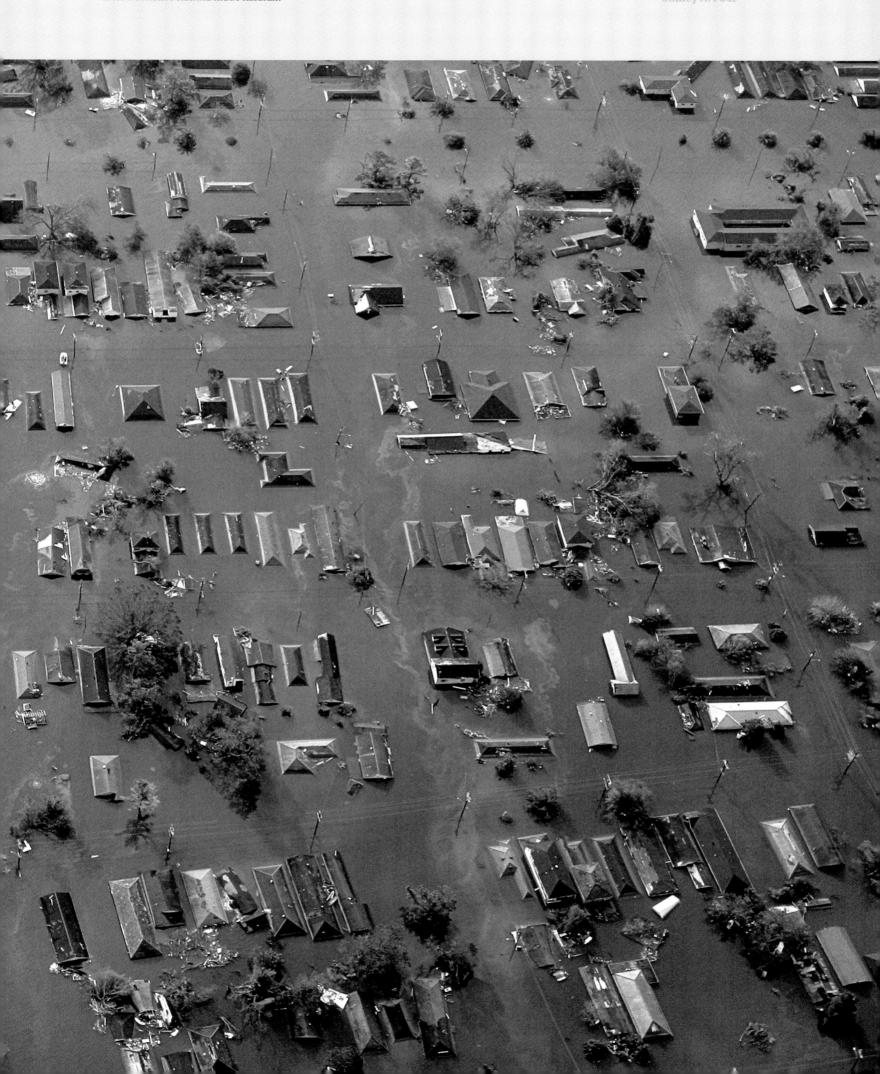

Water surrounds homes just east of downtown New Orleans, a day after Hurricane Katrina made landfall.

Tuesday 30 August 2005
Smiley N. Pool

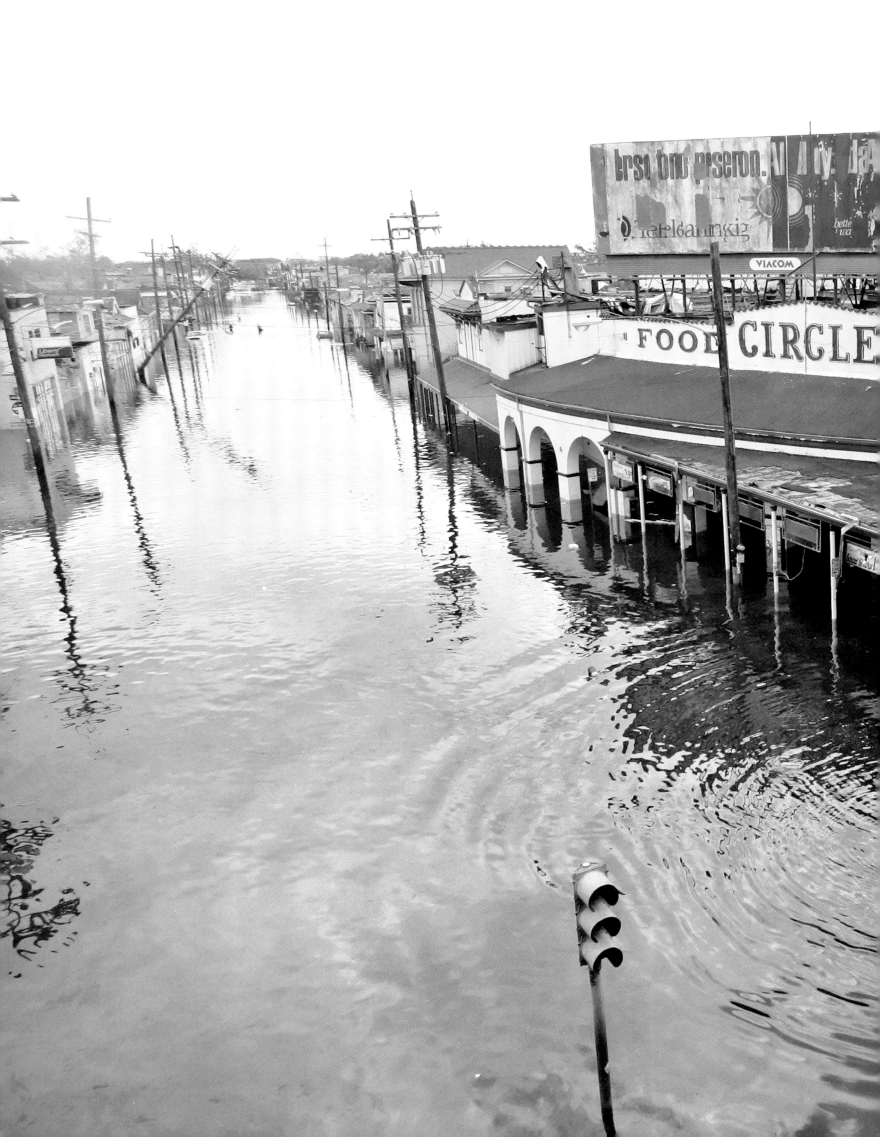

The city of New Orleans inundated with water as a result
of Hurricane Katrina.

Tuesday 30 August 2005
Dave Martin

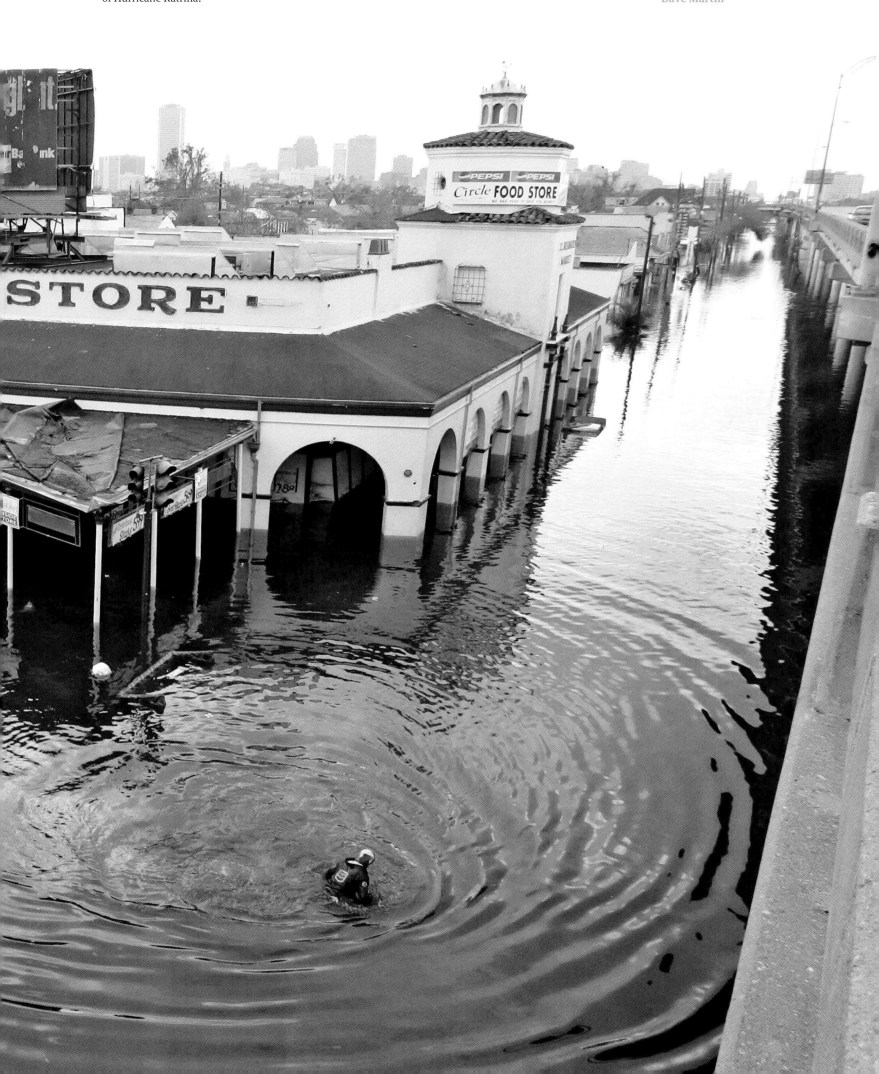

At the Cervietti marble sculpture workshop in Petrasanta, Italy, artist
Marc Quinn attends to his work *Alison Lapper Pregnant* before it is
sent to Trafalgar Square to be exhibited on the fourth plinth.

Thursday 1 September 2005
David Levene

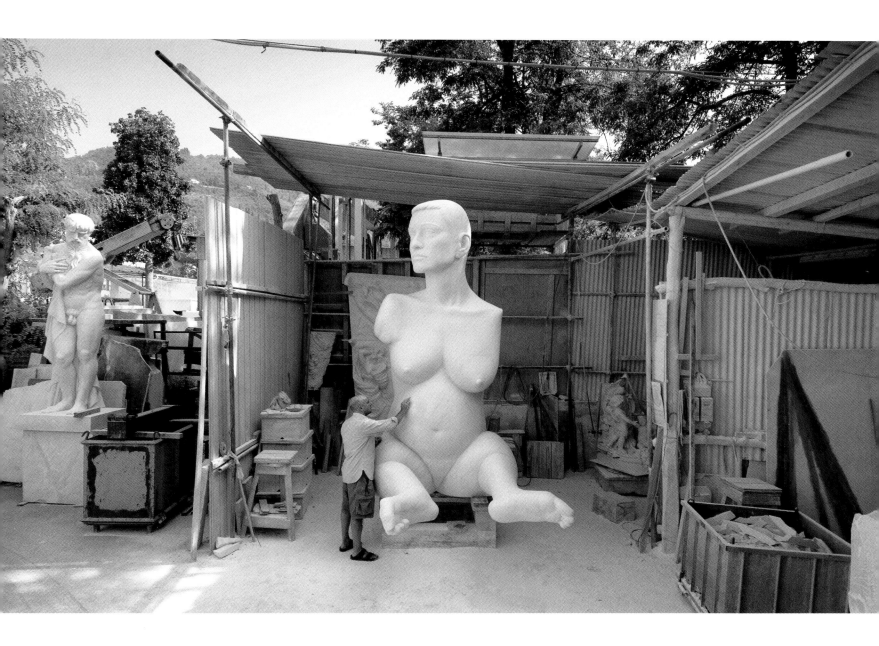

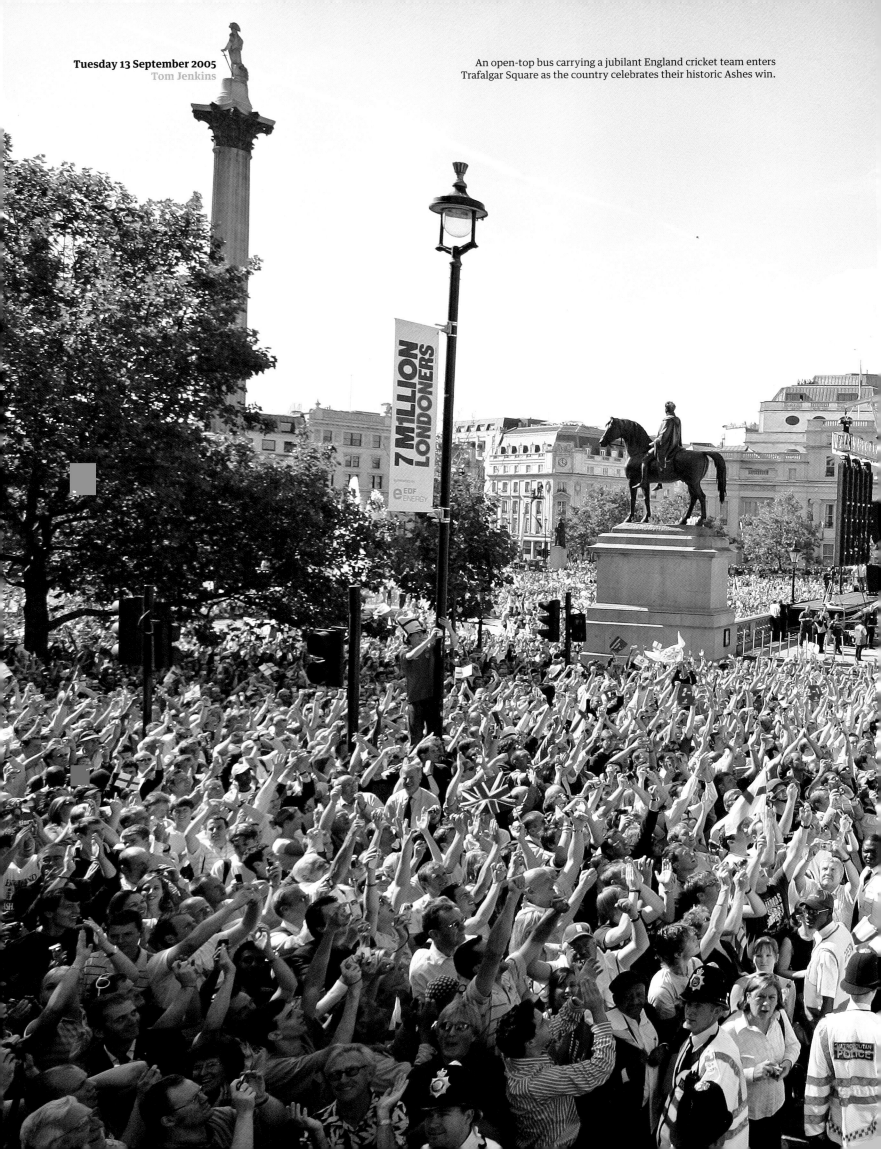

An open-top bus carrying a jubilant England cricket team enters Trafalgar Square as the country celebrates their historic Ashes win.

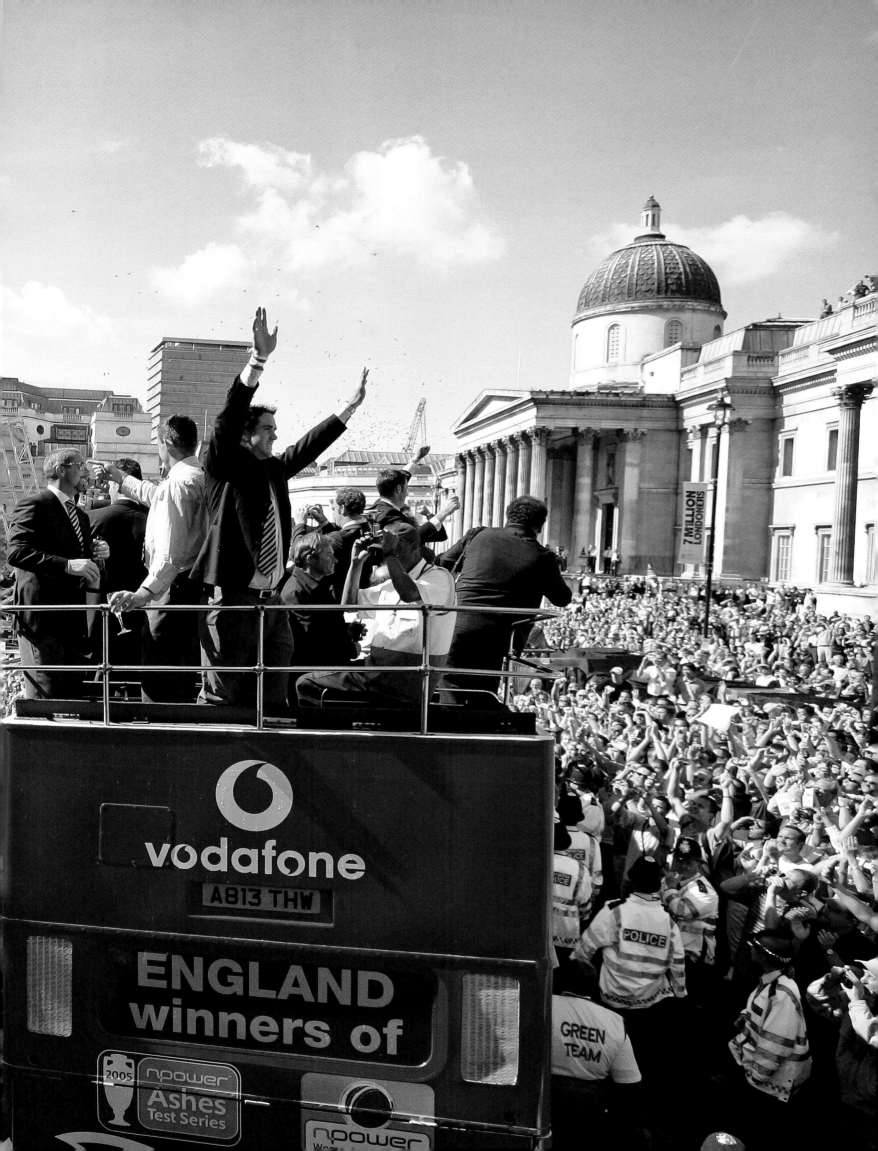

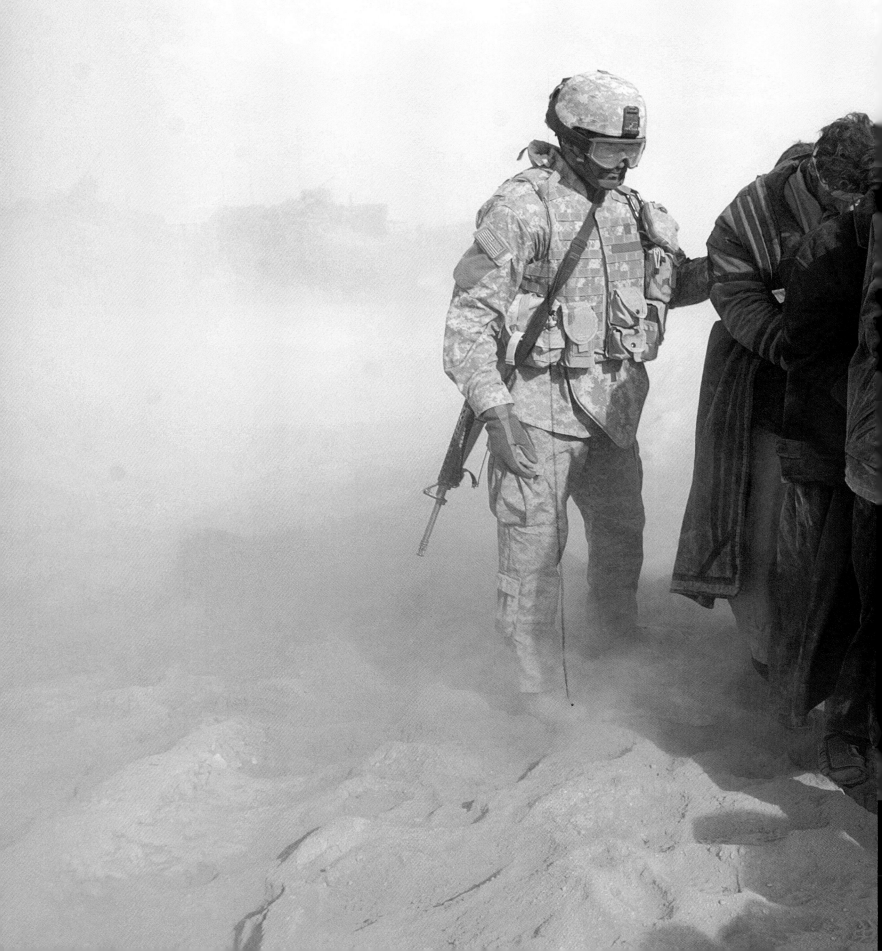

Operation Steel Curtain in Rawa, Iraq. Some of the men arrested in the heartland of Sunni insurgency are led towards a US helicopter.

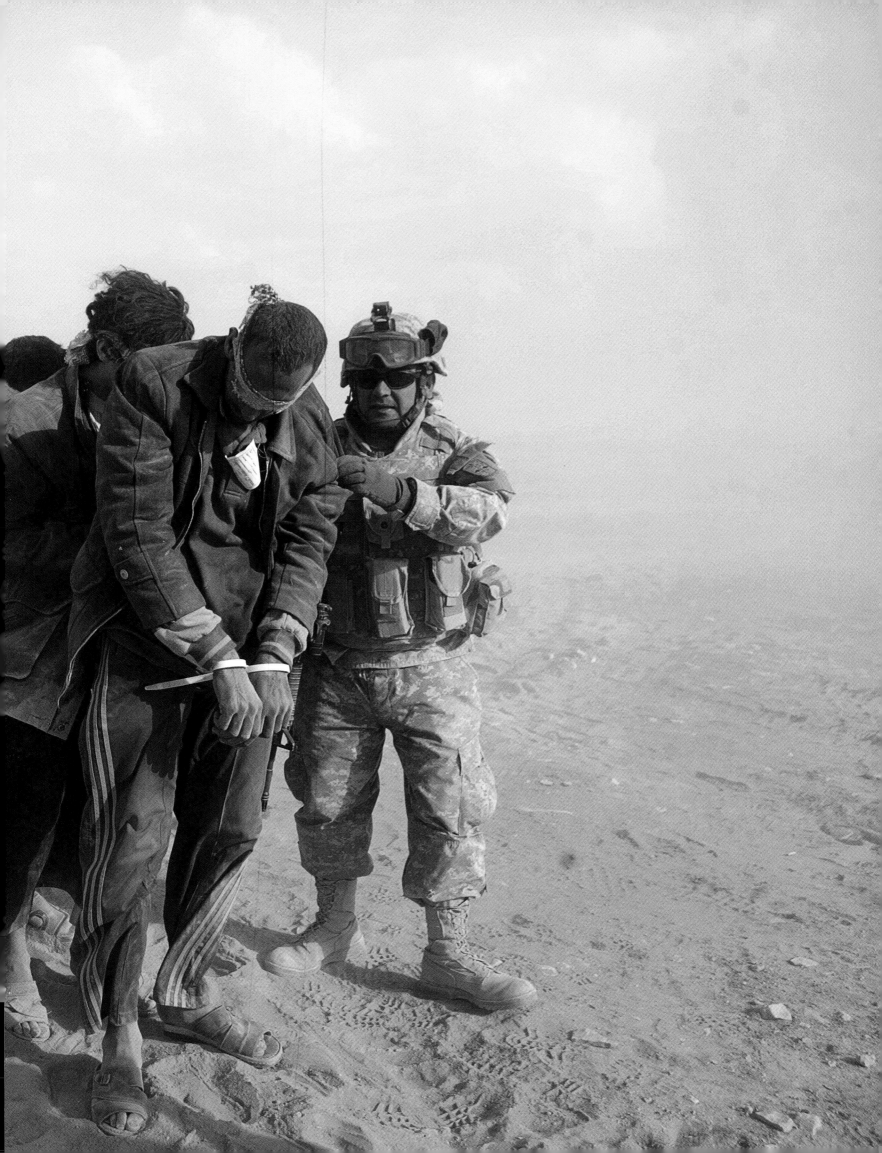

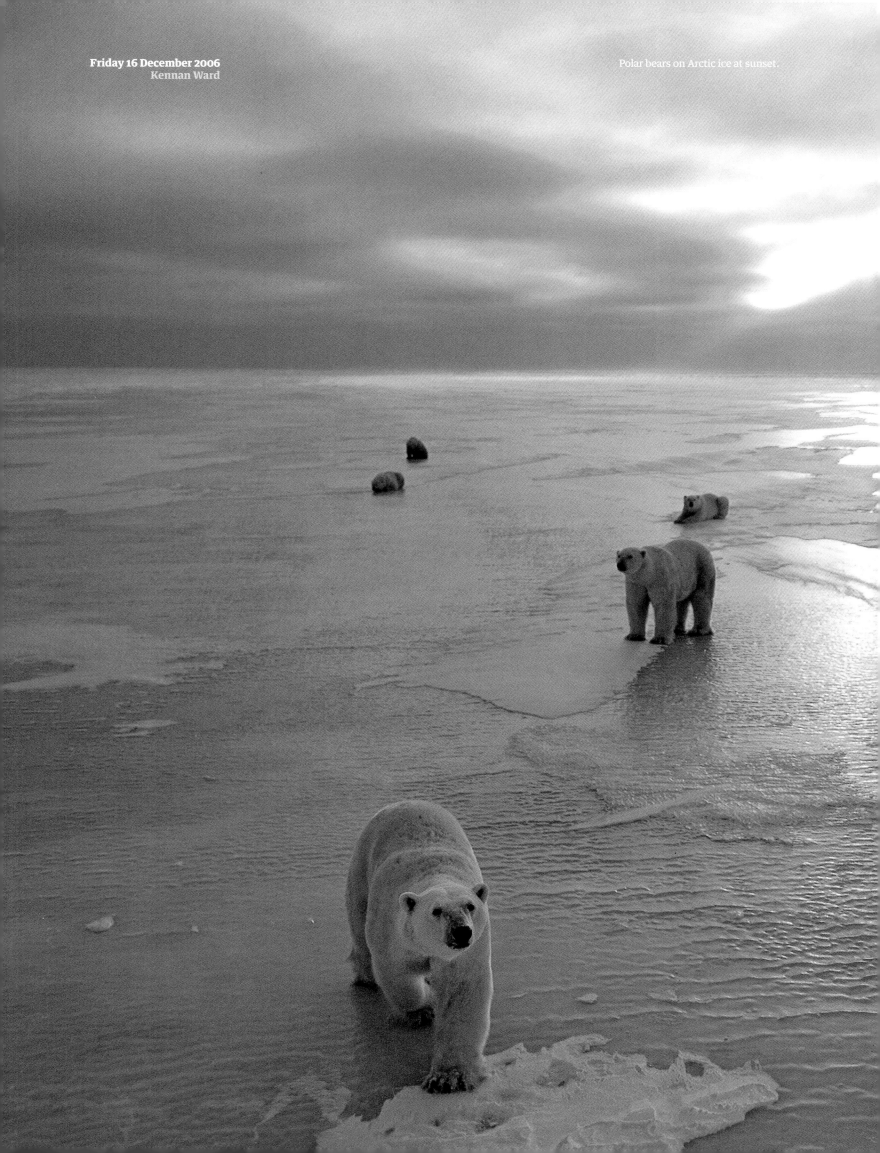

Polar bears on Arctic ice at sunset.

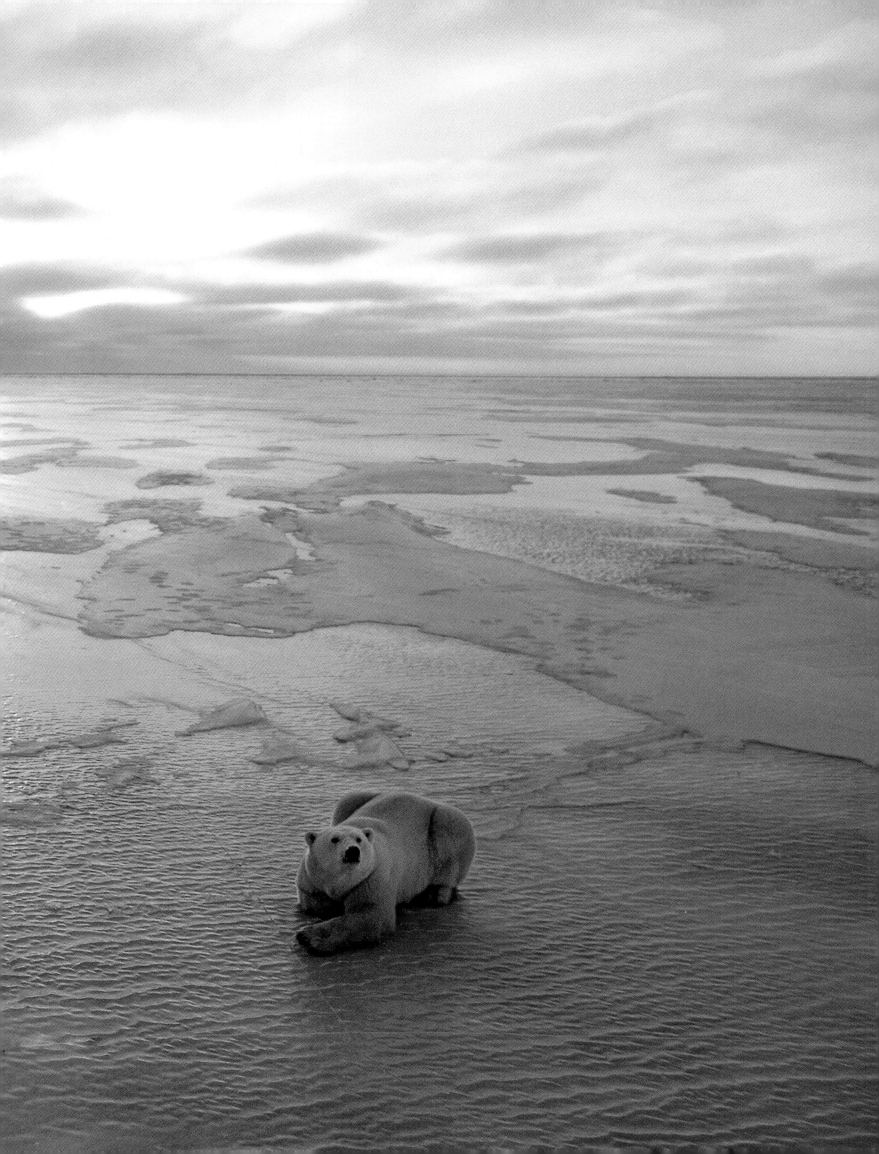

2006

It was a year the Middle East dominated from beginning to end, or rather provided a stage on which that often lethal mix of crabby Arab world politics, Islamic faith, and Western interventionism and incomprehension came together with explosive results. For this reason, 2006 remains with us now. Its unresolved tensions, tears, triumphs and terrors stretch forward into the unforeseeable future, forming a dread backdrop to an unknown time ahead.

Iraq is an awful case in point; 2006 was the year when all the American and British hubris, all the mistakes and miscalculations, all the bloody mayhem that followed the 2003 US-led invasion appeared to come together, piling up anarchically like some uncontrollable motorway collision. In February, after months of lesser provocations, Sunni Muslim extremists bombed the great golden dome of the Askariya shrine at Samarra.

Iraq's majority Shia population, which until then had mostly refrained from retaliation for repeated sectarian attacks, exploded in fury. Within weeks, the country seemed to teeter on the brink of all-out civil war, with the coalition's occupying army looking on helplessly. For the Bush administration, it was a critical moment. Its entire post-9/11 project was at risk. In near desperation, it sought to buy the Sunni militias, rather than fight them. Then Bush launched his famous troop 'surge' under General David Petraeus.

The Iraq of today, emerging from the ruins of 2006, still lives on a knife's edge, still violent (though less so), still uncertainly led, still vulnerable to geographical and ethnic disintegration and religious war. One reason is the activities of the unrepentant Ba'athist followers of Saddam Hussein. The penultimate day of 2006 brought the death of the dictator, hanged to death for his crimes amid much cruel taunting. But his bitter legacy lives on.

The year saw the downfall of another giant of the Middle Eastern stage. Ariel Sharon, Israel's prime minister, one-time general and self-styled scourge of the Palestinians, was removed from office after falling into a coma after a stroke. It seemed like the end of an era. Yet within months, his little known successor, Ehud Olmert, triggered a conflagration of truly Sharon-esque proportions when he ordered an all-out assault into Lebanon following serial provocations by Hizbullah.

The Lebanon war ended unpredictably, with a ceasefire forced on Israel by international pressure

Simon Tisdall is an assistant editor of the *Guardian* and a foreign affairs columnist. He was previously a foreign leader writer for the paper and has also served as its foreign editor and its US editor, based in Washington, DC. He was the *Observer*'s foreign editor between 1996 and 1998.

and with Hizbullah's leadership, having survived the onslaught, declaring victory over the Zionist foe. Many inquests followed. But one outcome was clear. Olmert's war, mismanaged, misdirected, and mis-sold, punctured the aura of Israeli military invincibility. That consequence lives on today, even as many in the region await the next round, possibly involving Hizbullah's chief patron, Iran.

Tensions between the Muslim world and the West manifested themselves in other, different ways. One was the furious row following the publication by a Danish newspaper of a cartoon of the Prophet Mohammad carrying a bomb in his turban. Another was the uproar that greeted the Pope's criticism of Islam in a lecture at Regensburg University, which he later retracted. And all the time, in Afghanistan, another war was brewing largely unnoticed, pitting Taliban zealots against the 'unbelievers'. In 2010, many died from neglect perpetrated in 2006.

The year was memorable for many other reasons, good and bad. In May, the Stormont Assembly in Northern Ireland sat for the first time in four years; in October, renegade North Korea joined the nuclear 'club' when it detonated an atomic device; and in November, the former KGB spy Alexander Litvinenko died in London of polonium poisoning, triggering a massive diplomatic row between Britain and Russia which remains unresolved.

The year 2006 brought breakthroughs such as a best director Oscar for Ang Lee for the movie *Brokeback Mountain*, an iconoclastic gay cowboy saga. It also brought heartbreaks, as with the discovery around Ipswich of five sex workers murdered by a serial killer, later identified as lorry driver Steve Wright.

And for football fans, at least, the year is remembered for a remarkable personal breakdown: that involving the legendary star Zinedine Zidane. The scene is the World Cup Final. France, at home, are playing Italy. It is Zinedine's final international match of a long, distinguished career. And what does he do? He loses his temper over a silly insult and headbutts the perpetrator, Marco Materazzi.

To his undying shame, Zinedine was sent off. And even now, the memory of his rank foolishness echoes down the years with undiminished power. Like much of 2006, it was a wholly avoidable tragedy.

30 January Kenneth Lay and Jeffrey Skilling's Enron trial begins.

5 March Ang Lee wins the best director Oscar for *Brokeback Mountain*.

11 April Iranian president Mahmoud Ahmadinejad announces that his country has successfully enriched uranium.

11 April Israeli PM Ariel Sharon is removed from office after 100 days in a coma. He is replaced by Ehud Olmert.

15 May Northern Ireland's Assembly, Stormont, sits for first time since its suspension in 2002.

27 May An earthquake off the southern coast of Java measuring 6.3 on the Richter scale kills over 6,000 people.

8 July Patricia Rashbrook becomes Britain's oldest mother at the age of 62.

9 July During the World Cup Final, French legend Zinedine Zidane headbutts Italian Marco Materazzi and is sent off.

11 July Seven bombs detonated on trains in Mumbai during rush hour kill 209 people.

12 July Israel launches air and sea attacks on targets in Lebanon.

30 July After 42 years, *Top of the Pops* comes to an end.

2 August Model Luisel Ramos, 22, dies during Uruguay's fashion week.

23 August Natascha Kampusch, 18, escapes from captivity.

24 August The International Astronomical Union downgrades the status of Pluto from a 'classical' to a 'dwarf' planet.

6 September George Bush confirms the existence of a secret CIA programme for interrogating suspects in foreign prisons, linked to 'rendition' flights.

9 October North Korea claims it has carried out its first nuclear test.

14 November South Africa becomes the first African country to legalise same-sex marriages.

23 November Former Russian KGB spy Alexander Litvinenko dies of polonium poisoning in London.

2-12 December The bodies of five sex workers are found over the course of ten days in Ipswich. Lorry driver Steve Wright is later found guilty and sentenced to life.

19 December Five Bulgarian nurses and a Palestinian doctor are sentenced to death in Libya after being accused of infecting children with HIV. They are eventually released on 24 July 2007 after negotiations led by Nicolas Sarkozy.

30 December Saddam Hussein is executed by hanging in Baghdad.

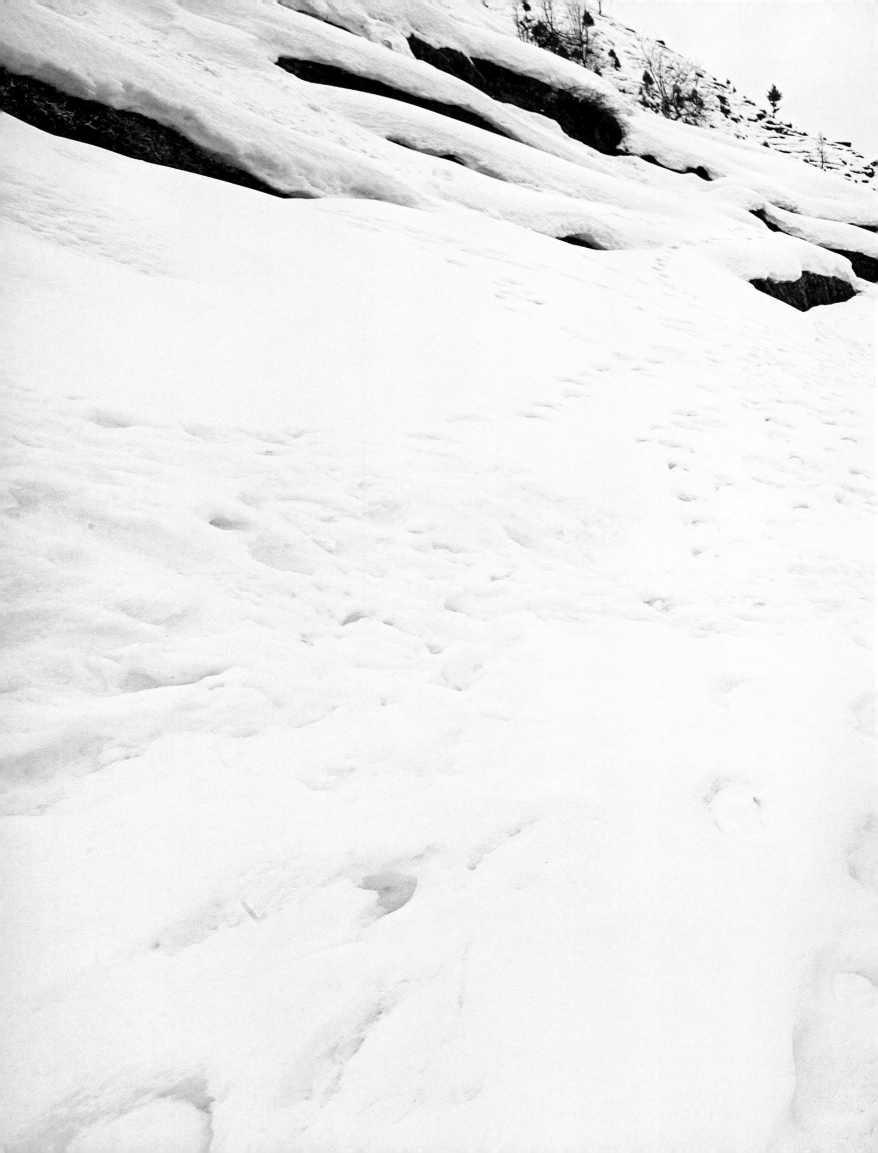

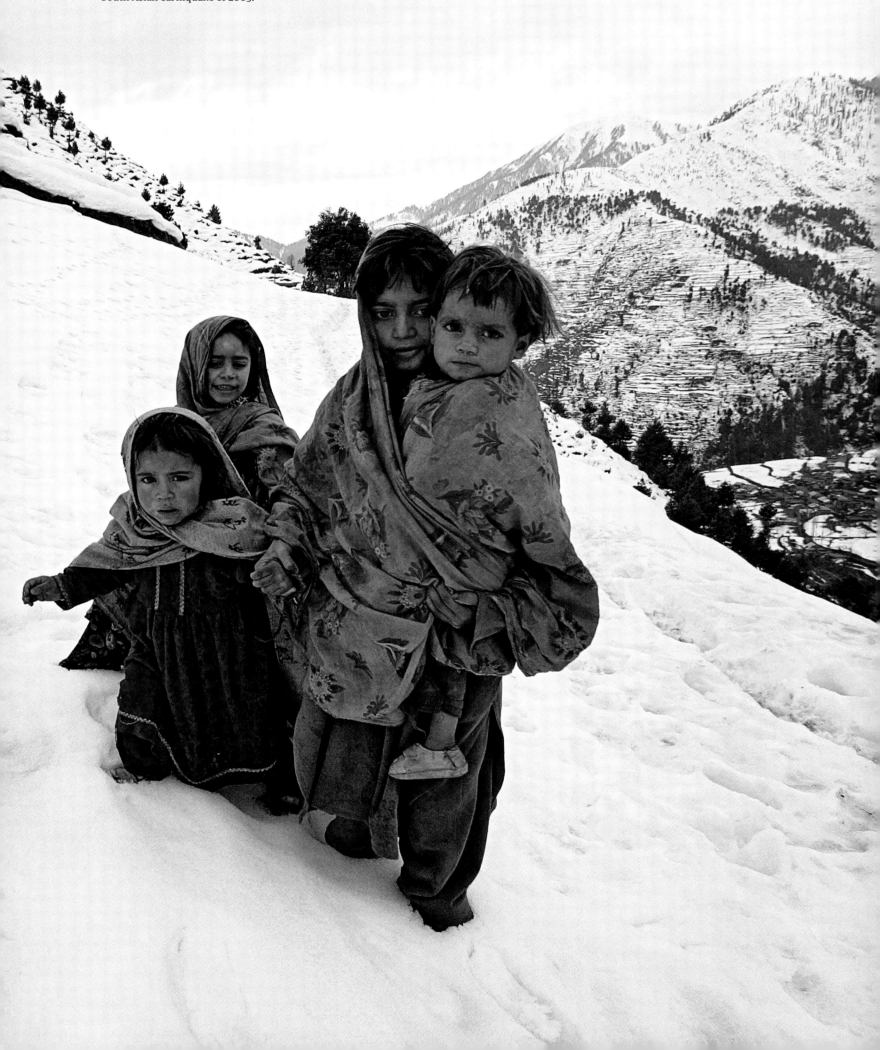

Young girls walk in the snow between the scattered houses of the village of Kuz Ganrshal, in the Peerkhana Union Council of Shangla. Life in this remote region was severely threatened by the devastating South Asian earthquake of 2005.

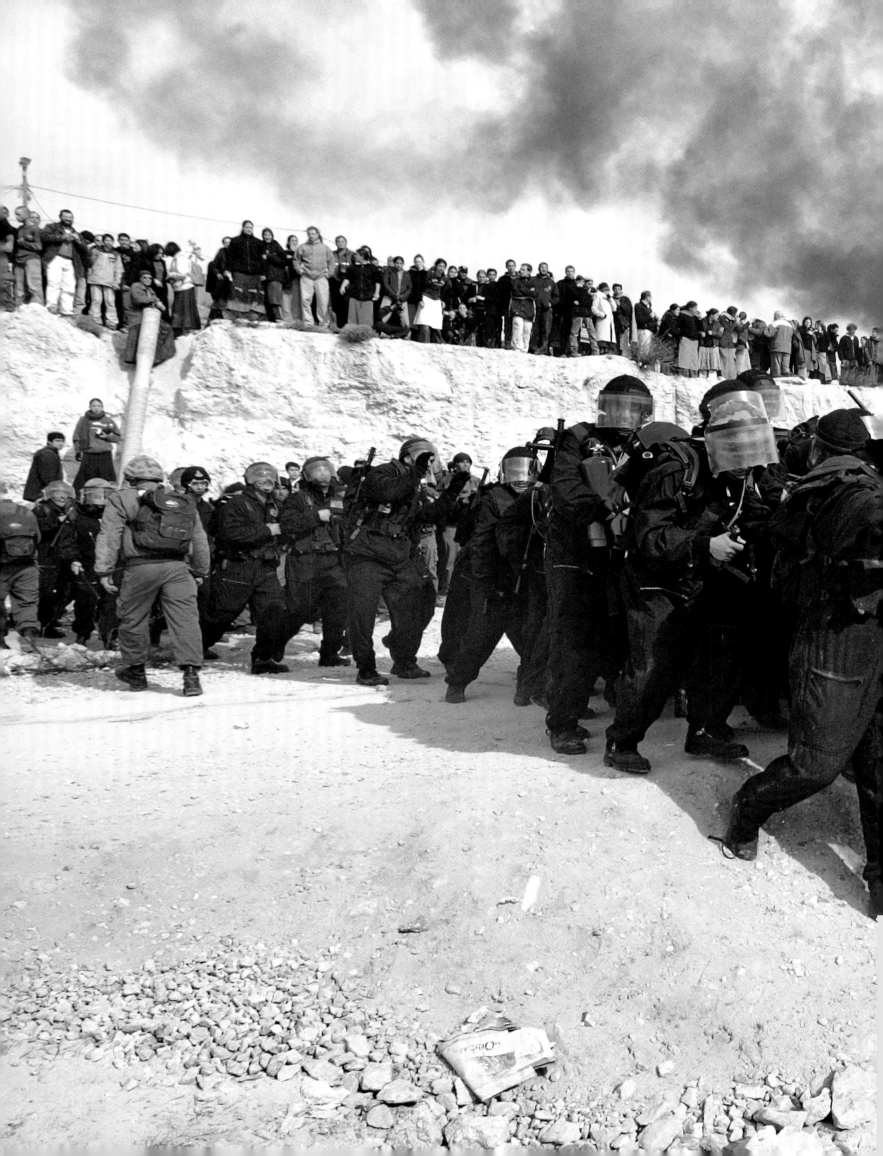

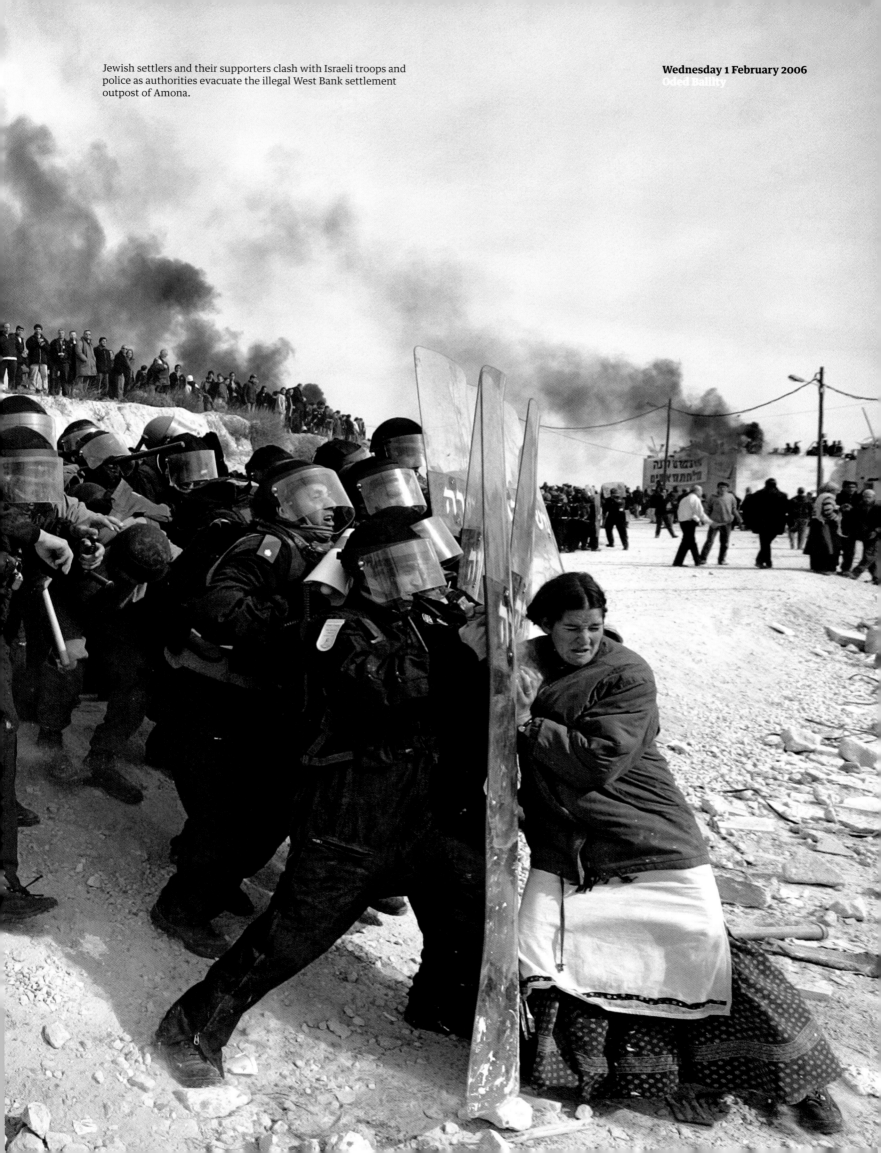

Jewish settlers and their supporters clash with Israeli troops and police as authorities evacuate the illegal West Bank settlement outpost of Amona.

Wednesday 1 February 2006
Oded Balilty

View from the central axis of the LHC (Large Hadron Collider) tunnel in Cern, Geneva.

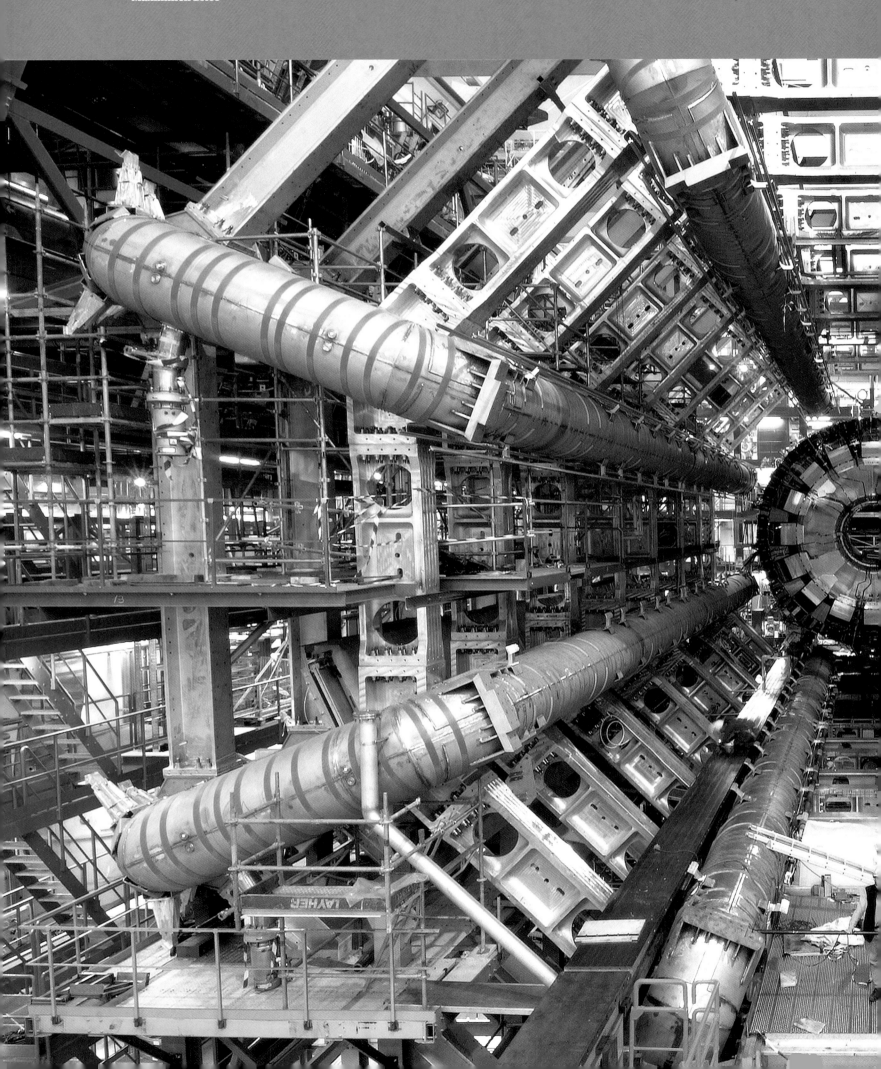

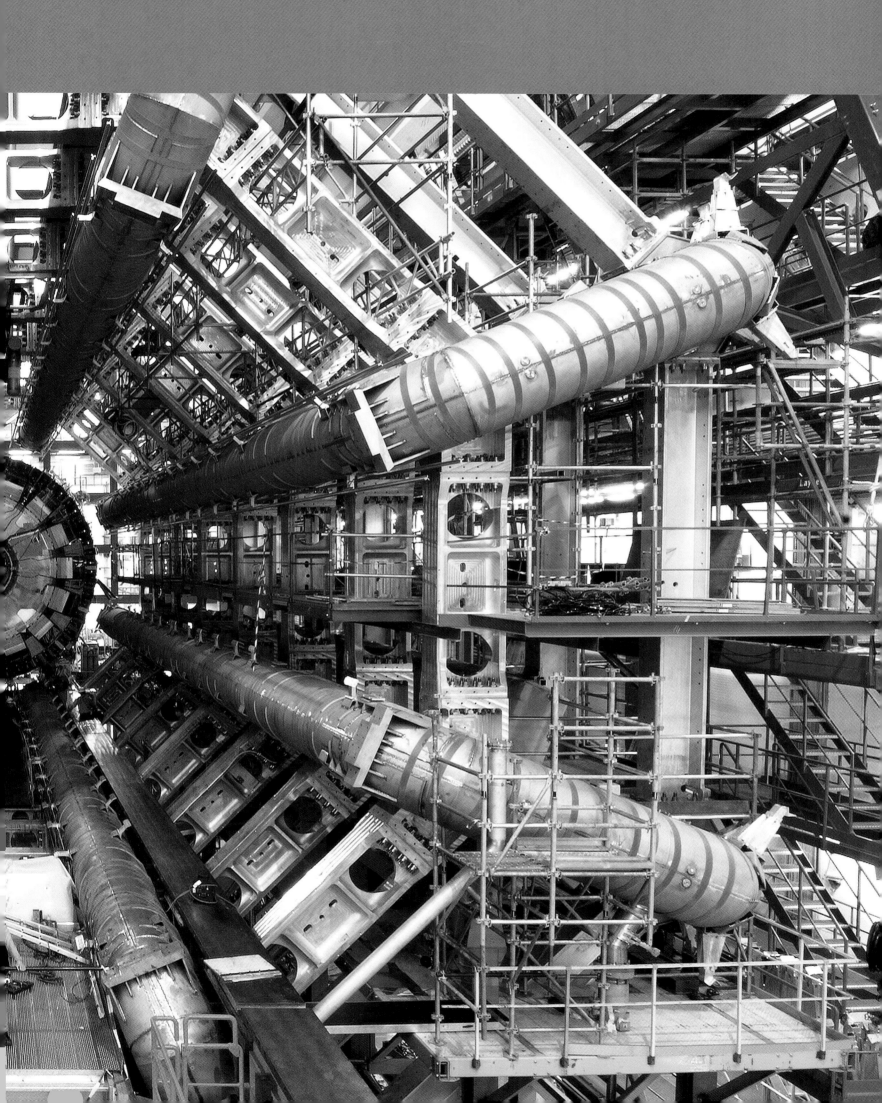

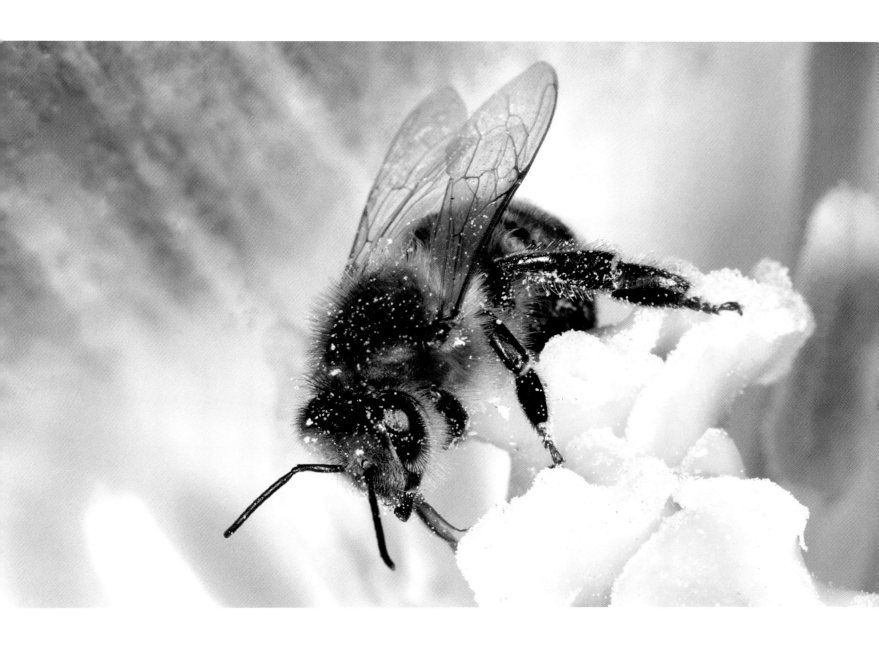

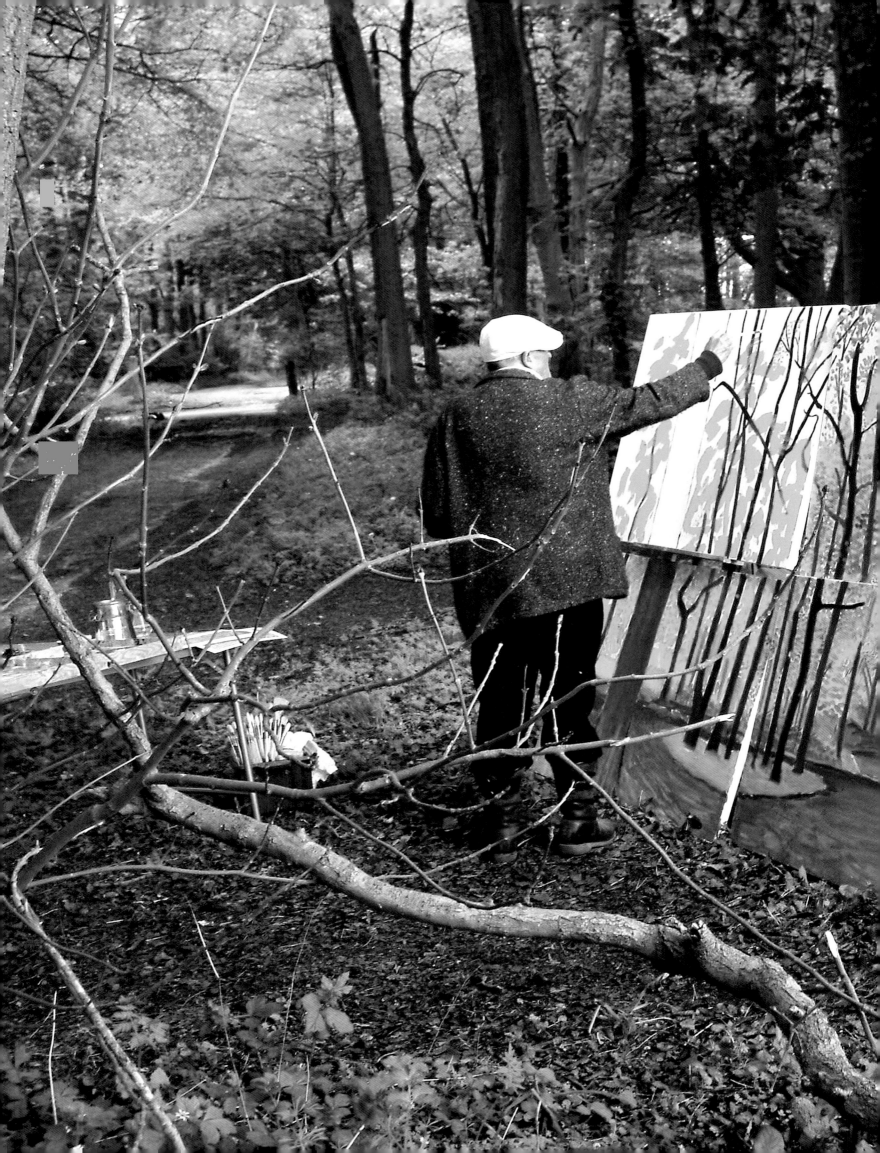

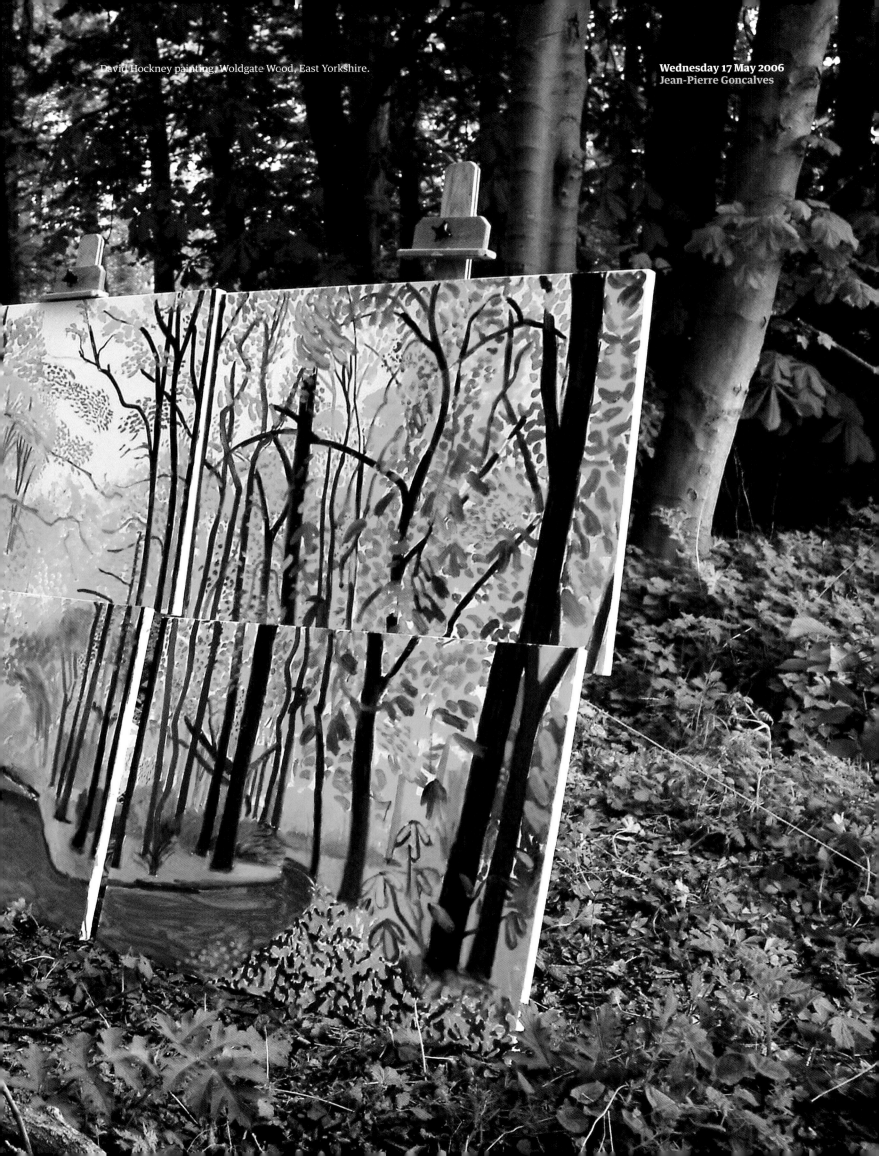

David Hockney painting, Woldgate Wood, East Yorkshire.

Wednesday 17 May 2006
Jean-Pierre Goncalves

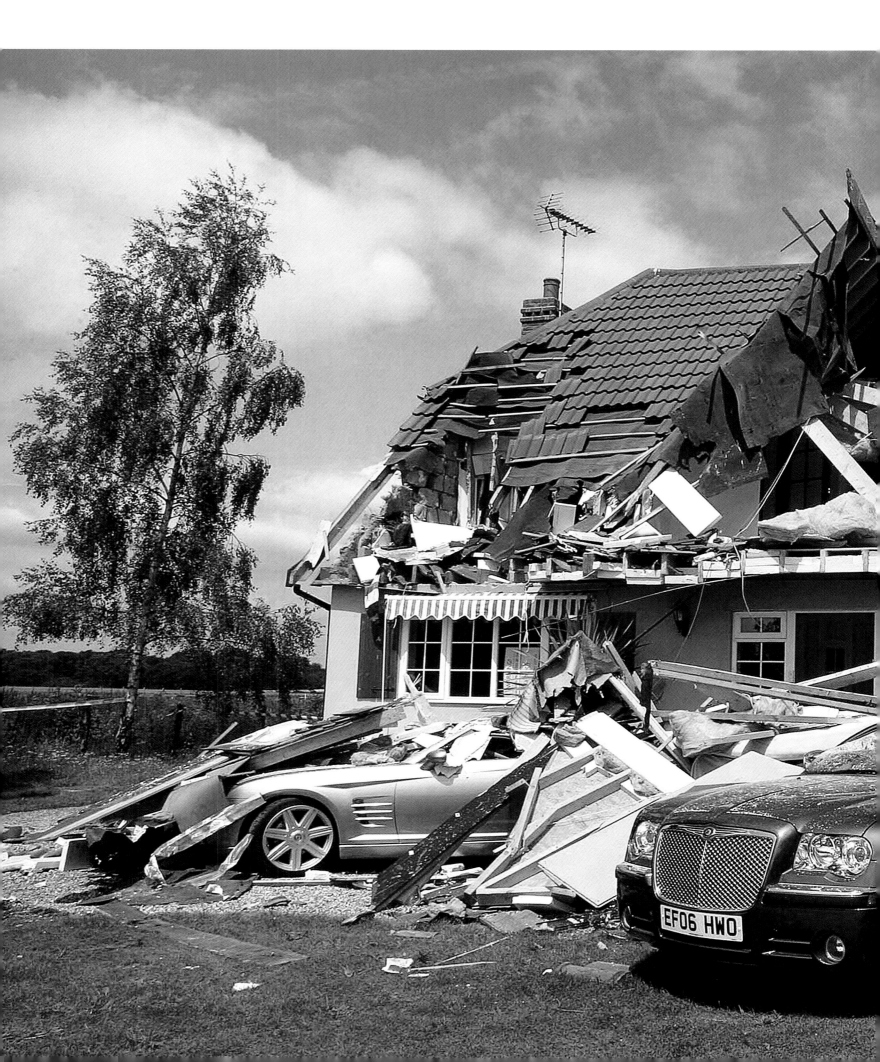

Tuesday 27 June 2006
Peter Lawson

The wrecked home of Essex caravan site owners Janice Gledhill and
James Harvard after a long-term resident attacked it with a JCB.

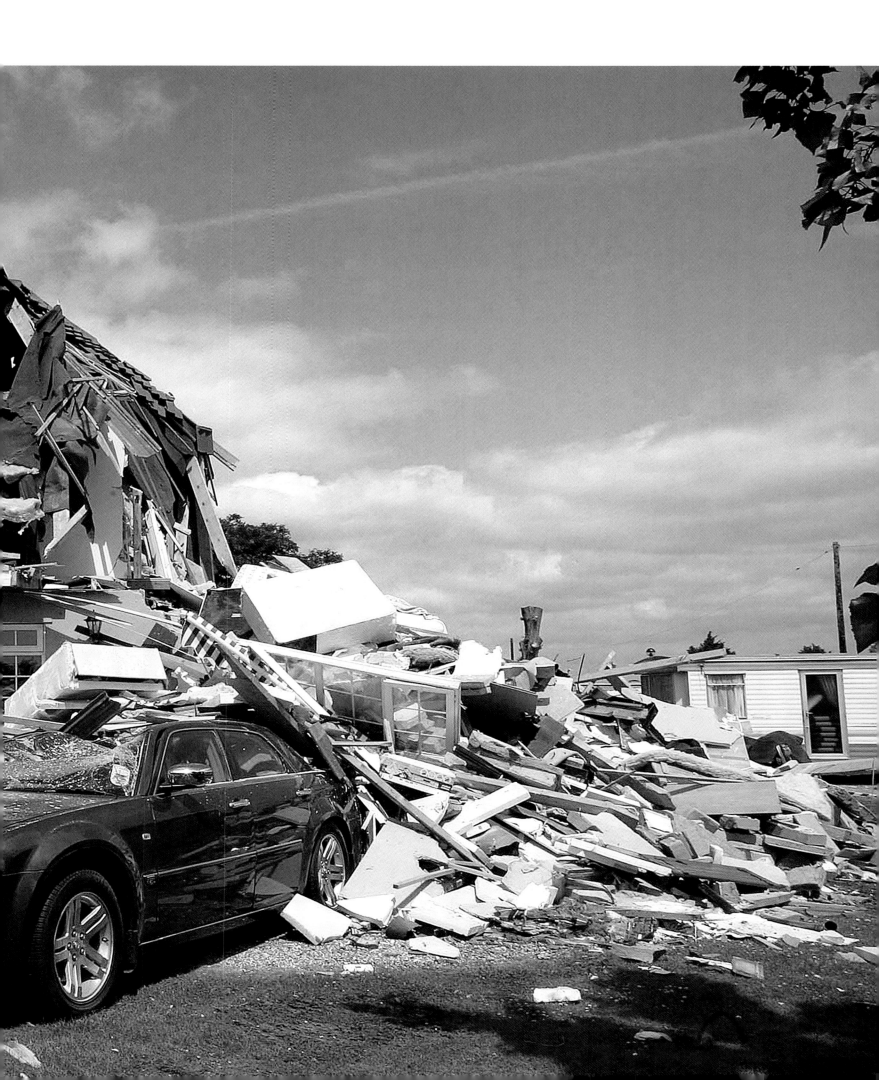

Sculptor Ron Mueck's *A Girl* is removed from its mould in
his Tufnell Park studio.

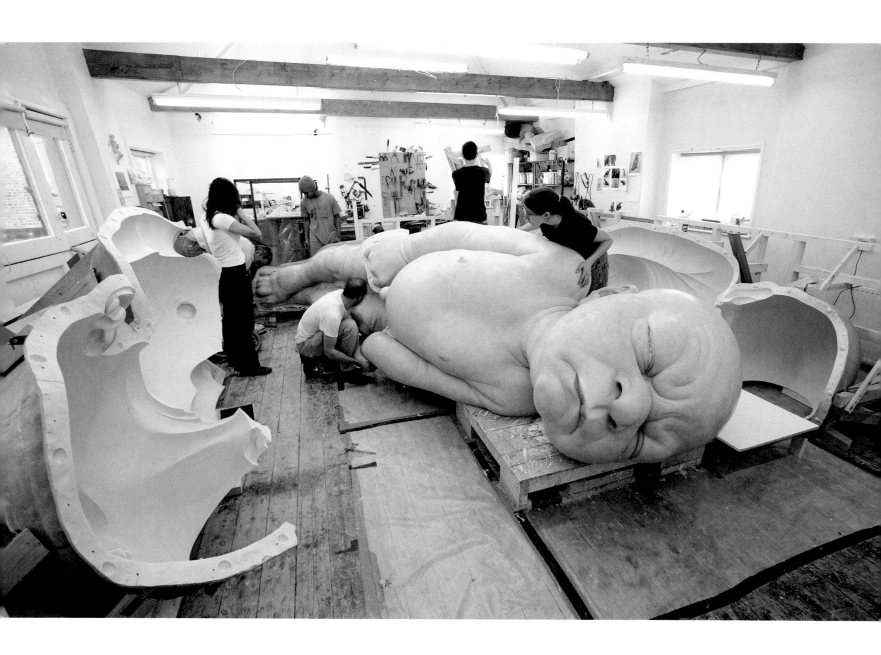

Men play a game of chess while standing in the naturally warmed
waters of the Szechenyi Furdo thermal baths in Budapest.

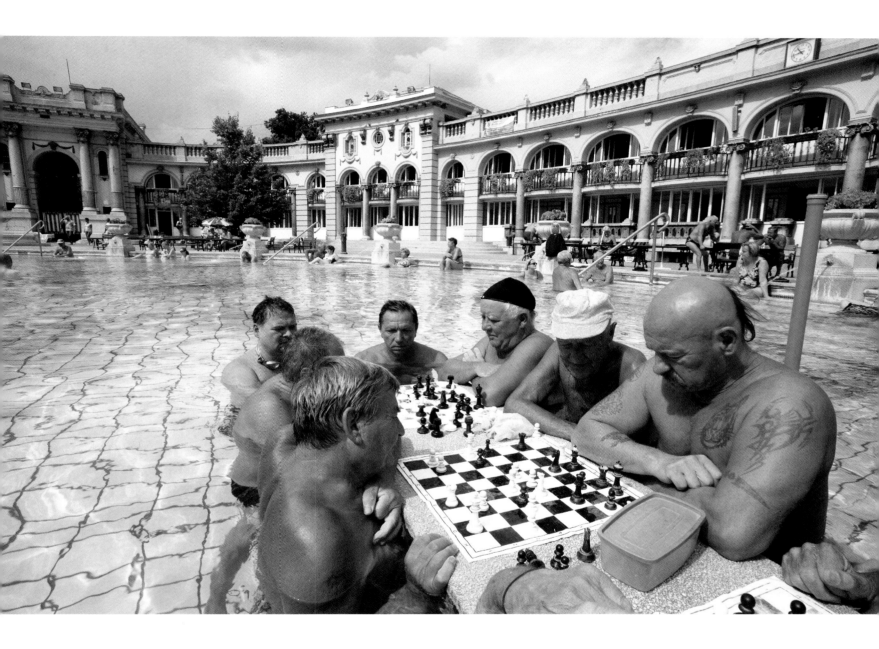

A doctor helps patients line up after receiving eye surgery at
the Cuban Ophthalmology Institute in Havana. Since 2004,
thousands of poor people have received free eye surgery thanks
to Operation Miracle.

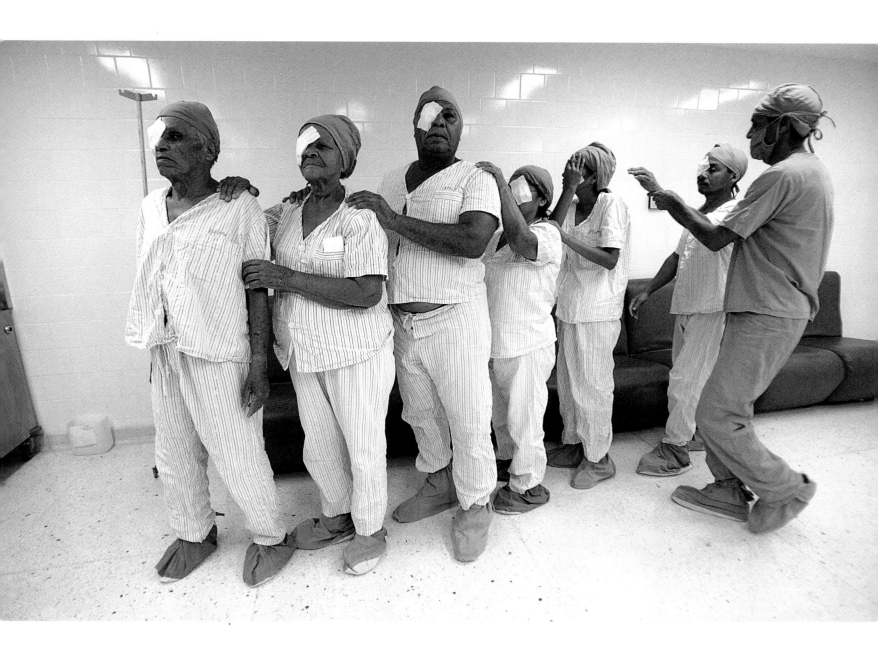

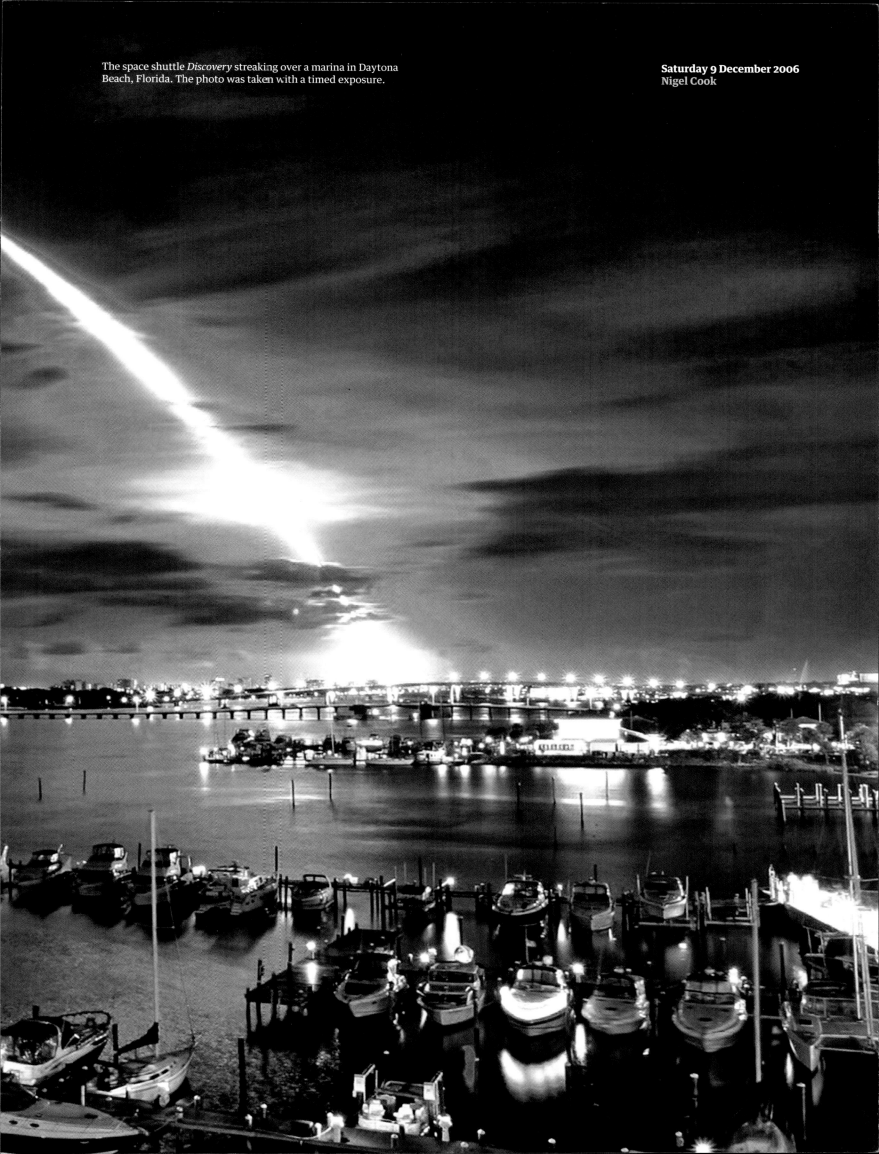

The space shuttle *Discovery* streaking over a marina in Daytona Beach, Florida. The photo was taken with a timed exposure.

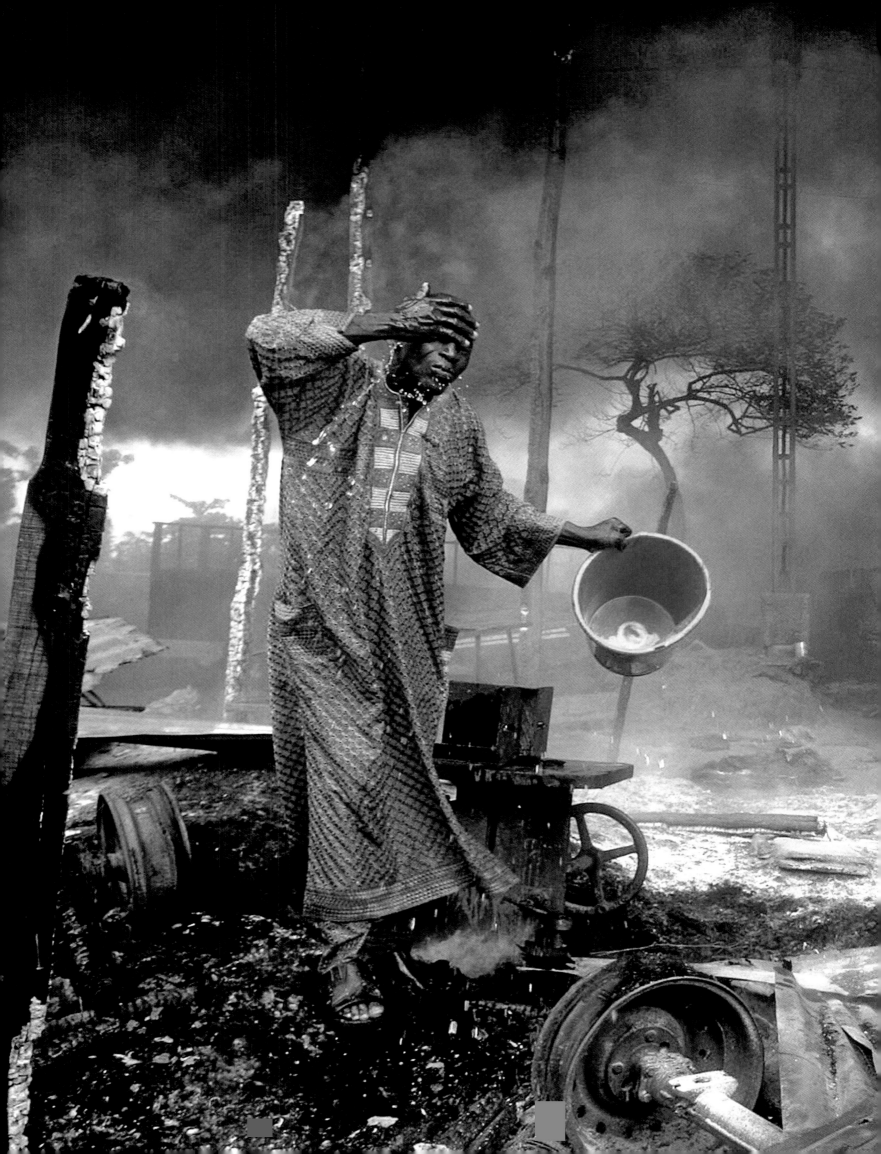

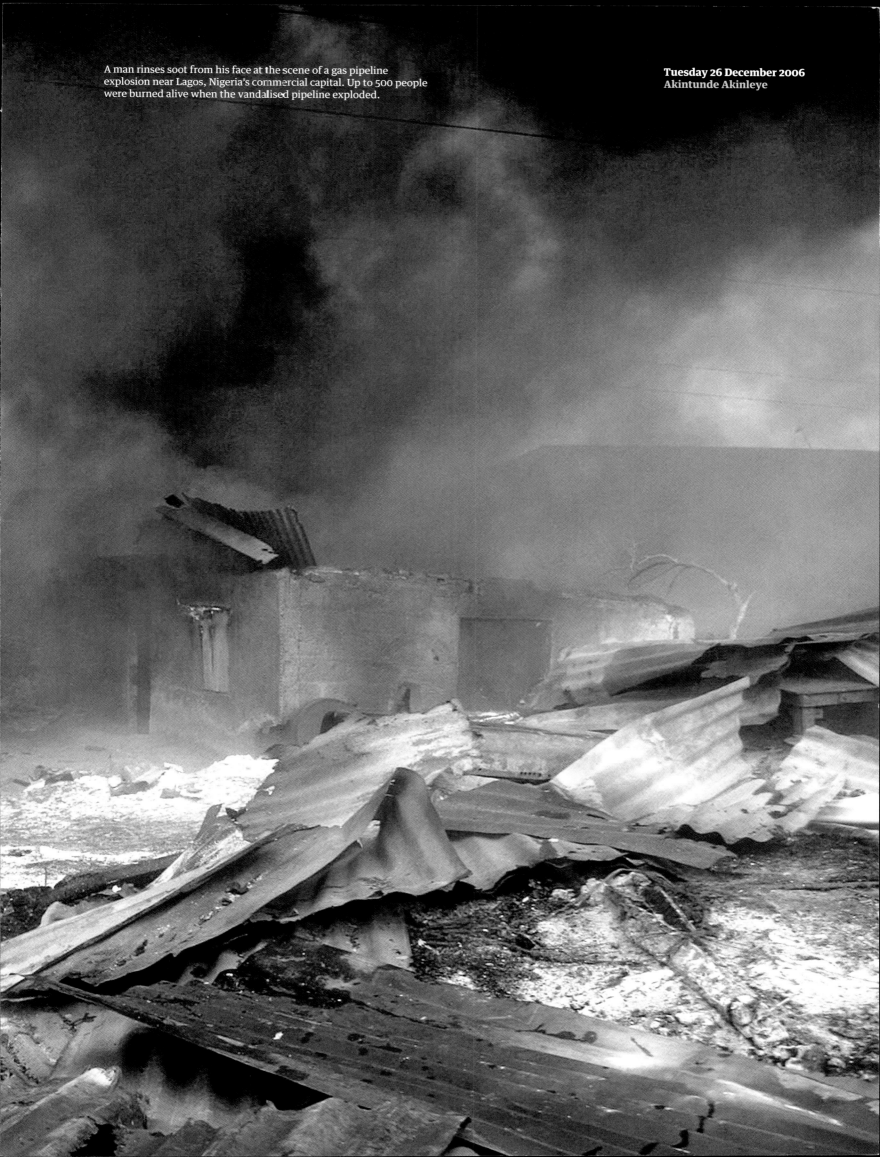

A man rinses soot from his face at the scene of a gas pipeline explosion near Lagos, Nigeria's commercial capital. Up to 500 people were burned alive when the vandalised pipeline exploded.

Tuesday 26 December 2006
Akintunde Akinleye

2007

What a year of grasp and greed, the last of the insane golden days, the end of the longest boom in history. Will we ever see its like again? Inside that luminous property bubble, the lucky 70% who were home-owners saw the value of their houses rise by £50 between breakfast and coming home from work - every day, year after year. It was a time of mammon-worship, fairy money and never-ending cheap credit. In that year, television boasted fifteen programmes a week of property lust, slavering over prices, profits and get-rich-quick property ladders.

Bliss it was to go shopping in that era when globalisation brought imports from China to Primark, Matalan, Argos, Ikea and lastminute.com for the cheapest ever clothes, electricals, furniture and holidays. iPods, iPhones, flat screen TVs, it was easy for many to feel rich. Remember, this was going to last for ever - hadn't the chancellor promised at every budget, 'No return to boom and bust'? It was a time of fantasy wealth built on a mirage of debt as the gap between haves and have-nots widened.

In this year, Conrad Black, the boasting, bullying, brazen right-winger who had bilked the *Daily Telegraph*'s shareholders of £3m in personal partying and private jetting, was put behind bars in Canada. Lord Browne, the £5m-a-year chief executive of BP, was disgraced for lying in court about his private life. Both men belonged in that stratosphere of hyper-wealth that considered itself far above the law. Eat-what-you-kill silverbacks of their era who thought that money bought everything - political parties, government influence, newspaper power and dominion over all the little people.

The money madness couldn't last, of course, and everyone knew it in their bones. The first crash of thunder struck on 14 September. Northern Rock shut its doors and begged the Bank of England for emergency funds. Its swaggering chief executive Adam Applegarth, king of sub-prime, had grown a small building society into the nation's fifth biggest mortgage lender - and he bust it, causing the first bank run for a hundred years.

Polly Toynbee is a columnist for the *Guardian* and president of the Social Policy Association. She was formerly BBC social affairs editor, columnist and associate editor of the *Independent*, co-editor of the *Washington Monthly* and a reporter and feature writer for the *Observer*.

His punishment? He left with £760,000 in his pocket - a pattern the people watched aghast over and over again.

'Don't worry, this is just a little local problem up north,' said the chancellor. It wasn't. 'The US sub-prime calamity won't come here.' It did. 'We are best placed to resist it.' We weren't. 'We will be first out of recession.' We were last. But all that was still thunderclouds on the horizon. The next streak of lightning came in December, with the shocking news that the Bank of England had to pay out £50bn to calm the financial markets: that looks like chicken-feed now. But the band played on right to the end of the year, with only a few Cassandra voices warning that this was the beginning of the end. That year saw the last bumper Christmas.

In politics, as in economics, this was the hinge year, the change year.

Gordon Brown stepped into the job he had coveted so long, promising 'I will do my utmost', and for the first time in two years Labour swept upwards in the polls on a tide of hope for change. The same month, Brown was buffeted by near biblical plagues - a car bomb at Glasgow airport, floods in Hull, a foot-and-mouth outbreak - as if warning of worse to come. He rode those storms well, bathed in popularity that had him surfing into a triumphal autumn party conference where he had stoked up expectations of an early election. Crestfallen Conservatives all but despaired, until their promise to almost abolish inheritance tax caught the frenetic property-obsessed mood of the moment. When Labour's ratings dropped, Brown panicked and pretended he never meant to call an election at all, lying that the polls had nothing to do with it.

By the end of the year, it felt all over for Labour and nearly all over for the booming noughties amid ominous clouds of uncertainty - but few guessed the enormous scale of economic disaster ahead. Champagne corks still popped to see in the New Year - but in reality they were seeing out the end of an era.

1 January Ban Ki-moon takes office as the new UN secretary-general.

18 January The *Celebrity Big Brother* race row erupts as Jade Goody, Danielle Lloyd and Jo O'Meara gang up on Bollywood actress Shilpa Shetty.

12 March BBC journalist Alan Johnston is kidnapped in Gaza. He is released after 114 days.

17 March The new Wembley Stadium opens.

1 May Lord Browne resigns as chief executive of BP after lying in court about his relationship with former boyfriend Jeff Chevalier.

3 May Madeleine McCann, three, disappears from her parents' holiday apartment in Praia de Luz, Portugal.

8 May Martin McGuinness and Ian Paisley sit side by side at Stormont as they launch a power-sharing government.

25 June 24,000 homes in Hull are flooded as Britain experiences its wettest summer since 1766.

27 June Gordon Brown takes over from Tony Blair as PM.

30 June A car bomb is driven into the entrance of Glasgow airport, but fails to detonate fully.

1 July The smoking ban comes into effect in England and Wales.

22 August Rhys Jones, 11, is shot dead in a pub car park in Liverpool.

14 September Northern Rock becomes the first British victim of the credit crunch.

26 September GMTV is fined £2m for deceiving viewers with phone-ins they had little or no chance of winning.

20 November Alistair Darling announces that the personal data of 25 million individuals (7.25m child benefit families) has gone missing.

1 December Missing canoeist John Darwin, who faked his death in 2002, hands himself in to police.

3 December British teacher Gillian Gibbons is pardoned after eight days' imprisonment in Khartoum for naming the class teddy Mohammed (as voted for by her pupils).

10 December Conrad Black is sentenced to six and a half years for stealing £3m from Hollinger.

12 December Five major global banks, including the Bank of England, inject £50bn into financial markets in an attempt to halt the financial crisis.

27 December Benazir Bhutto, leader of the Pakistan People's Party, is assassinated in Rawalpindi.

A young Highland cow covered in snow at Carronbridge in Scotland.

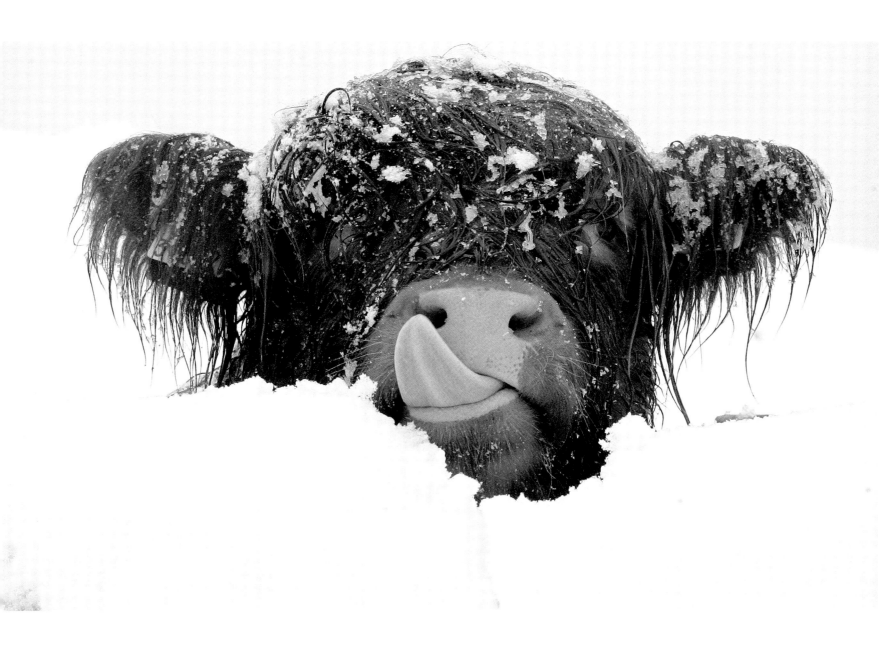

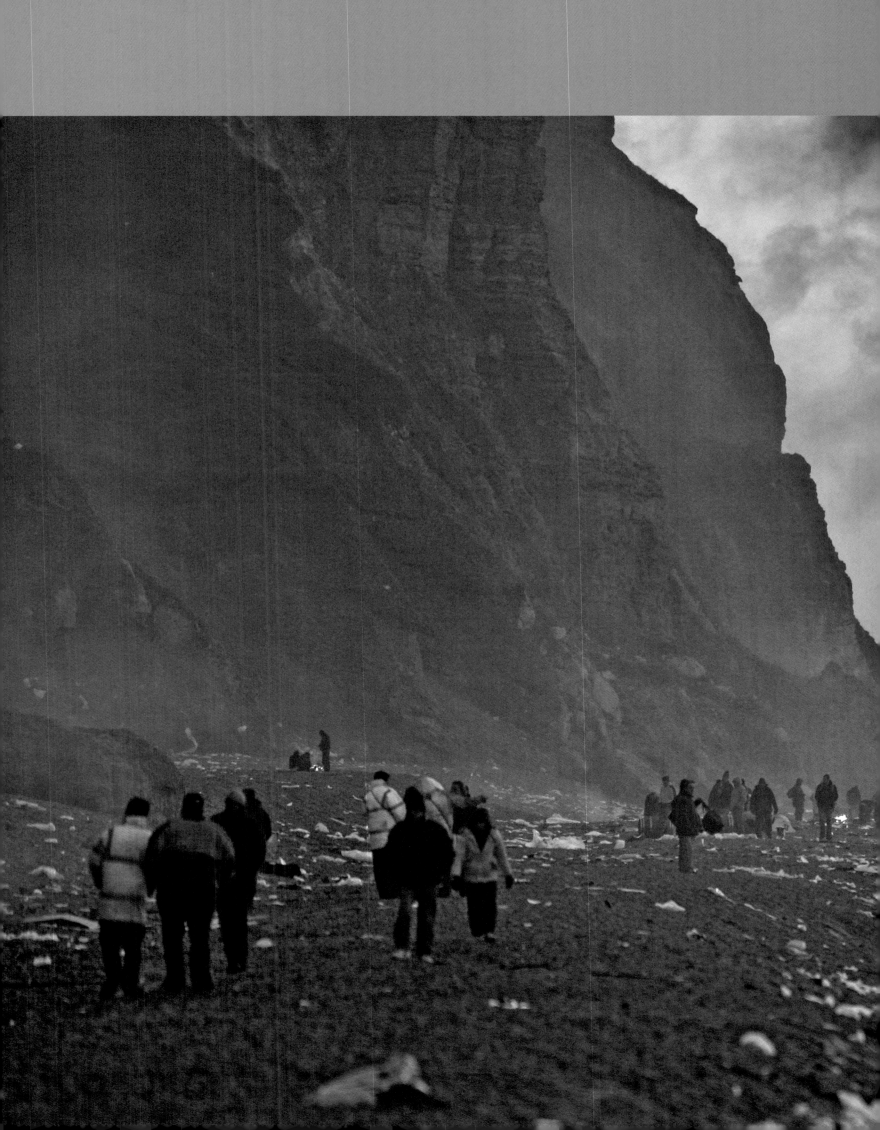

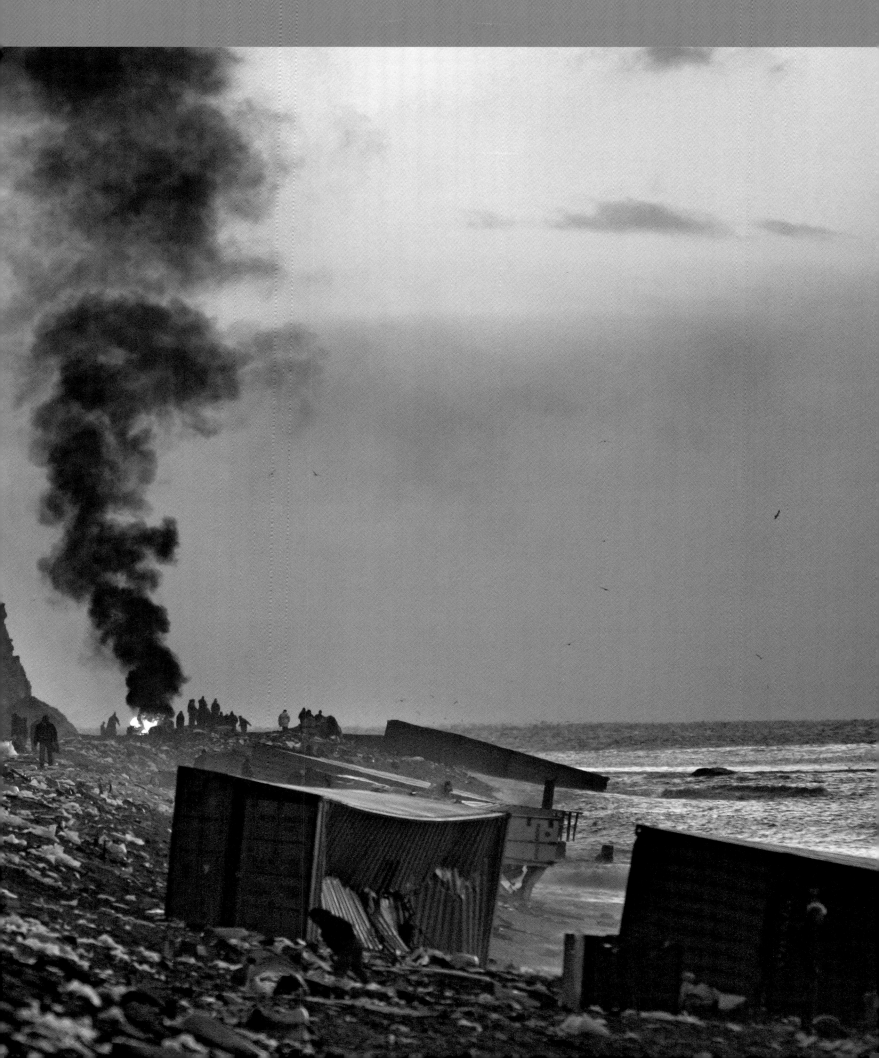

Salvagers picking over goods from the stranded container ship MSC *Napoli* that had washed up on the beach at Branscombe in south Devon.

Tuesday 23 January 2007
David Levene

Presidential hopeful US Senator Hillary Rodham Clinton speaking at a barbecue in Fort Madison, Iowa.

Monday 2 April 2007
Kevin Sanders

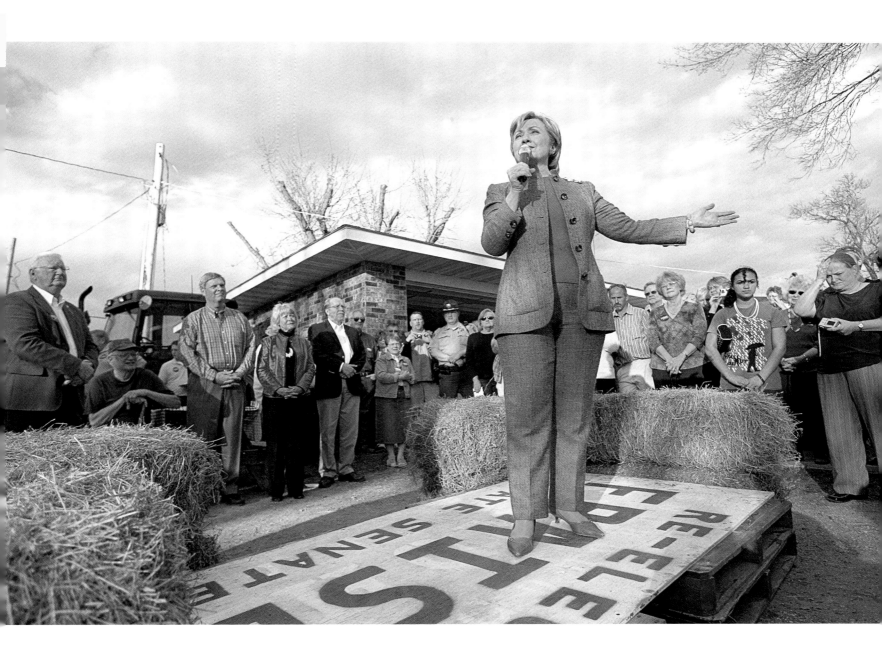

Democratic Unionist leader Reverend Ian Paisley arrives at Stormont to be sworn in as First Minister of Northern Ireland. As part of a power-sharing deal, Sinn Fein's Martin McGuinness is also sworn in as Deputy First Minister.

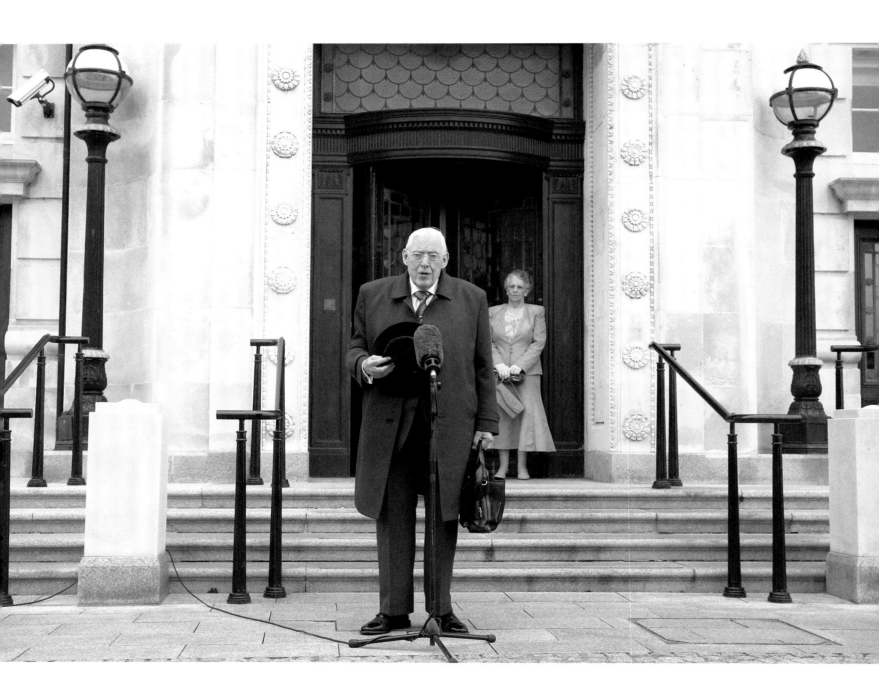

Blind Light by Anthony Gormley, part of an exhibition of the artist's work in the Hayward Gallery in London.

Monday 14 May 2007
David Levene

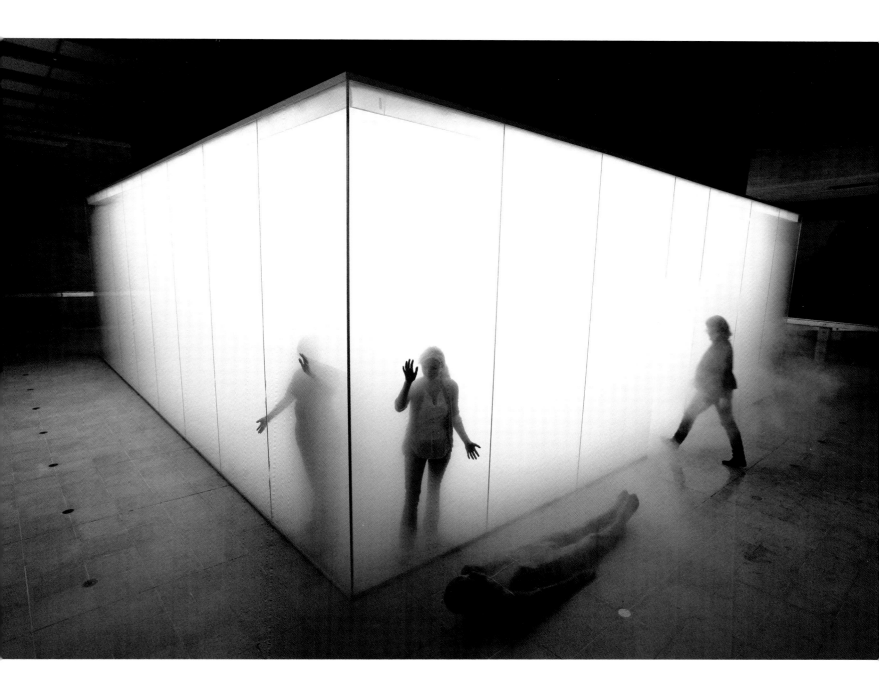

Saturday 19 May 2007
Sean Smith

An American soldier in Amiryah, west Baghdad, provides cover as his colleagues try to extinguish a flaming fighting vehicle that has been hit by an IED (improvised explosive device). The blast killed six American soldiers and a translator.

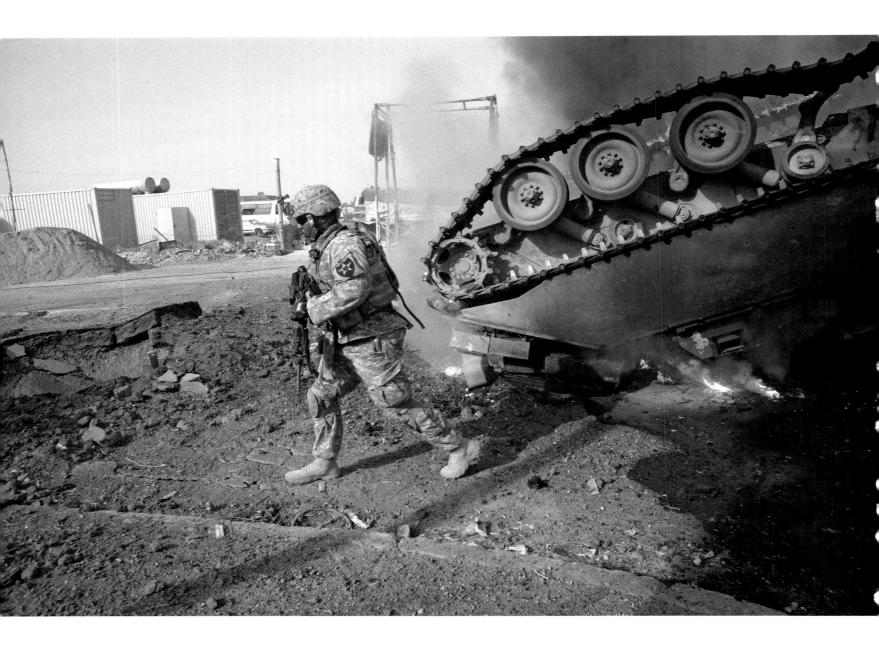

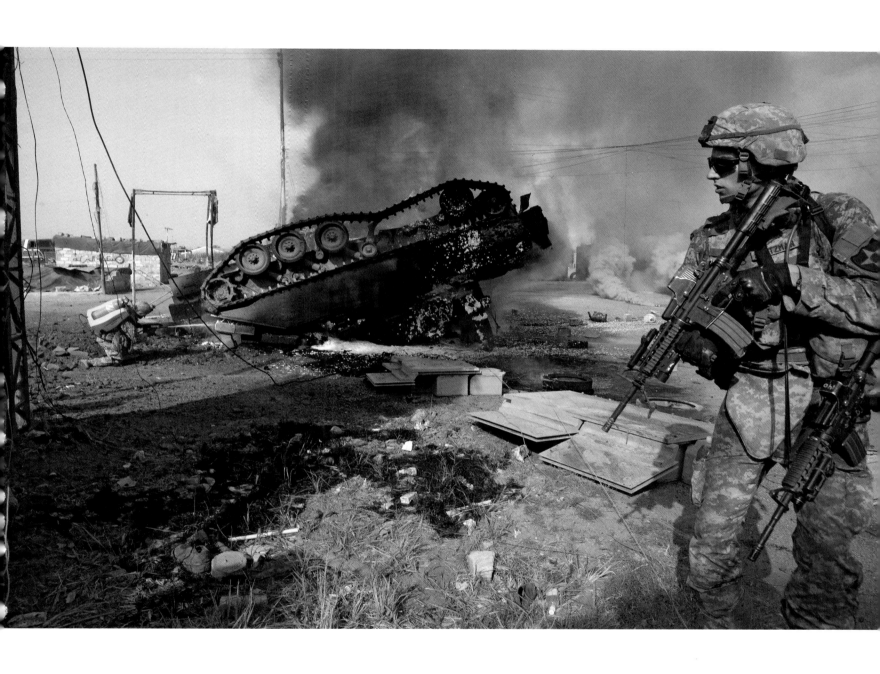

Accompanied by his wife, Sarah, Gordon Brown walks into No. 10 Downing Street as Prime Minister.

Wednesday 27 June 2007
Dan Chung

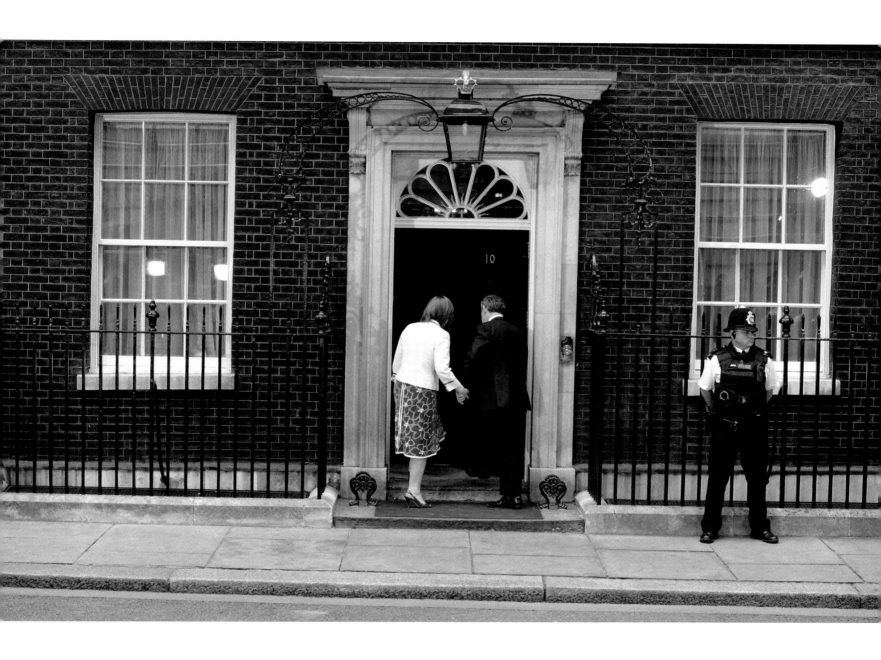

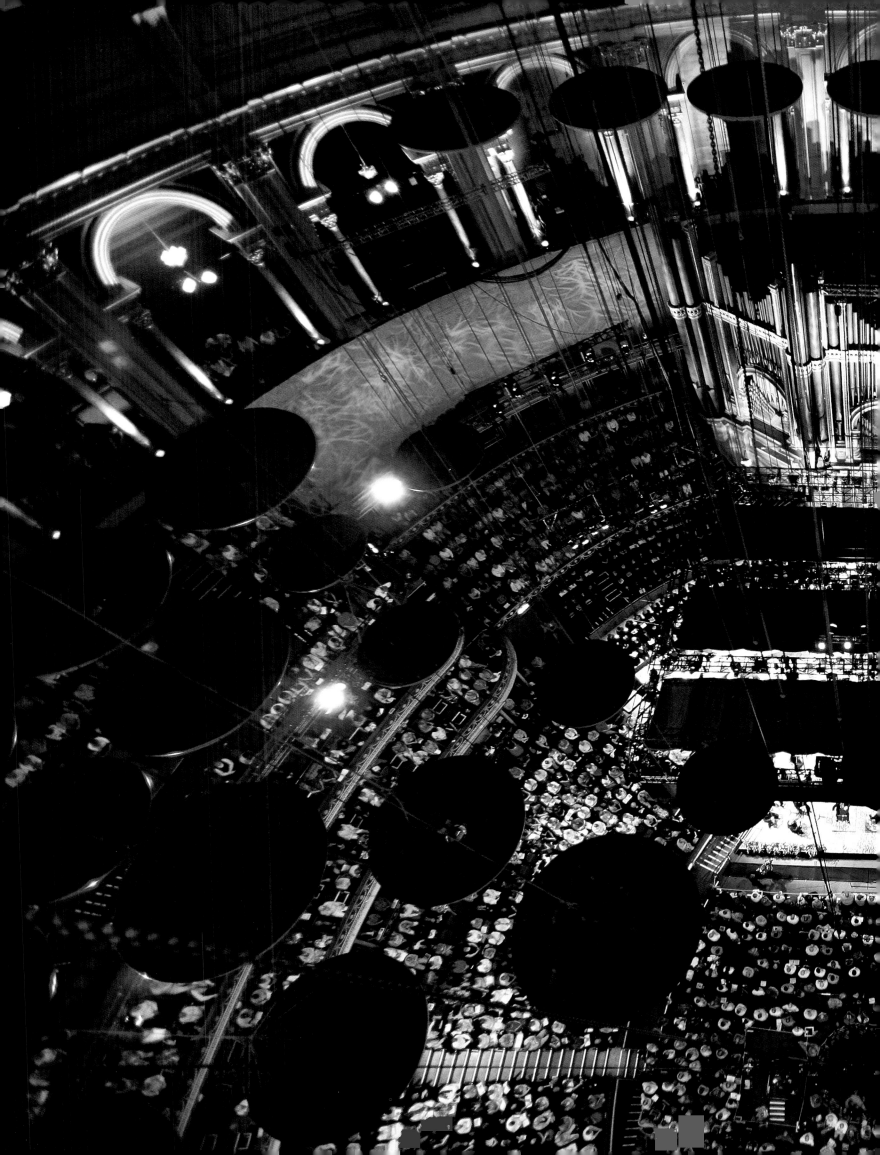

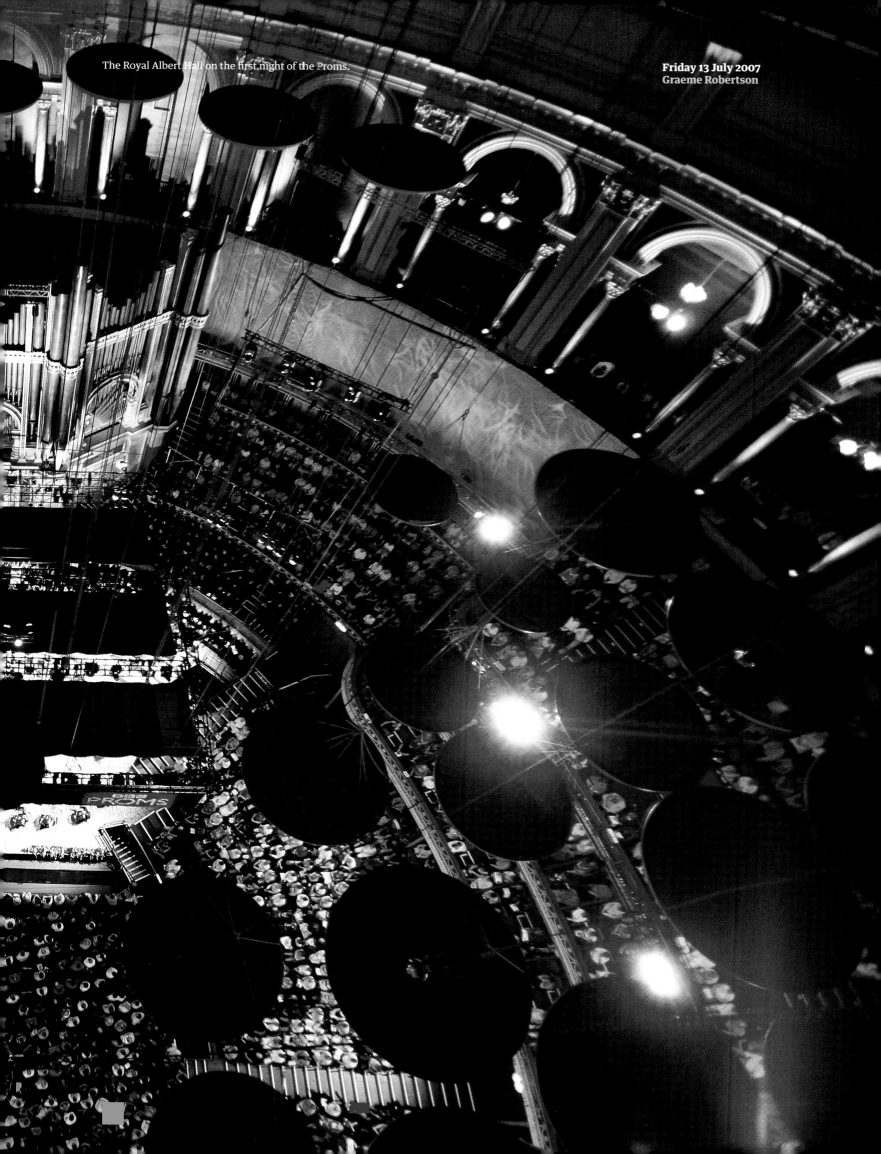

The Royal Albert Hall on the first night of the Proms.

Friday 13 July 2007
Graeme Robertson

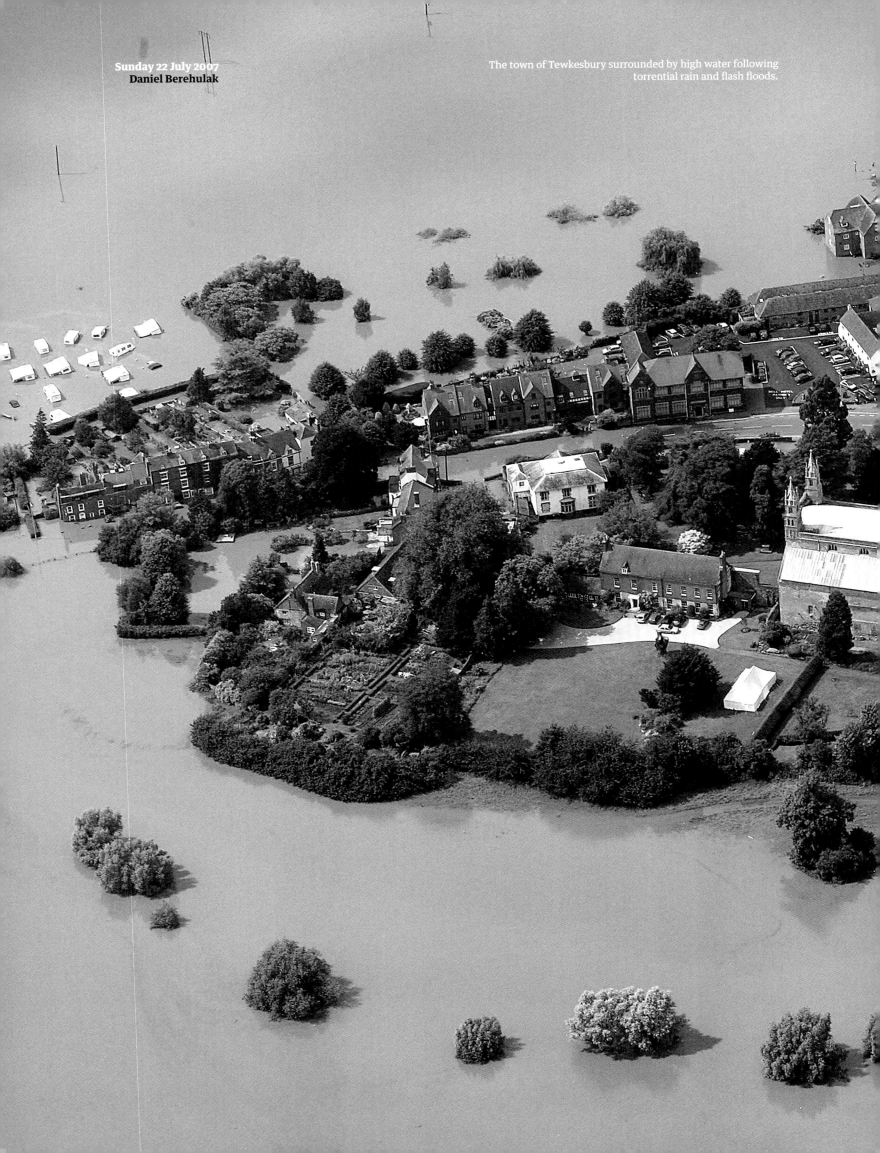

Sunday 22 July 2007
Daniel Berehulak

The town of Tewkesbury surrounded by high water following
torrential rain and flash floods.

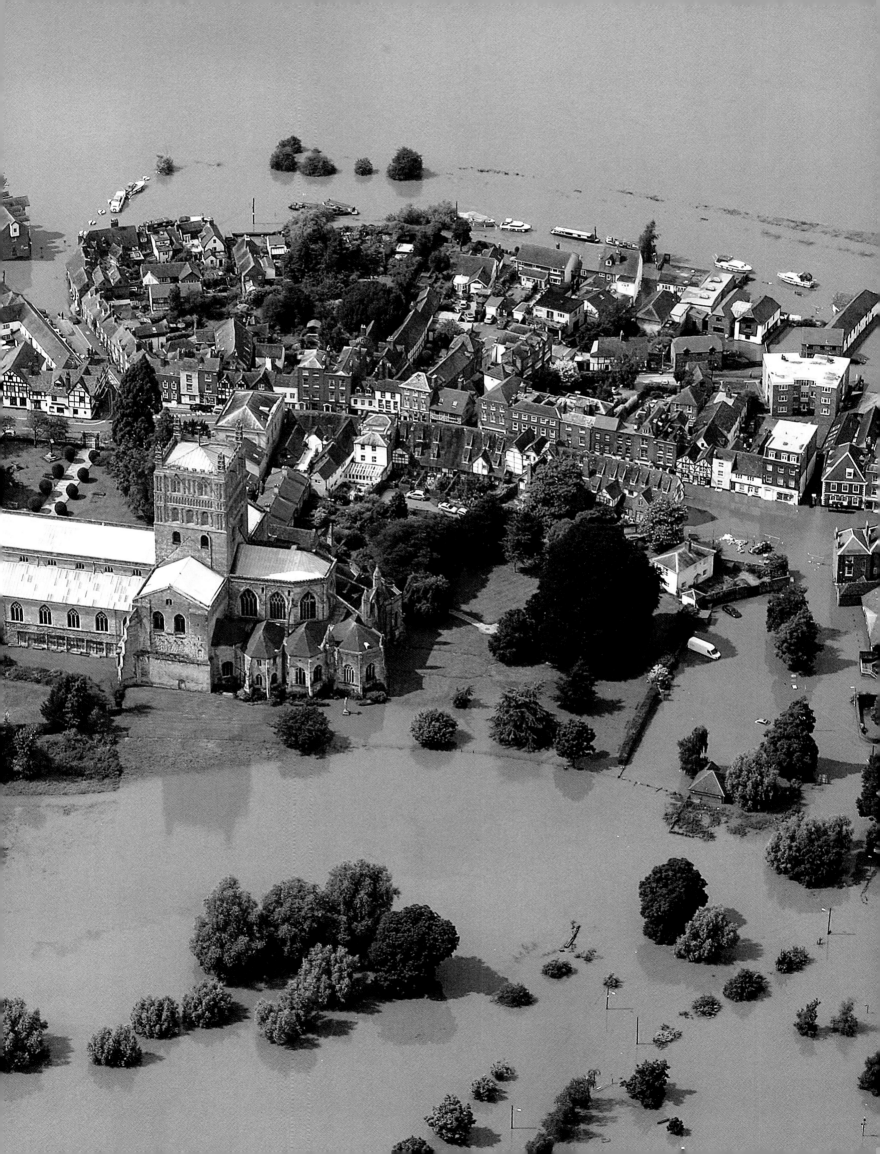

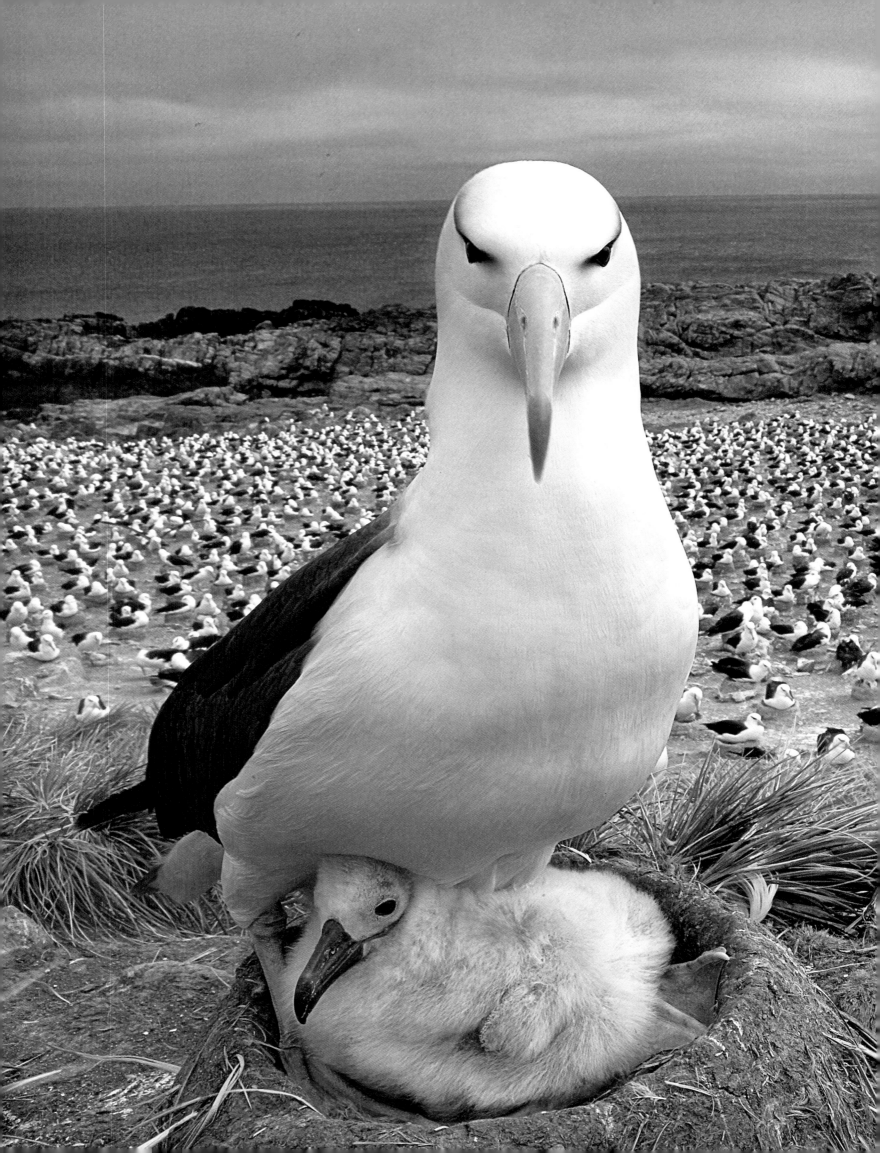

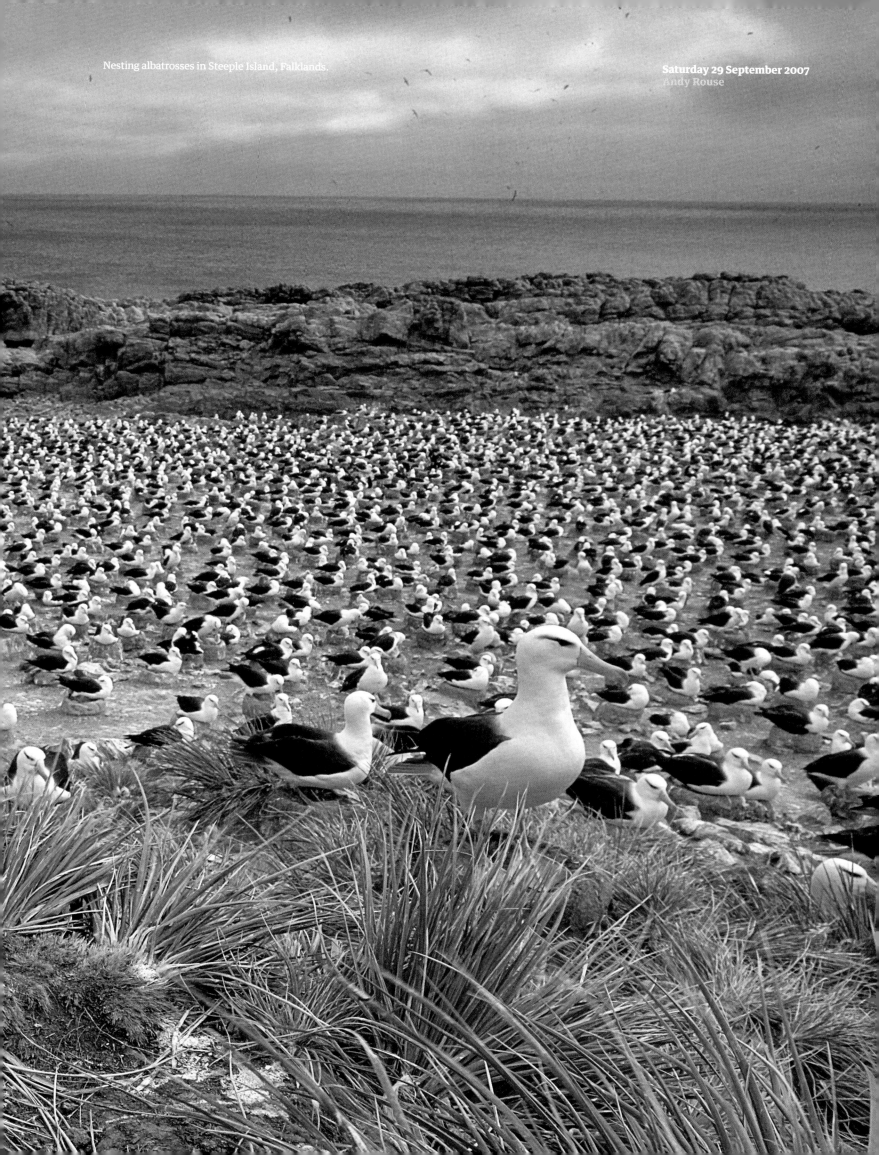

Nesting albatrosses in Steeple Island, Falklands.

Democratic presidential candidate Senator Barack Obama on the
phone to his family during a campaign bus trip.

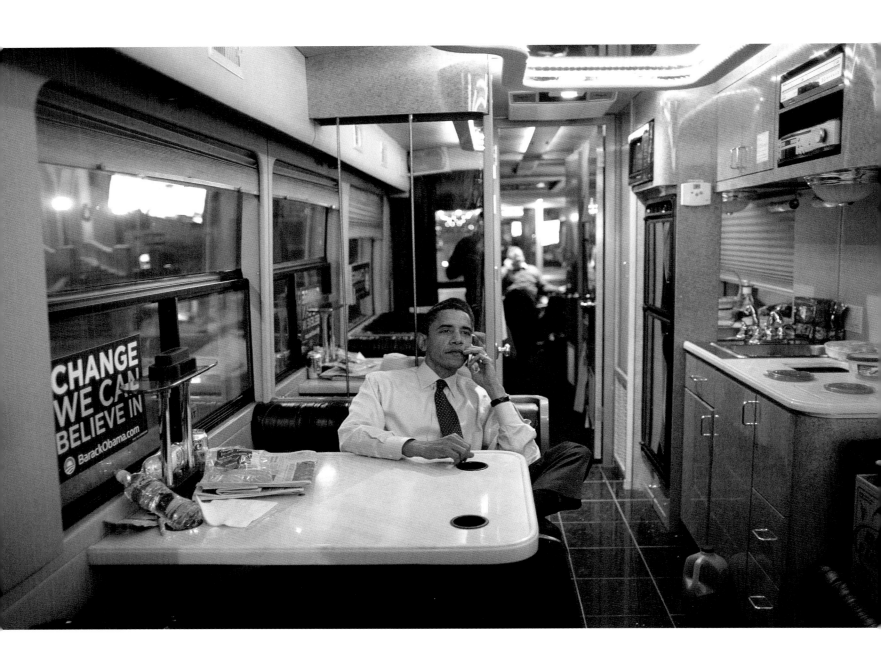

2008

Dan Roberts is head of business for the *Guardian* and *Observer*. He was previously deputy editor of the *Sunday Telegraph* and before that was the US business editor of the *Financial Times*. His awards include the Harold Wincott Foundation Senior Financial Journalist of the Year in 2007.

Livelihoods, not lives, were at stake, but there were echoes of the calamities of 1940 for Britain's economy in 2008.

The year of financial armageddon began with the nationalisation of Northern Rock: a humiliating retreat from the free-market certainties of a generation. Since a forced evacuation of savings had brought the former building society to its knees the previous autumn, the public rapidly lost faith in the stability of private sector financial institutions, and by the time a government rescue operation was completed in February, public ownership no longer seemed such a strange alternative.

More was to follow, but first came the phoney war, as larger banks tried to disguise their own bankruptcy. Throughout the spring and early summer, a sense of foreboding hung in the air. It was clear something was seriously awry, yet the City of London and Wall Street worked furiously to paper over the cracks. Life continued as normal in the rest of economy, but without access to fresh financing, it was only a matter of time before more over-extended banks began to crash to earth.

Events began to pick up speed first in America, where investment bank Bear Stearns had to be rescued and then, later in the summer, the giant US mortgage group Fannie Mae started to teeter. By September 2008, the bail-outs were making Northern Rock look like a minor skirmish. Then, on the weekend of 13 and 14 September, the US government decided to try a different approach. Frantic efforts to find a rescue buyer for Lehman Brothers had failed (partly after British authorities scotched a proposed rescue by Barclays) and, rather than put more public money at risk, Washington decided to let the market take its course.

The ensuing Lehman bankruptcy was the largest in history and triggered worldwide financial panic. Even Goldman Sachs and Morgan Stanley looked on the verge of collapse as investors rushed to pull their money out. International capital markets froze solid. Realising what it had unleashed, the US government hurriedly arranged rescues for Merrill Lynch and AIG, the world's largest insurance group. Politicians warned there might

be civil unrest if Congress did not act fast to pass a more comprehensive bail-out of Wall Street.

On this side of the Atlantic, the City of London was in even worse shape. The imminent collapse of Halifax Bank of Scotland forced the government to sanction a controversial rescue takeover by Lloyds. Then the Royal Bank of Scotland saw panic withdrawals of the type that had brought Northern Rock down. With few solvent institutions left in a position to organise a private-sector solution, the government had to step in even more aggressively than Washington - first to take control of RBS and then to part-nationalise Lloyds HBOS too.

A British economy that had relied almost exclusively on the City for growth faced ruin. The housing market was in freefall and unemployment seemed sure to follow. Though he attracted ridicule at the time, Chancellor Alistair Darling called it the economy's darkest hour for six decades.

Just what a battle for economic survival took place that autumn only emerged subsequently. Still petrified by the run on Northern Rock, the Bank of England had been making preparations to turn off the nation's cash machines during the week when RBS and HBOS went down. The failure of the system of money distribution threatened not just the British way of life but the future of Western capitalism.

And yet, the curious thing was that it never looked that bad from the outside. Though we may be paying for it for generations, the public rescues largely worked: calm was restored and civil unrest averted. Just as the long boom years had not felt much like a boom (except, perhaps, for the very wealthy), the crash did not feel like the 1930s. Mass unemployment, at least in Britain, has so far been avoided.

One other event in 2008 was also to bring hope around the world: the election of America's first black president, Barack Obama. Just as faith in the market reached its nadir, the sight of a democratic revolution restored hope in the power of politics - and hope that something might change.

23 January Heath Ledger is found dead at his home in Manhattan.

23 January Thousands of Palestinians cross into Egypt after the border wall with Gaza in Rafah is blown up by militants.

28 January Rogue trader Jerome Kerviel is placed under formal investigation for alleged fraud at the French bank Société Générale.

2 February French president Nicolas Sarkozy marries Carla Bruni.

17 February Kosovo declares independence from Serbia.

19 February Fidel Castro announces he will not accept another term as president of Cuba and his brother, Raul, officially takes over.

19 February Nine-year-old Shannon Matthews goes missing in Dewsbury. She is later found at her stepfather's uncle's house, and her mother is found guilty of plotting her kidnap.

22 February Northern Rock is nationalised.

29 February Prince Harry flies back to the UK from serving in Helmand after foreign websites break a media blackout on details of his deployment.

17 March Bear Stearns is acquired by JP Morgan Chase at a cut-rate price.

29 March Elections are held in Zimbabwe. The results are disputed.

27 April Police arrest Joseph Fritzl on suspicion of incest and abduction.

1 May Boris Johnson is elected mayor of London.

2 May Cyclone Nargis kills 133,000 in Burma.

12 May A Sichuan earthquake kills 90,000.

3 June Barack Obama becomes the presumptive nominee of the Democratic Party.

22 July Radovan Karadzic is arrested in Serbia for war crimes and genocide.

7 August War breaks out between Russia and Georgia over Abkhazia and South Ossetia.

30 August Chancellor Alistair Darling says the economy is the worst it has been in 60 years.

15 September Lehman Brothers goes bankrupt. Merrill Lynch agrees to be taken over by the Bank of America.

7 October The Icelandic government takes control of the country's second largest bank, Landsbanki (owners of Icesave).

4 November Barack Obama is elected as the first black president of the USA.

29 November Terrorists attack hotels in Mumbai, killing 166.

27 December Israel launches airstrikes on the Gaza Strip.

A shipbreaker in Chittagong, Bangladesh, dismantling a freighter for recycling. Workers wear little protection and are exposed to toxic waste and oil residue.

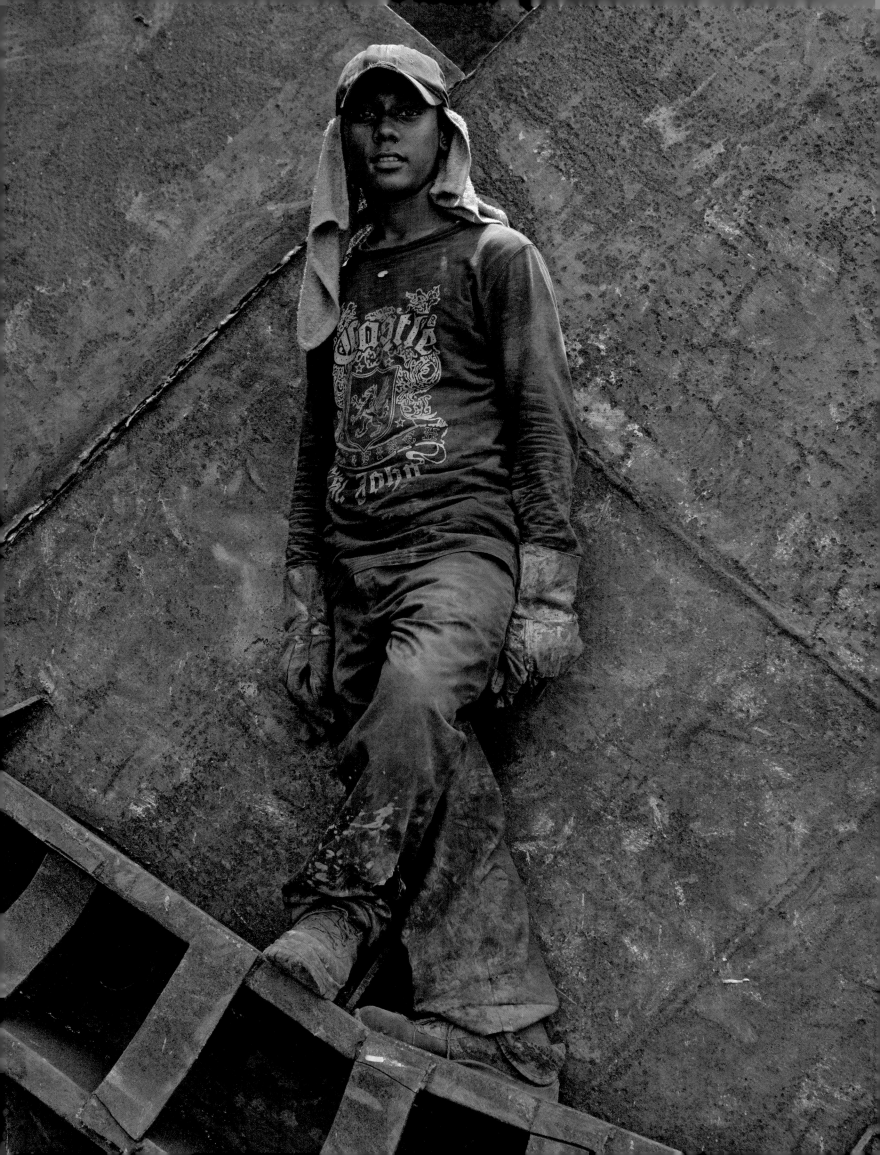

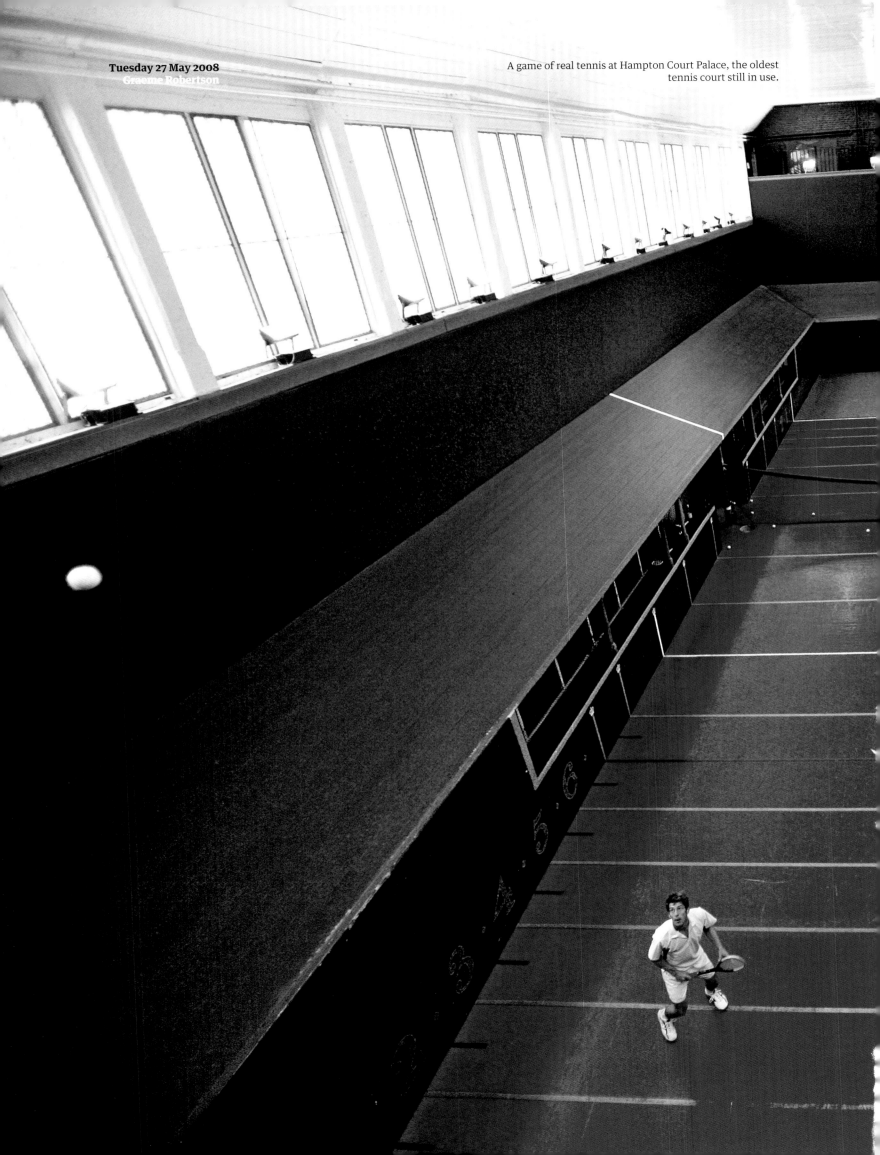

A game of real tennis at Hampton Court Palace, the oldest tennis court still in use.

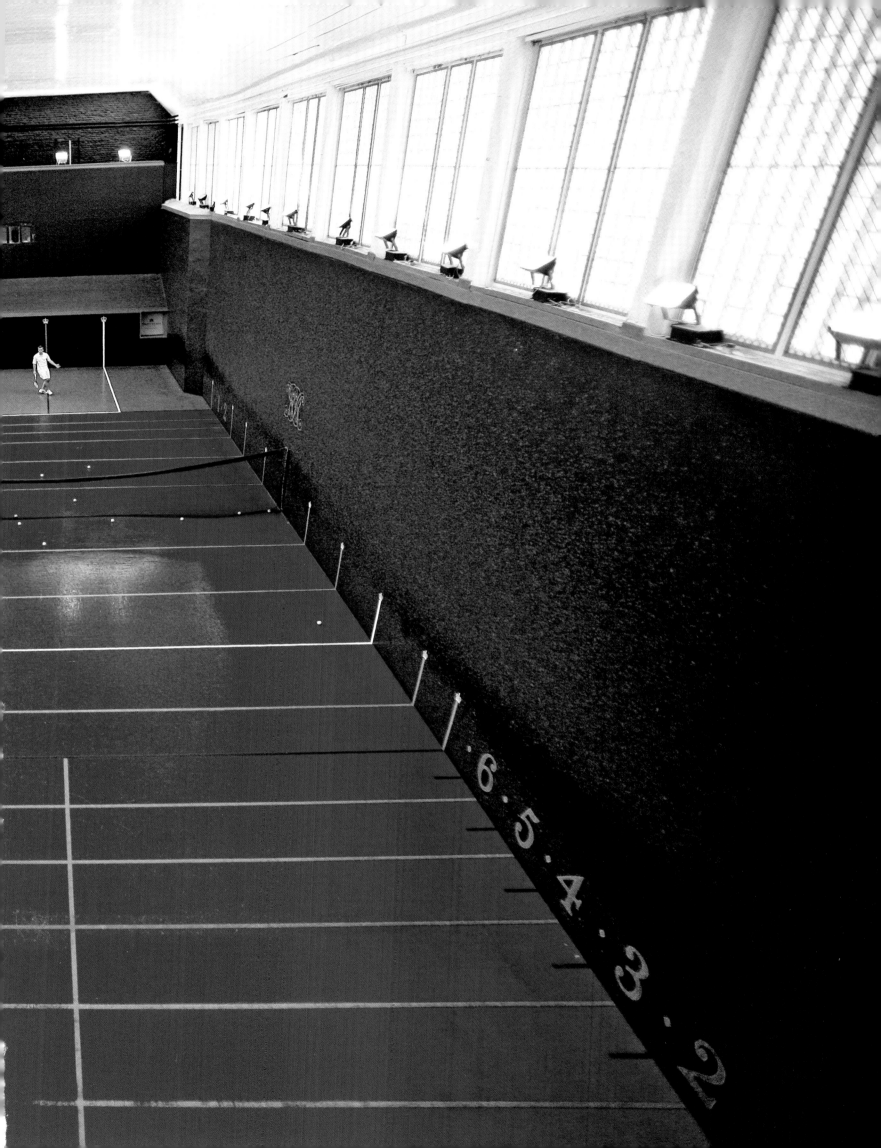

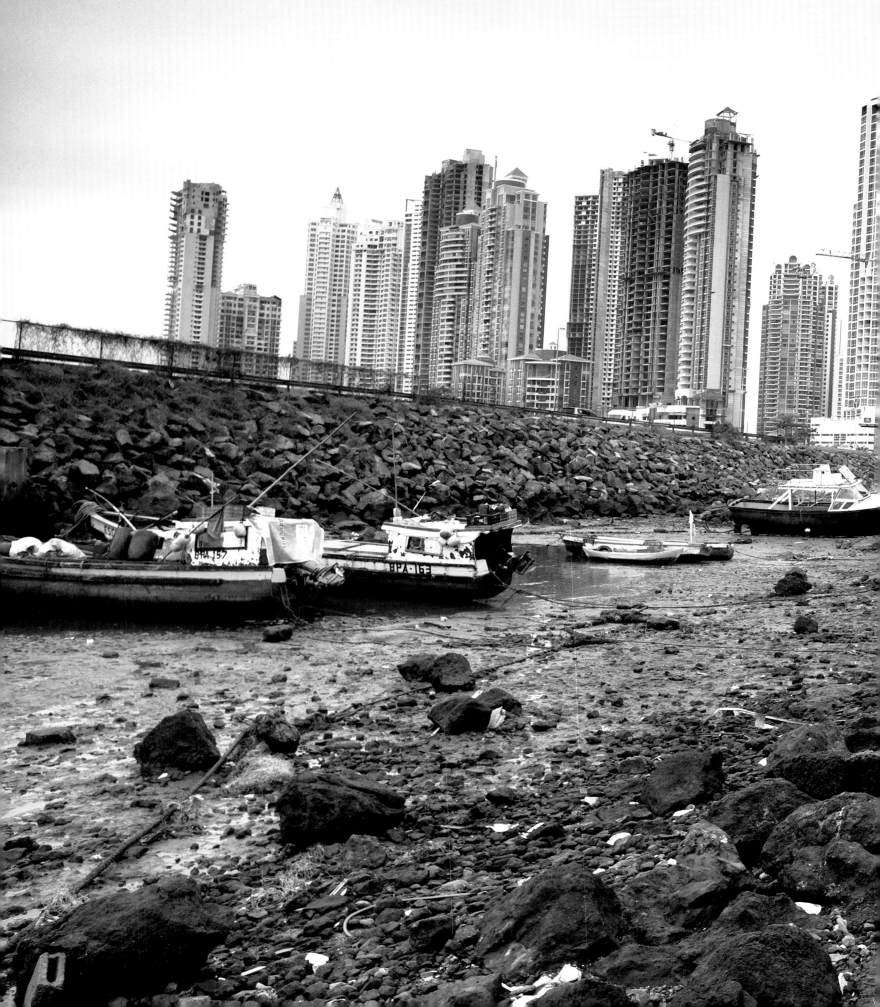

Monday 2 June 2008
David Levene

A property boom turns Boca la Caja, an impoverished, muddy slum on the edge of Panama City, into an irresistible target for developers.

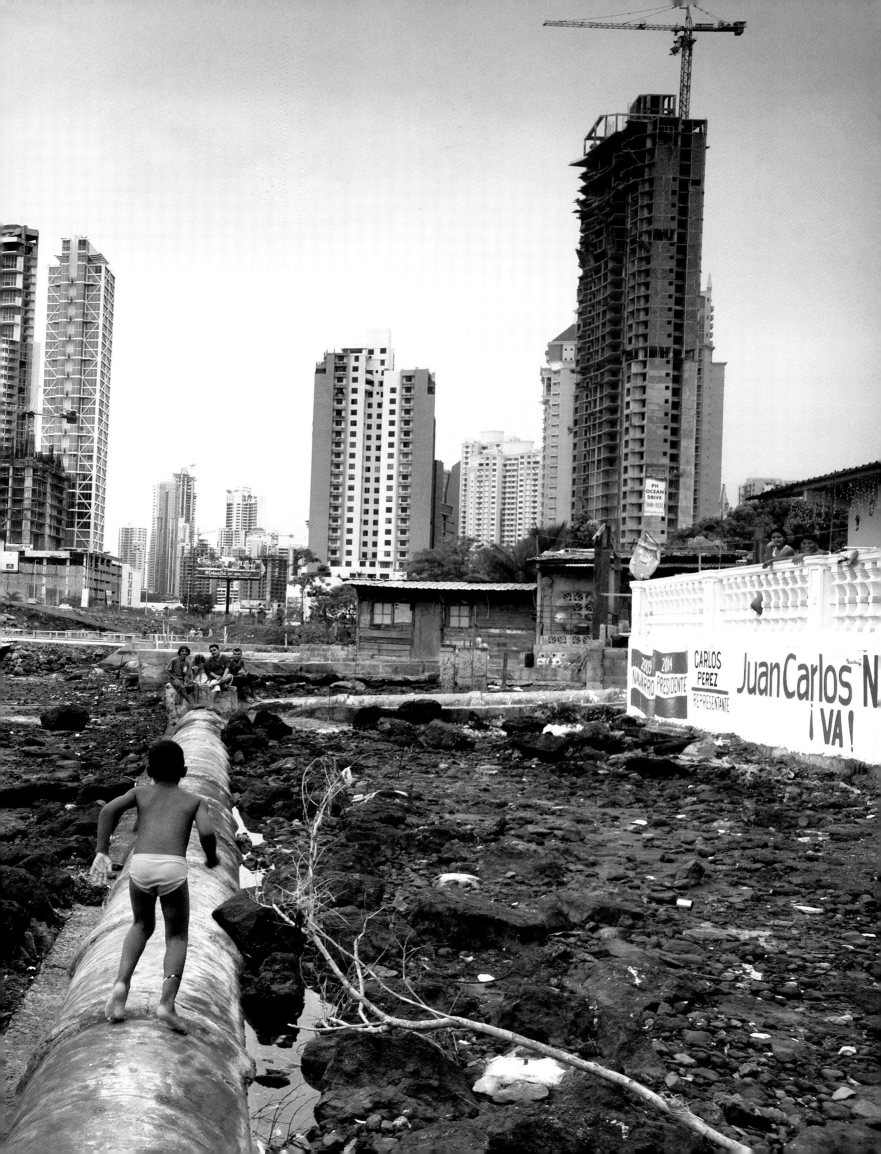

American troops distributing food in Shulla, north-west Baghdad.

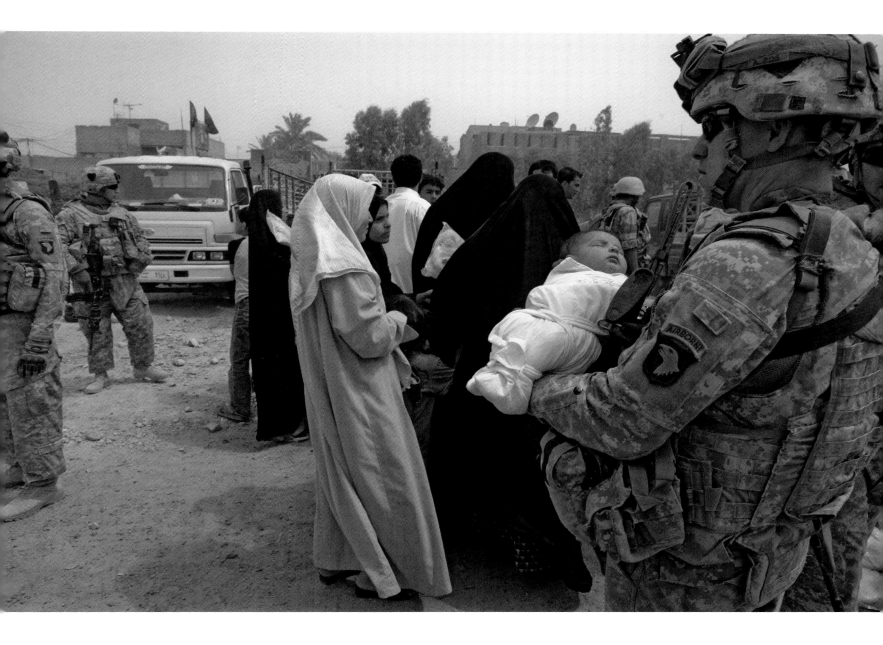

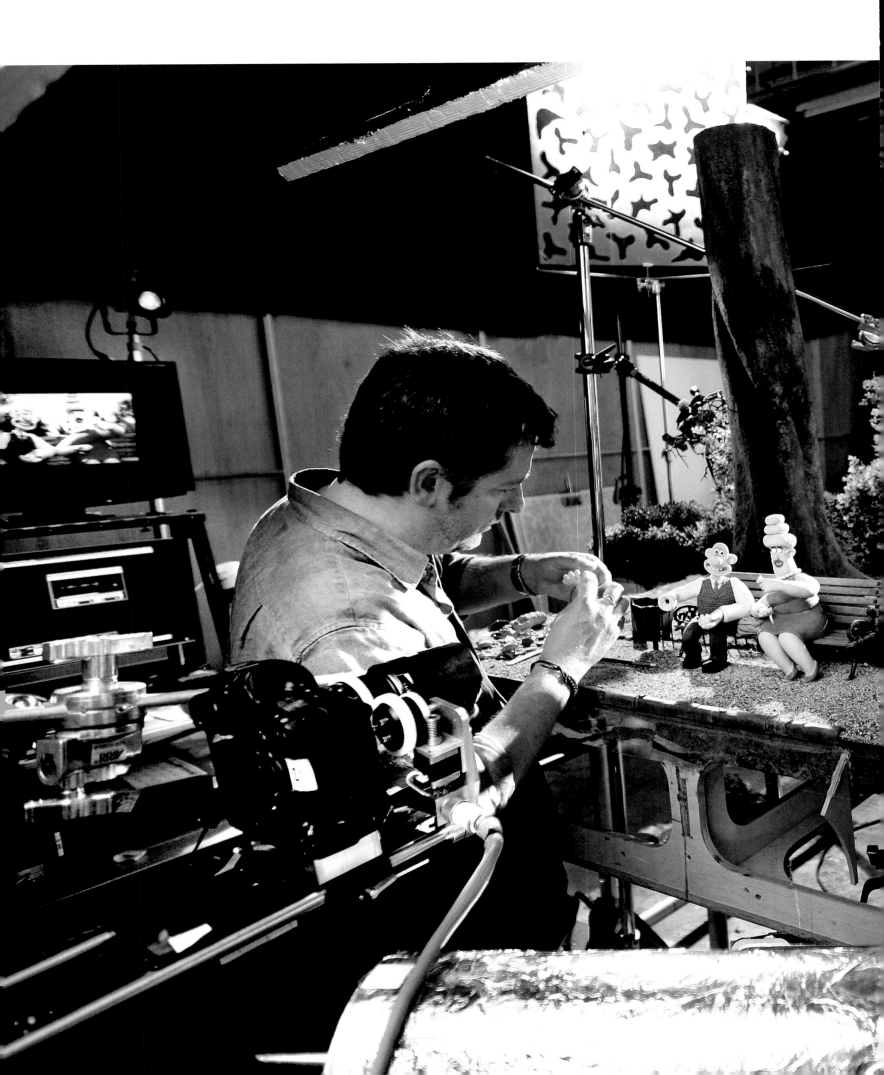

Aardman head of animation Loyd Price prepares his models for their next shot in BBC TV's Wallace and Gromit Christmas special *A Matter of Loaf and Death*.

Tuesday 9 September 2008
Graeme Robertson

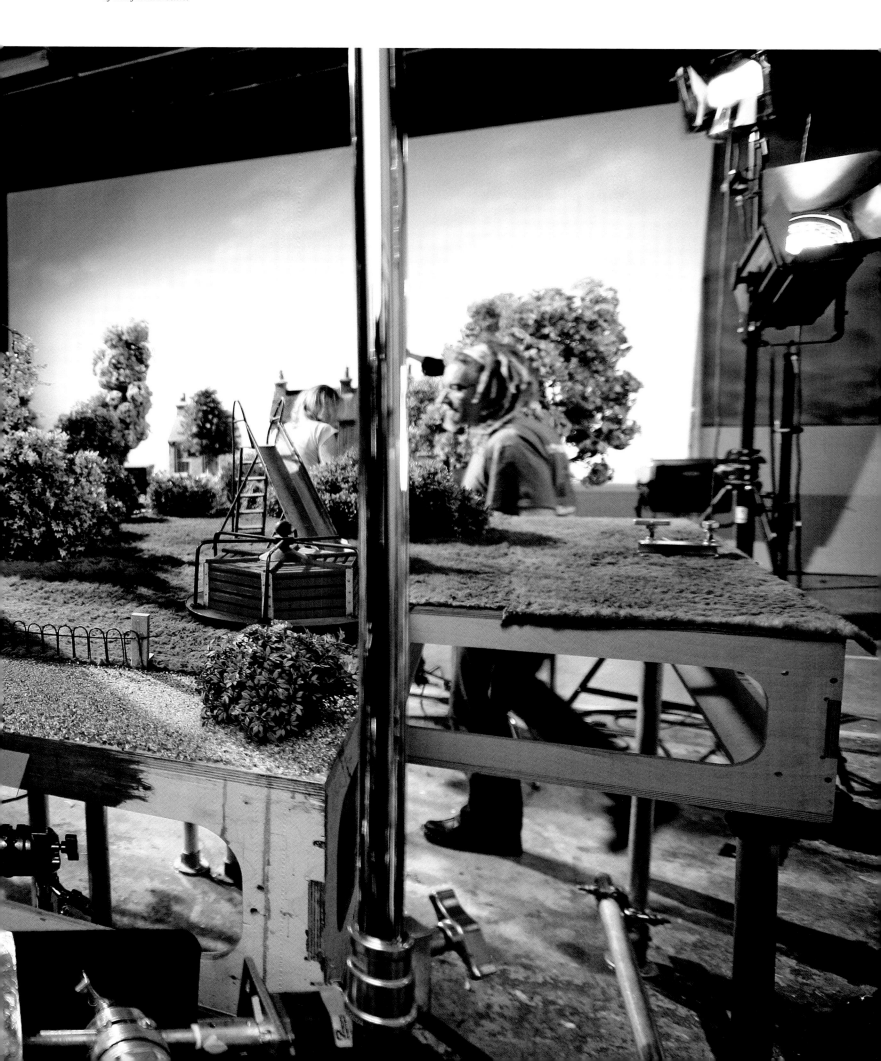

Police and locals in Roanoke, Virginia, help a young man who has been stabbed on his porch.

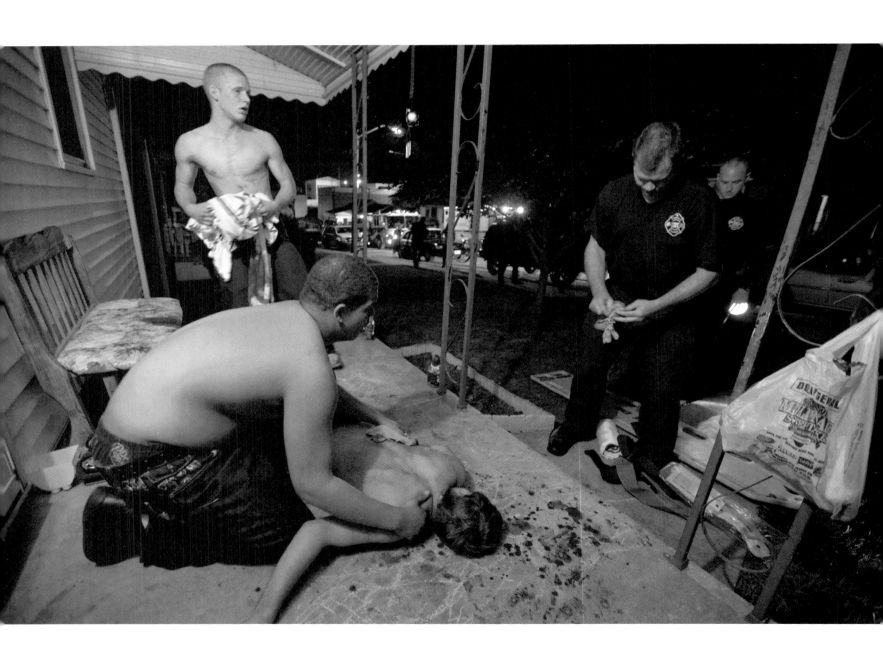

Aerial view of the Bank of England and the City of London taken the
day after the government bail-out of three major banks.

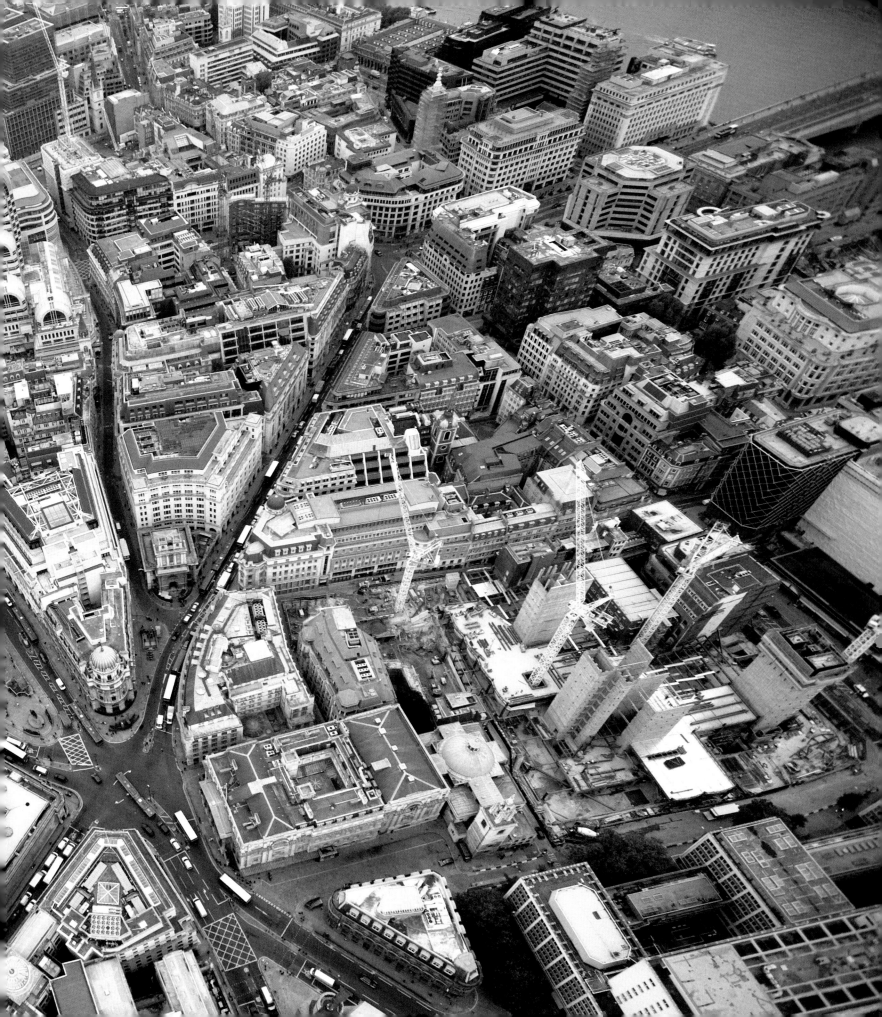

The view from the newly built air traffic control tower
at Heathrow Airport.

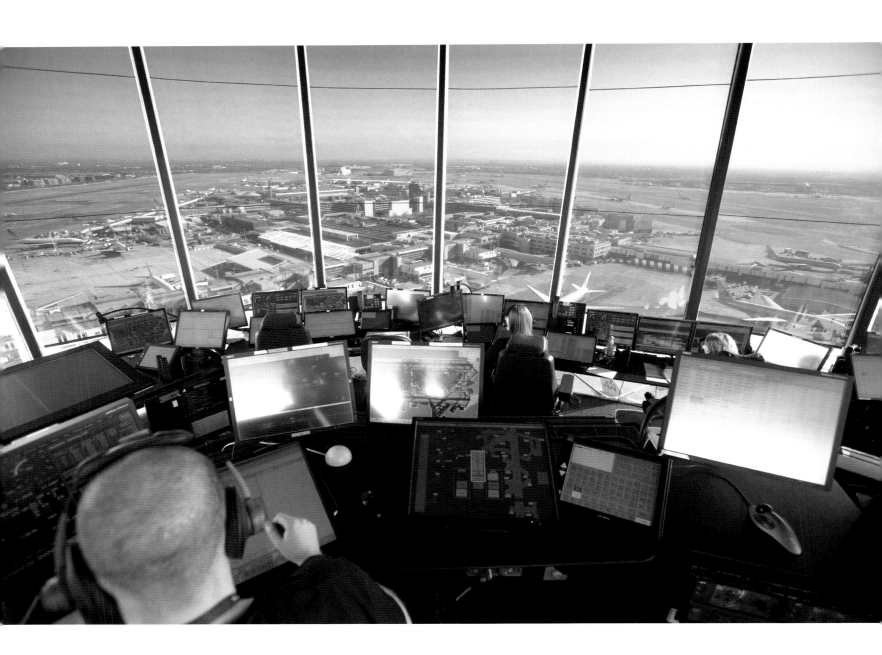

Stone cutters re-engraving First World War headstones at the
Commonwealth War Graves Commission cemetery in La Targette,
France.

Friday 31 October 2008
Paul O'Driscoll

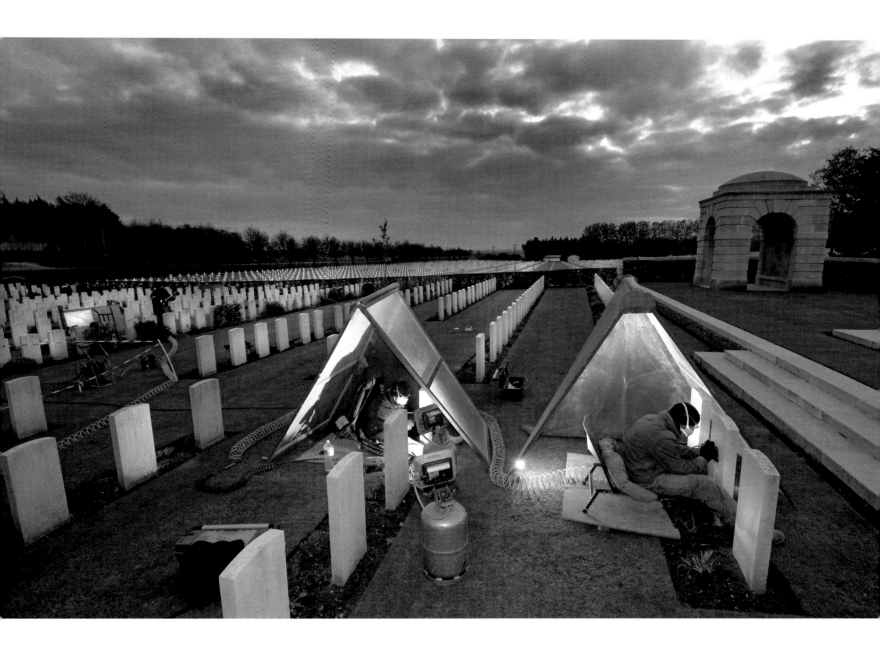

Eight-year-old Faraja and ten-year-old Pishon Mhewa with their baby
brother Jeminus. Their parents are both black-skinned carriers of the
recessive albinism gene.

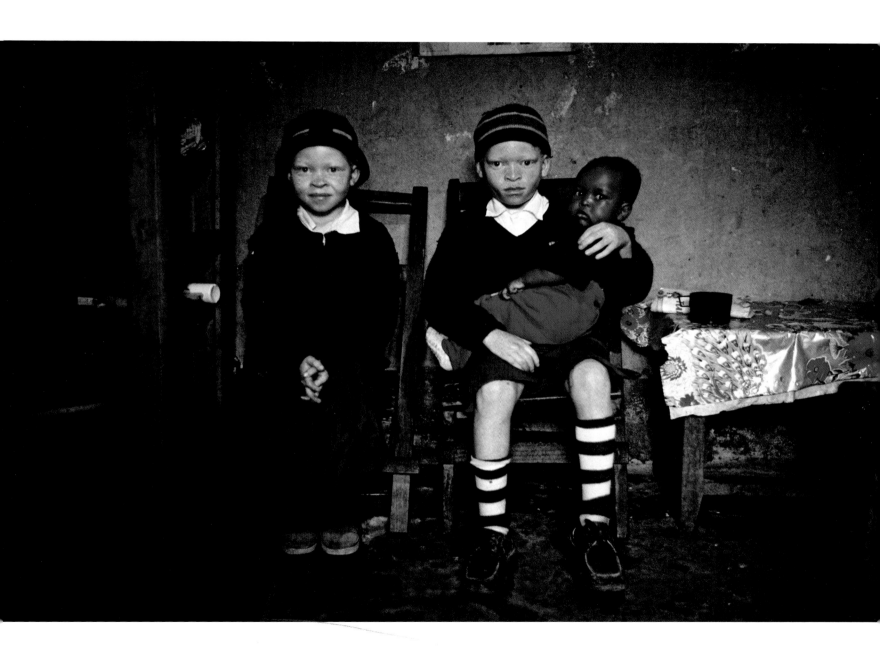

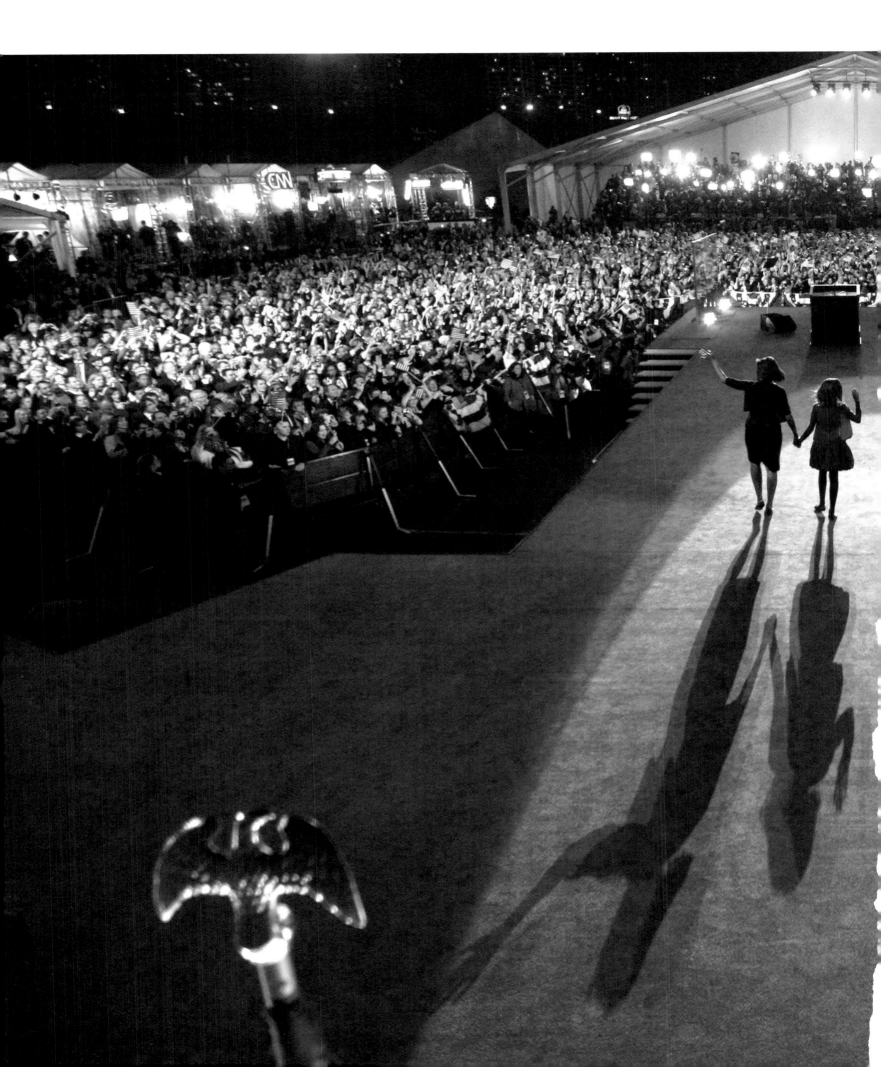

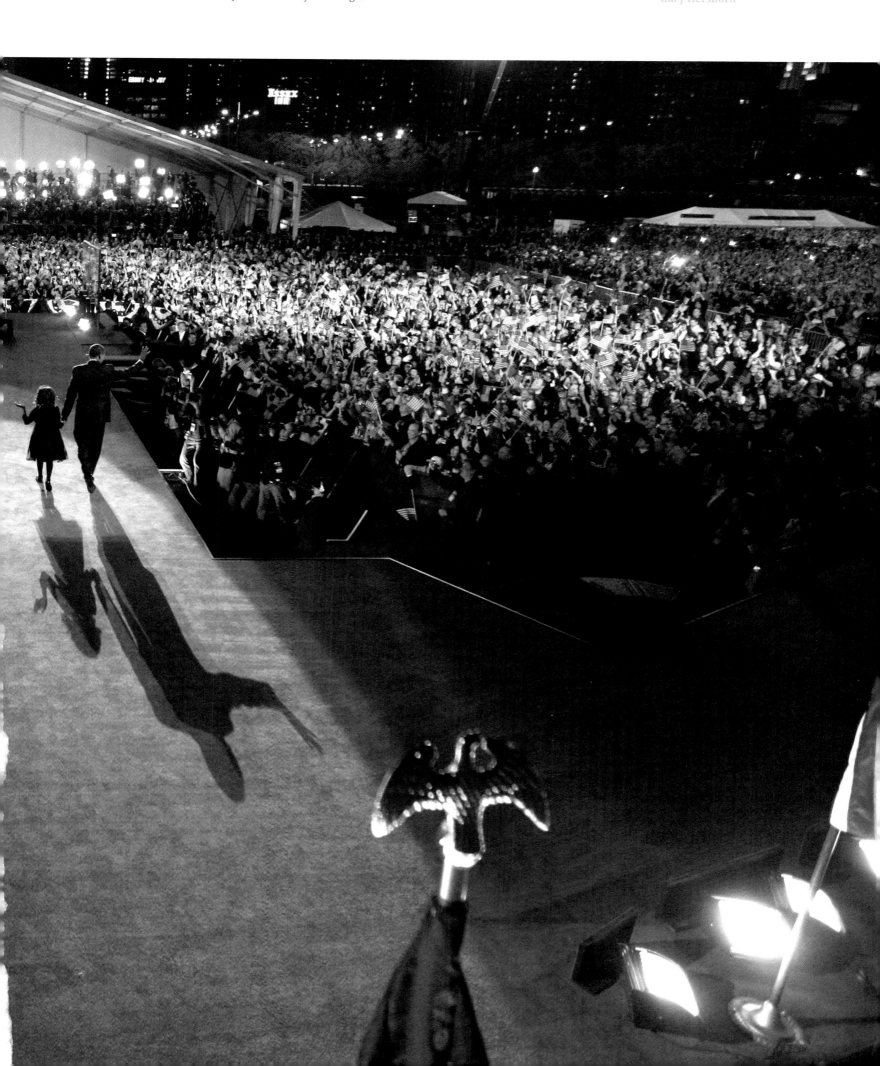

Fresh from his historic success in the US presidential election, Barack Obama and his family arrive at a rally in Chicago.

2009

The last year of the decade began pregnant with optimism and excitement and ended in a fug of disappointment and cynicism. How quickly those millions of wide-eyed, tear-streaked faces packing Washington for President Obama's inauguration seem to belong to another age. It was their day, but it seemed to promise something for all of us: an end to the Manichean lunacy of the war on terror, a new kind of politics, even the beginnings of a post-racial world.

In those heady days it even seemed - what were we thinking! - that the world might finally confront the elephant in its front room and take collective action against the problem of climate change. Like most news organisations, we counted down the weeks to the Copenhagen climate conference, describing the summit in ever more portentous terms. As it opened, fifty-two newspapers around the world joined the *Guardian* in a joint front-page editorial: 'The politicians in Copenhagen have the power to shape history's judgement on this generation: one that saw a challenge and rose to it, or one so stupid that we saw calamity coming but did nothing to avert it.'

Closer to home, the *Guardian* captured the green mood with the launch of the 10:10 campaign, calling on individuals, businesses and organisations to lead the way by cutting their own emissions of greenhouse gases by 10% during 2010. Within days, all major politicians had signed up and within a few months thousands of companies, councils, schools and hospitals had pledged to do their bit.

But the tantalising suggestion that we might rise above our rivalries and short-termism to tackle a common threat was crushed in the space of a few short weeks. First came the leak of the so-called 'climategate' emails that punctured public faith in the scientists urging us to act. Then came the great Copenhagen washout, perhaps as big a disaster for the idea of multilateralism as it was for the planet.

But by then there had been plenty more bad news to chip away at the hopefulness of January. The steady drip drip of preposterous MPs' expenses claims initially offered a delightful seam of rich comic material - did we even know that £1,645 duck houses existed until we discovered Sir Peter Viggers had bought one on us? But after a while the country stopped giggling and settled

Ian Katz is deputy editor of the *Guardian*. He joined in 1990 as editor of the paper's youth pages, and has since worked as a reporter, New York correspondent and editor of the G2 section.

into a sullen contempt for the entire political class. From the audacity of hope to the garlic peelers of James Arbuthnot.

If the one steady backbeat of the year was the arrival in the stocks of one penny-grabbing MP after the next, the other was the grim trickle - occasionally a stream - of servicemen's bodies returning from Afghanistan. They arrived, wrapped in Union Jacks in the cavernous hold of a military transporter, and were borne through the little town of Wootton Bassett on a heart-breaking journey that offered a weekly reminder of the horrors unfolding in an unwinnable war thousands of miles away.

If Wootton Bassett produced some of the most striking photographs of the year, perhaps the most memorable for those of us who work in the *Guardian* newsroom was the grainy image of a 47-year-old newspaper seller being pushed to the ground by a riot police officer during protests against the G20 summit in London. Paul Lewis's story about the events leading up to the death of Ian Tomlinson may have been a land-mark in multimedia reporting but it was also the kind of old-fashioned scoop about abuse of power that reminds us all of why we became journalists.

What else will 2009 be remembered for? The passing of a freakish and morally dubious pop star who, we were reminded, made some good records? Our mildly embarrassing ebola-style panic over a virus that proved rather less deadly than seasonal flu? A miraculous crash-landing in the Hudson River that will make all of us listen a little more closely when the stewardess tells us how to don a life-jacket? The emergence of the 140-character message as a staple unit of human communication? The discovery that the world's most famous tiger was also a bit of a dog?

To me, 2009 was the year so many things seemed to come full circle. A year that began with the government offering life support to a banking sector close to death's door - and ended with bankers looking forward to seven-figure bonuses once more. The year Iran took a step towards freedom, then two steps back. The year we woke up to the threat of climate change, then turned over and went back to sleep. The year so much seemed about to change, and so much ended up just the same.

20 January Barack Obama is sworn in as the first black president of the USA.

5 February The Bank of England cuts interest rates to 1%.

7 February 173 people die in Australia's worst ever bush fires.

3 March Gunmen attack the Sri Lankan cricket team in Lahore, Pakistan.

30 April British troops formally end their combat mission in Iraq.

8 May The *Daily Telegraph* reveals the expenses details of 13 Cabinet ministers.

19 May The Speaker of the House of Commons Michael Martin announces his resignation.

22 May Jade Goody dies of cervical cancer aged 27.

3 June Communities Secretary Hazel Blears resigns from the Cabinet in the wake of the MPs' expenses scandal.

25 June Michael Jackson, aged 50, dies from a heart attack caused by an overdose of the anaesthetic propofol.

22 July The longest solar eclipse of the 21st century takes place across a large area of Asia.

25 July The last British survivor of WWI, Harry Patch, dies aged 111.

15 August Richard Hunt, 21, becomes the 200th British soldier to die in Afghanistan.

20 August Lockerbie bomber Abdelbaset Ali al-Megrahi is released from prison on compassionate grounds.

1 September The 10:10 campaign is launched.

26 September Film director Roman Polanski is arrested in Switzerland.

28 September Angela Merkel wins the German general election.

9 October President Barack Obama is awarded the 2009 Nobel Peace Prize.

16 October An article by Jan Moir about the death of singer Stephen Gately is published on the *Daily Mail* website.

22 October Leader of the BNP Nick Griffin MEP makes an appearance on BBC's *Question Time*.

21 November It emerges that hundreds of private emails and documents were stolen from the University of East Anglia's Climate Research Unit.

4 December Amanda Knox, along with Raffaele Sollecito, is found guilty of the murder of British student Meredith Kercher.

15 December Italy's prime minister Silvio Berlusconi is hit in the face with a plaster souvenir during a rally in Milan.

19 December The Copenhagen climate change summit comes to a close with country leaders pledging to make a reduction in greenhouse gas emissions.

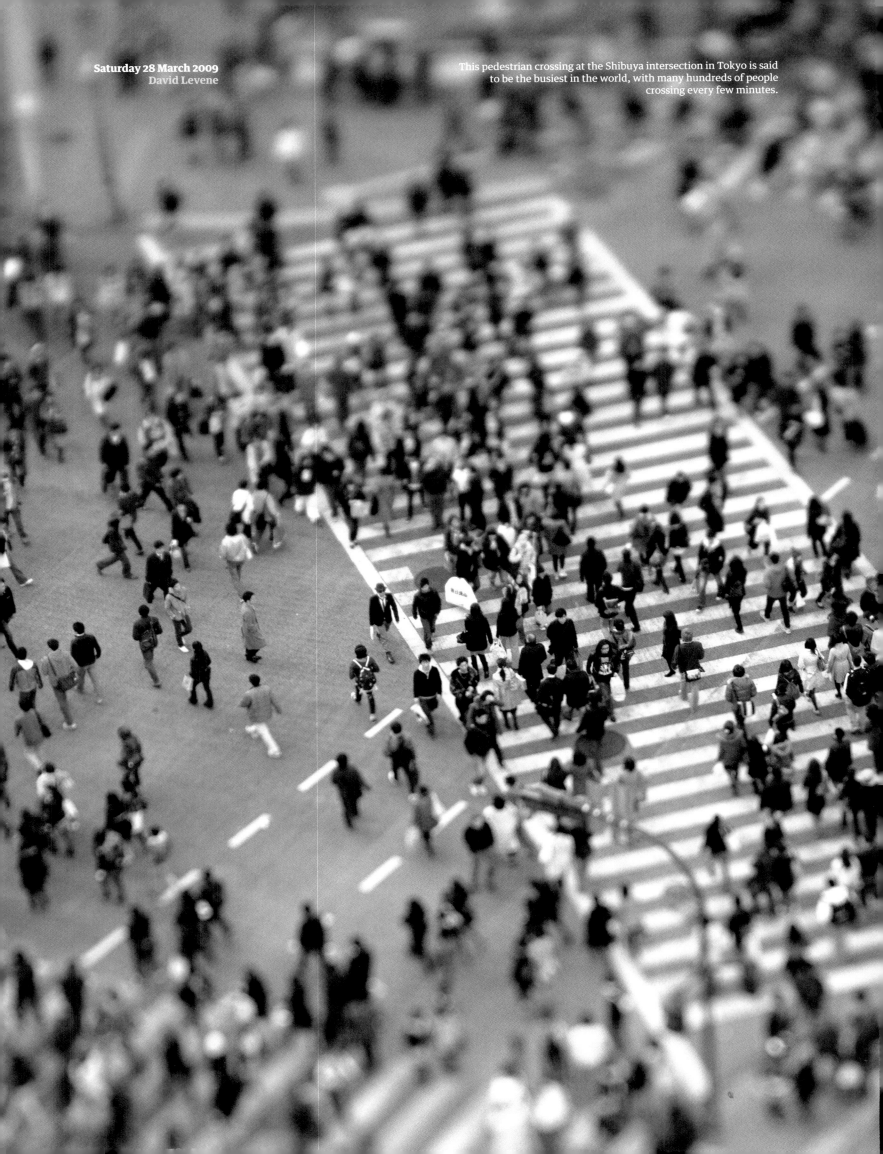

This pedestrian crossing at the Shibuya intersection in Tokyo is said to be the busiest in the world, with many hundreds of people crossing every few minutes.

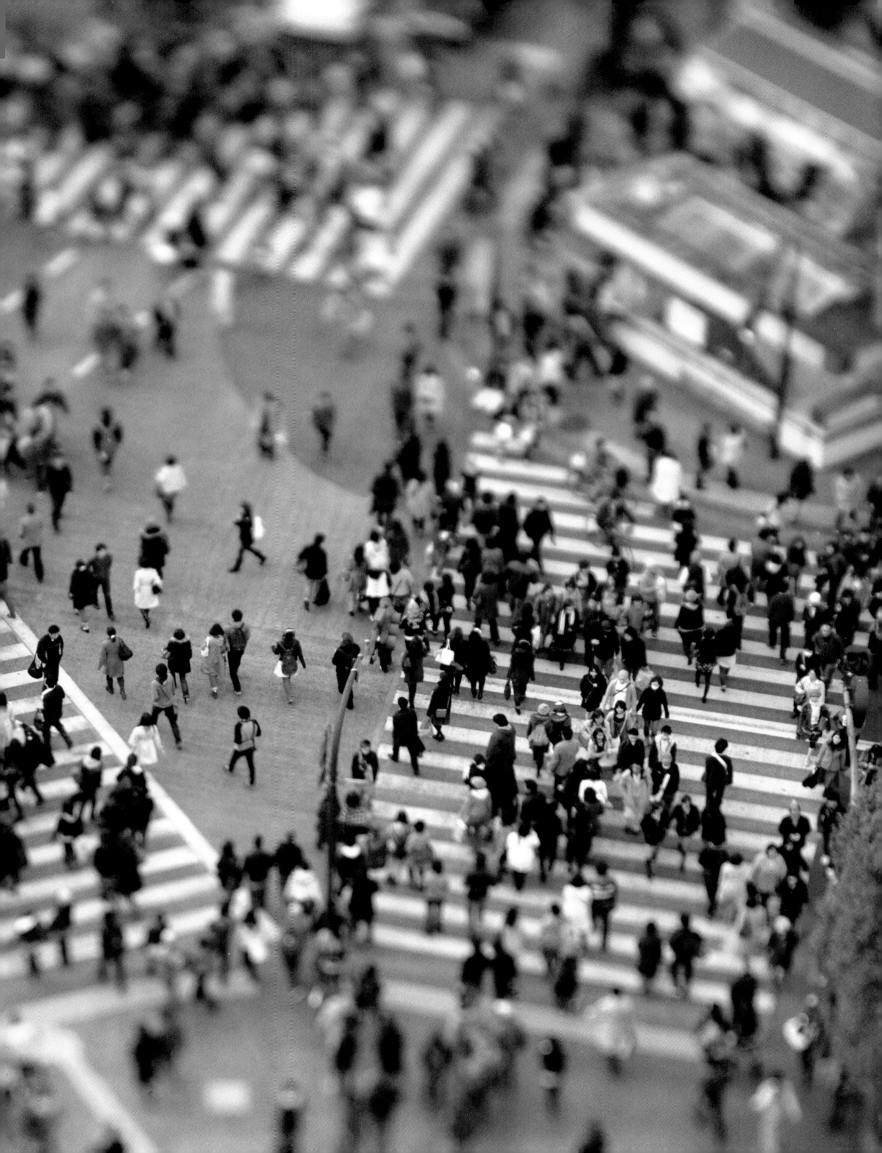

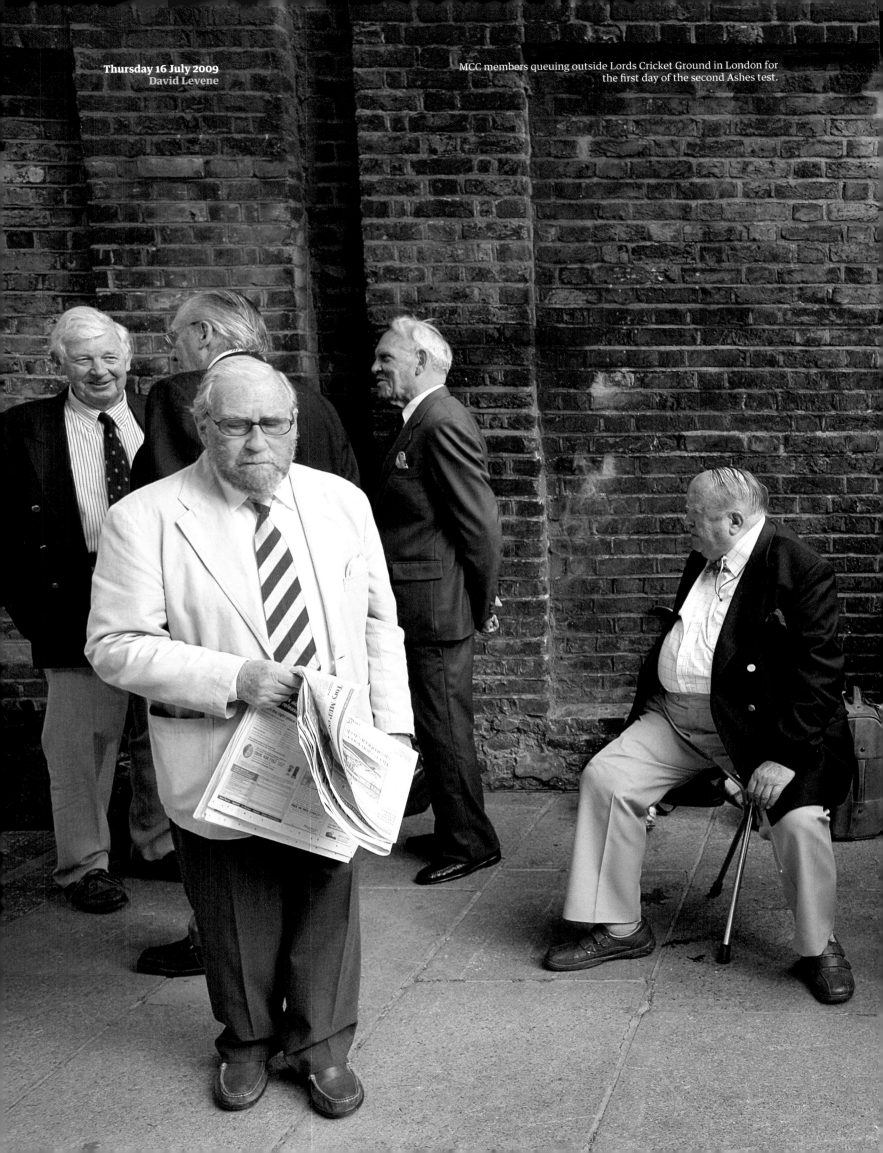

Thursday 16 July 2009
David Levene

MCC members queuing outside Lords Cricket Ground in London for
the first day of the second Ashes test.

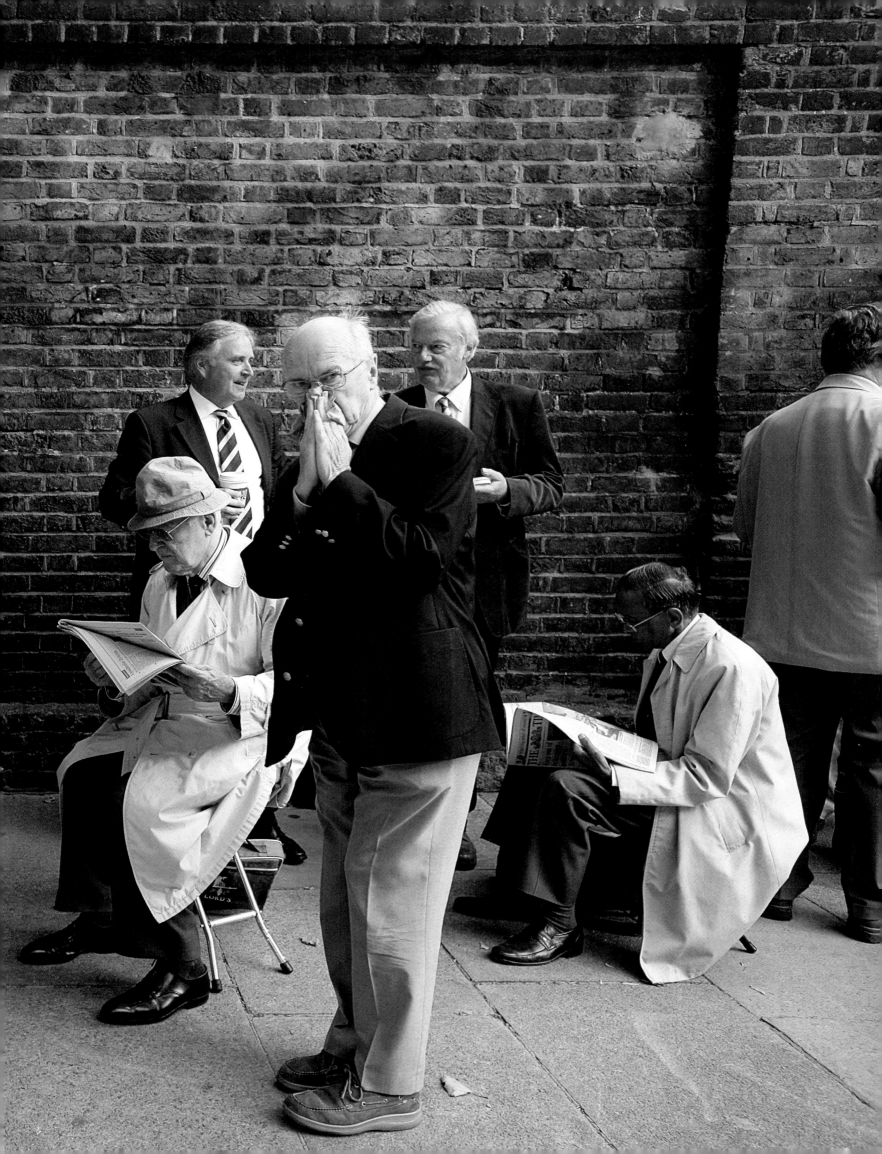

Watching the sunrise from Mount Moses in the Sinai Peninsula.

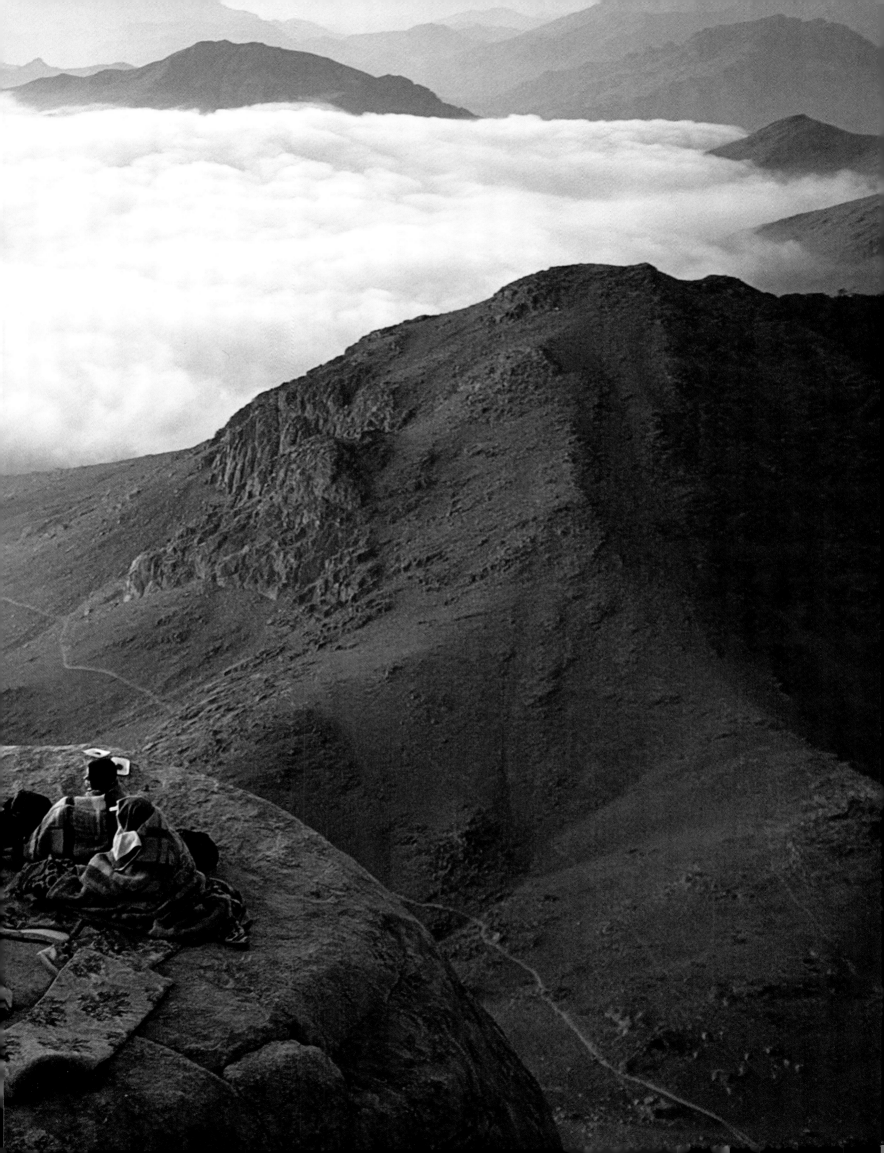

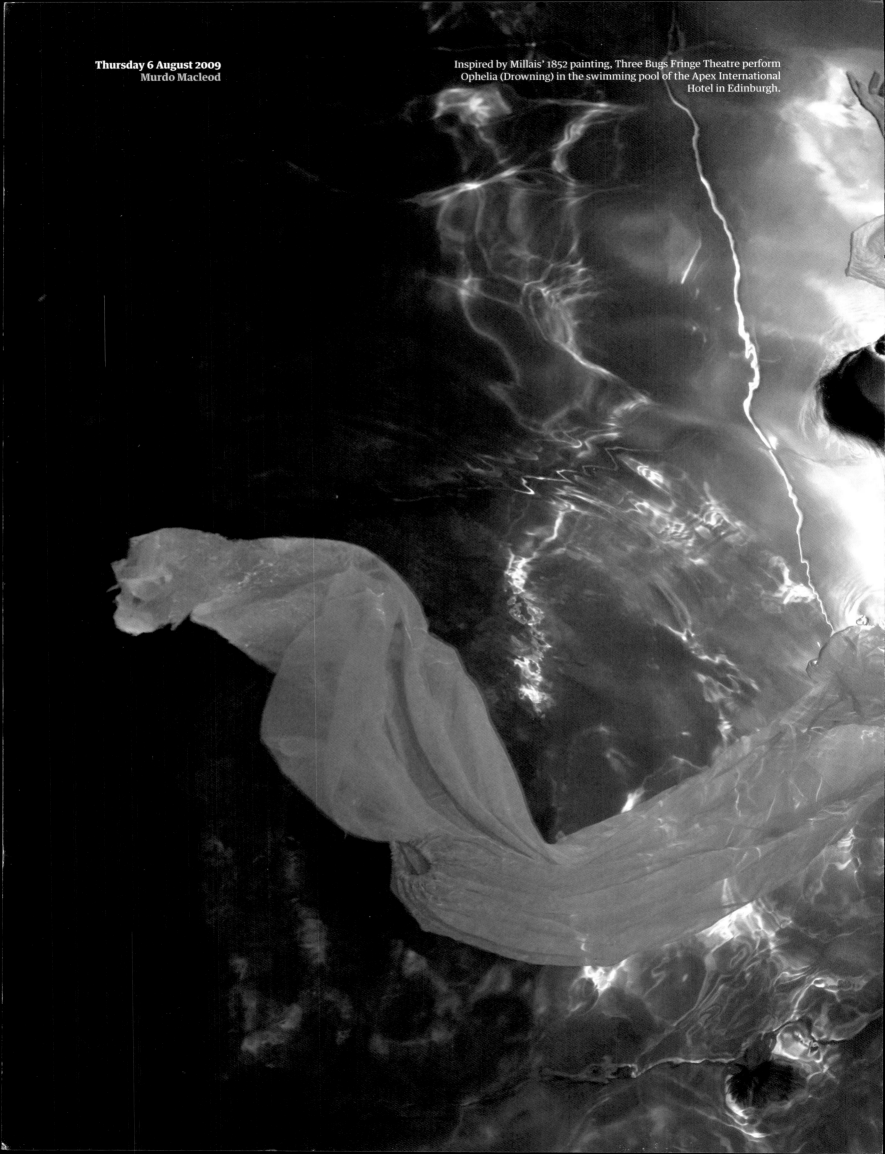

Thursday 6 August 2009
Murdo Macleod

Inspired by Millais' 1852 painting, Three Bugs Fringe Theatre perform
Ophelia (Drowning) in the swimming pool of the Apex International
Hotel in Edinburgh.

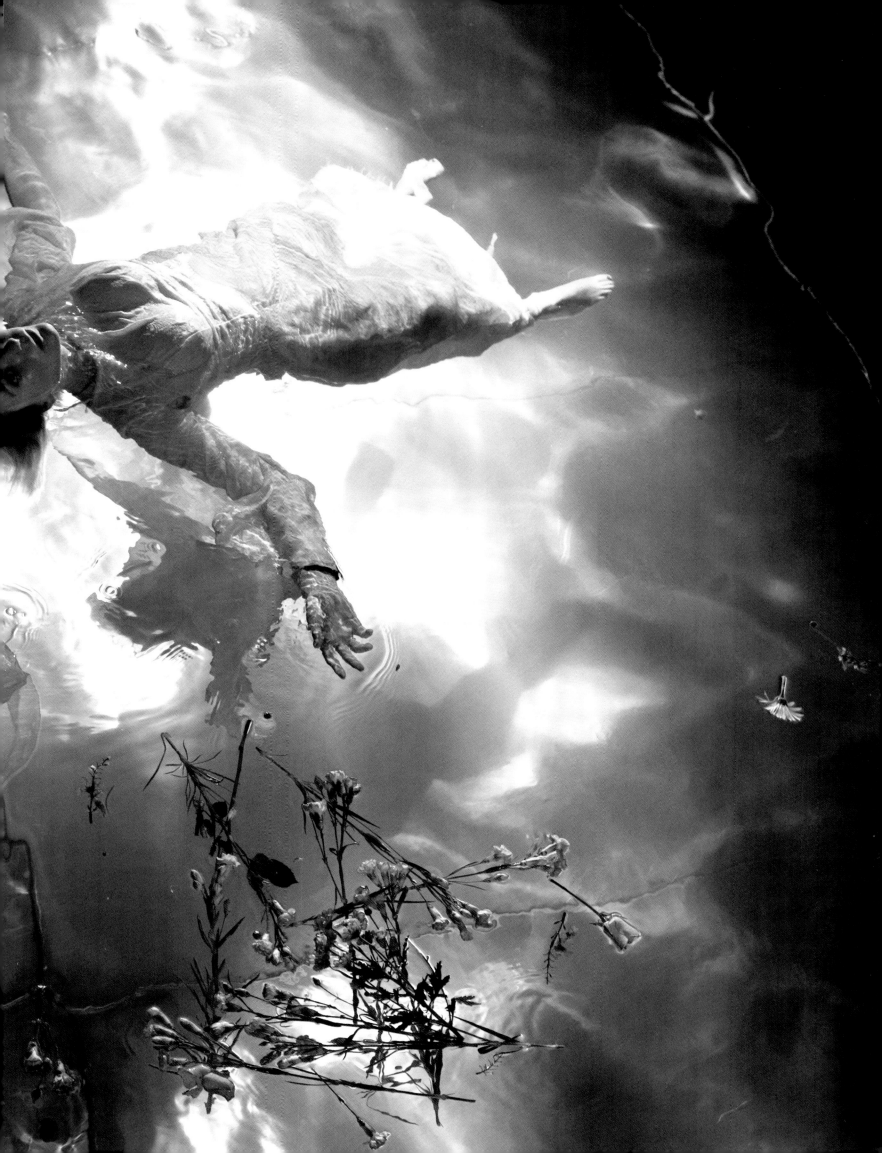

Local farmer Martyn Price harvests apples in Somerset.

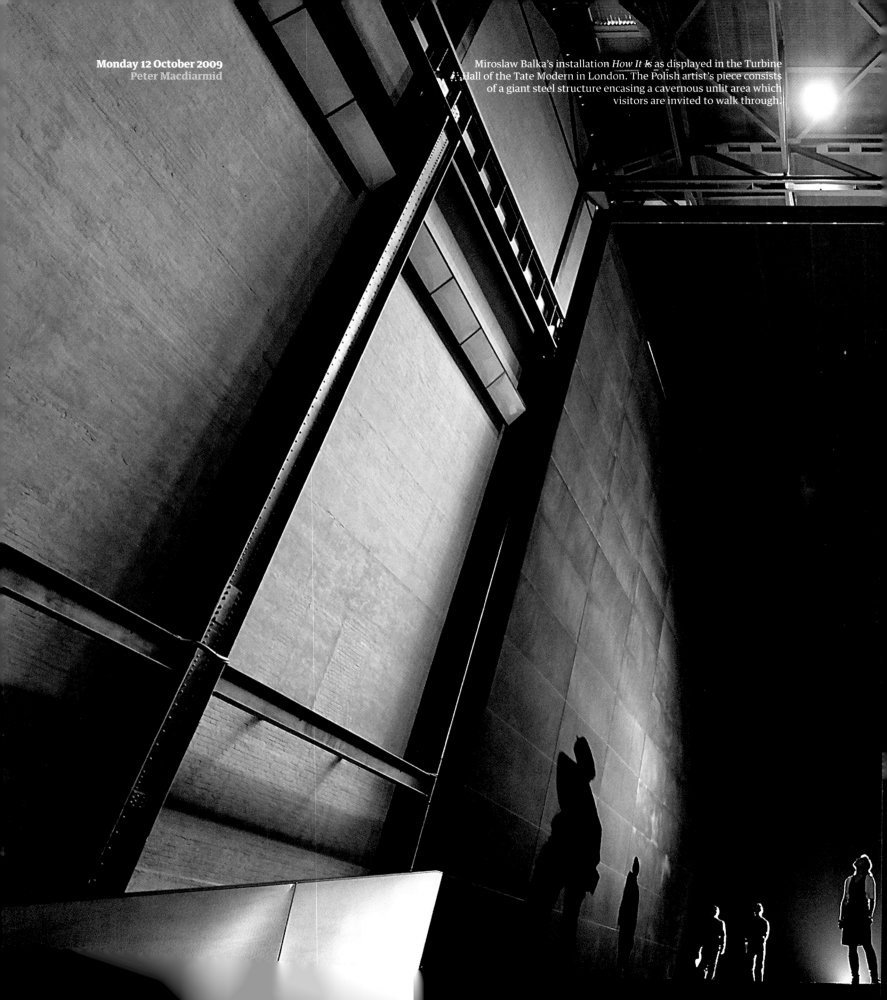

Monday 12 October 2009
Peter Macdiarmid

Miroslaw Balka's installation *How It Is* as displayed in the Turbine Hall of the Tate Modern in London. The Polish artist's piece consists of a giant steel structure encasing a cavernous unlit area which visitors are invited to walk through.

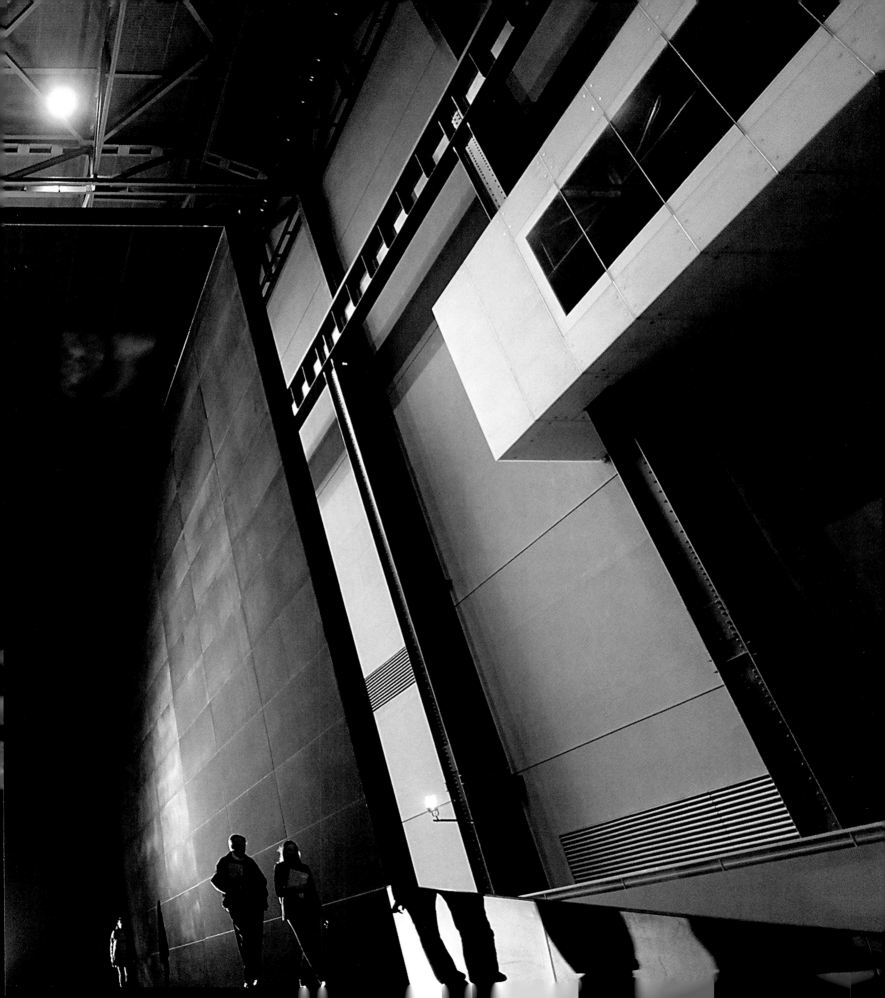

A multiple exposure of a competitor on the beam during the final
practice day before the World Artistic Gymnastics championships,
held at the O2 Arena in Greenwich.

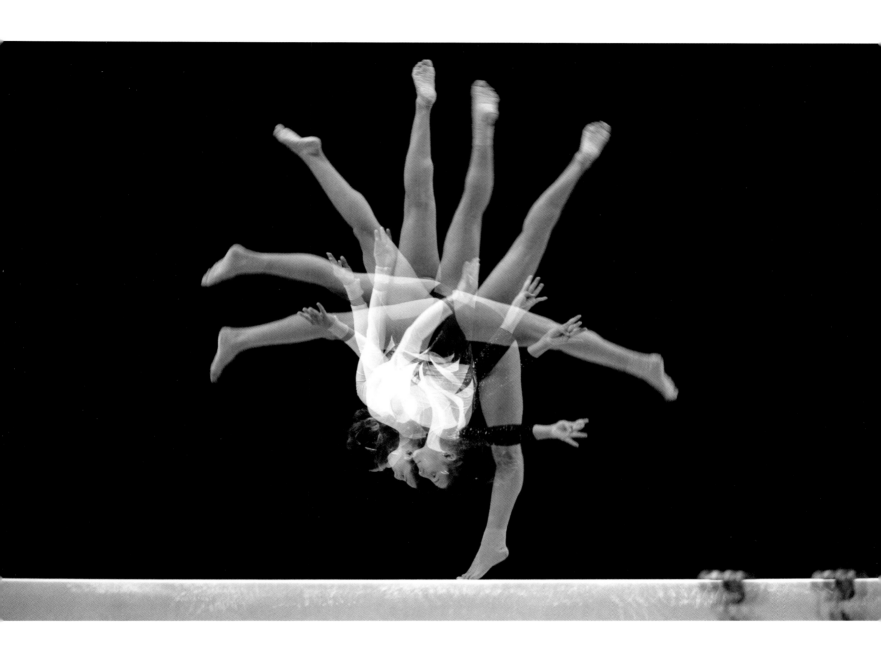

Mohammed Shuhadeh, 70, works out at his small gym in the West Bank town of Jenin. Shuhadeh was a boxing champion in the 1980s, and says he was the first person to open a gym in the Palestinian territories, 40 years ago.

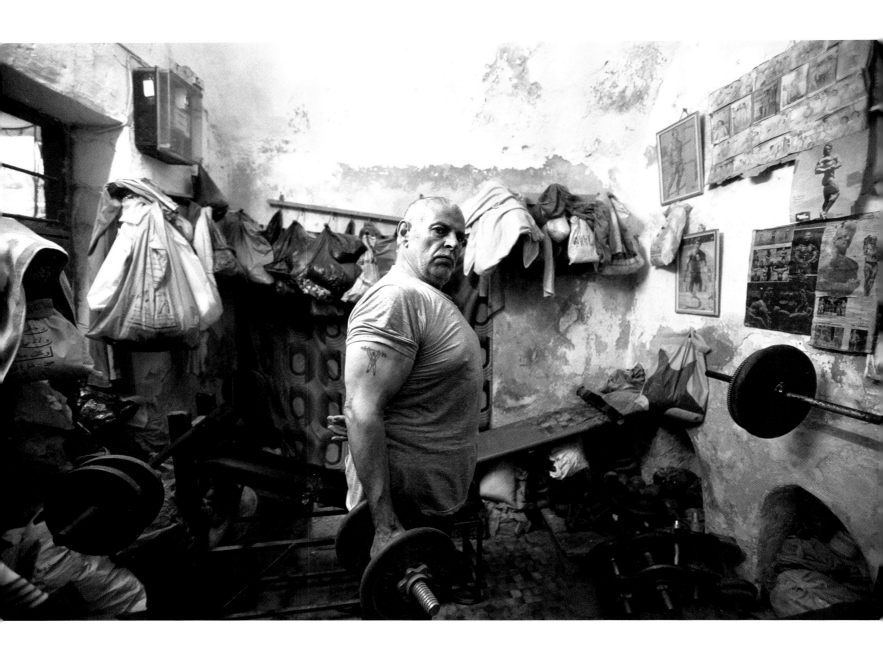

An Indian elephant swimming underwater, and seen from below.

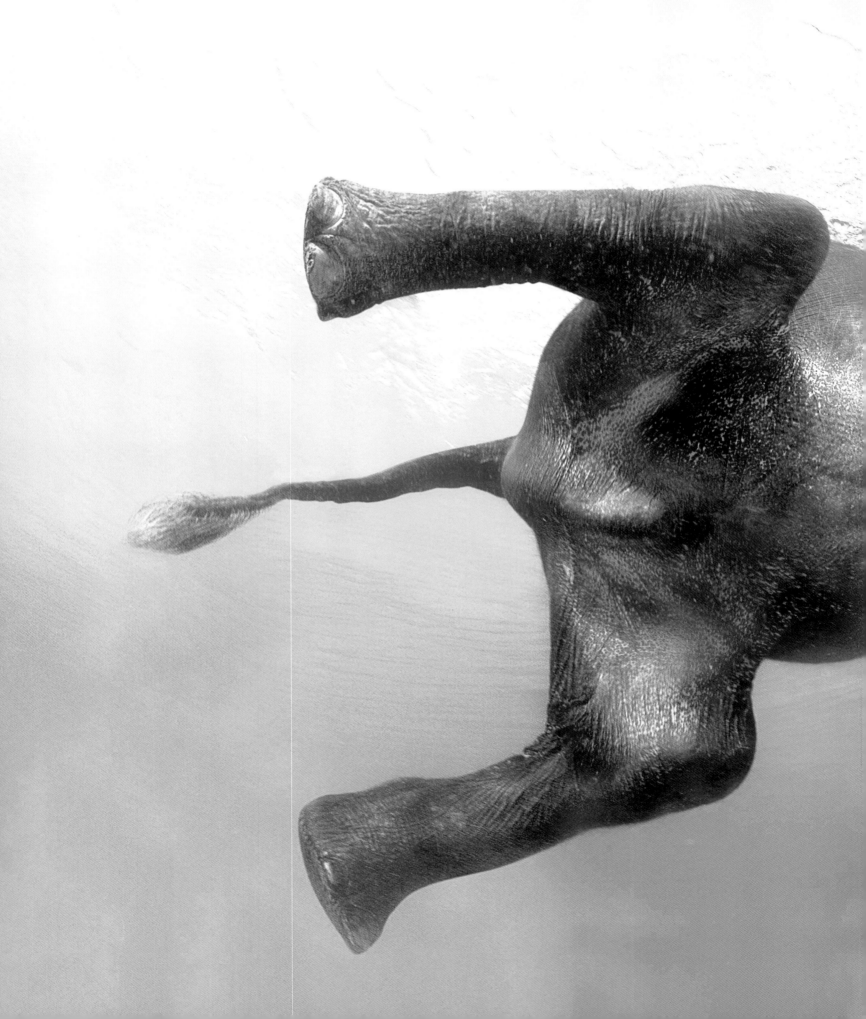

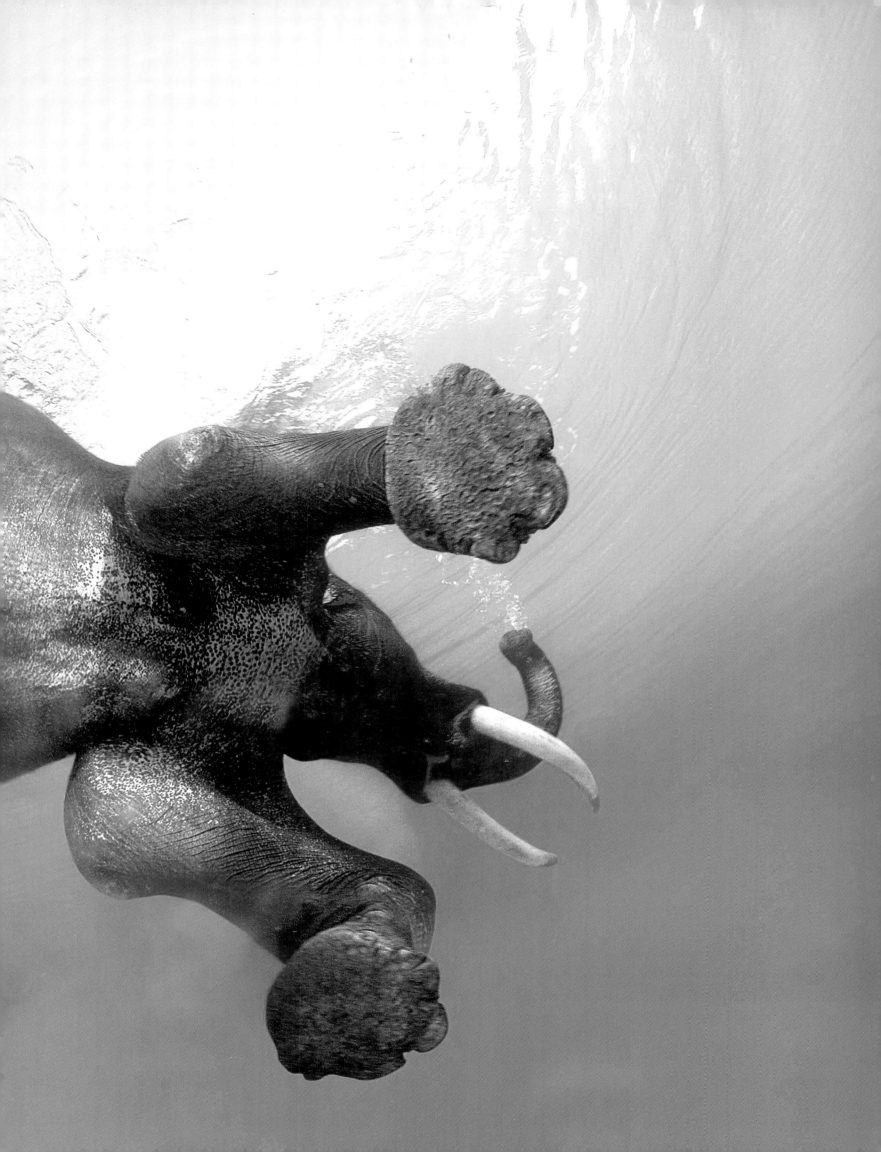

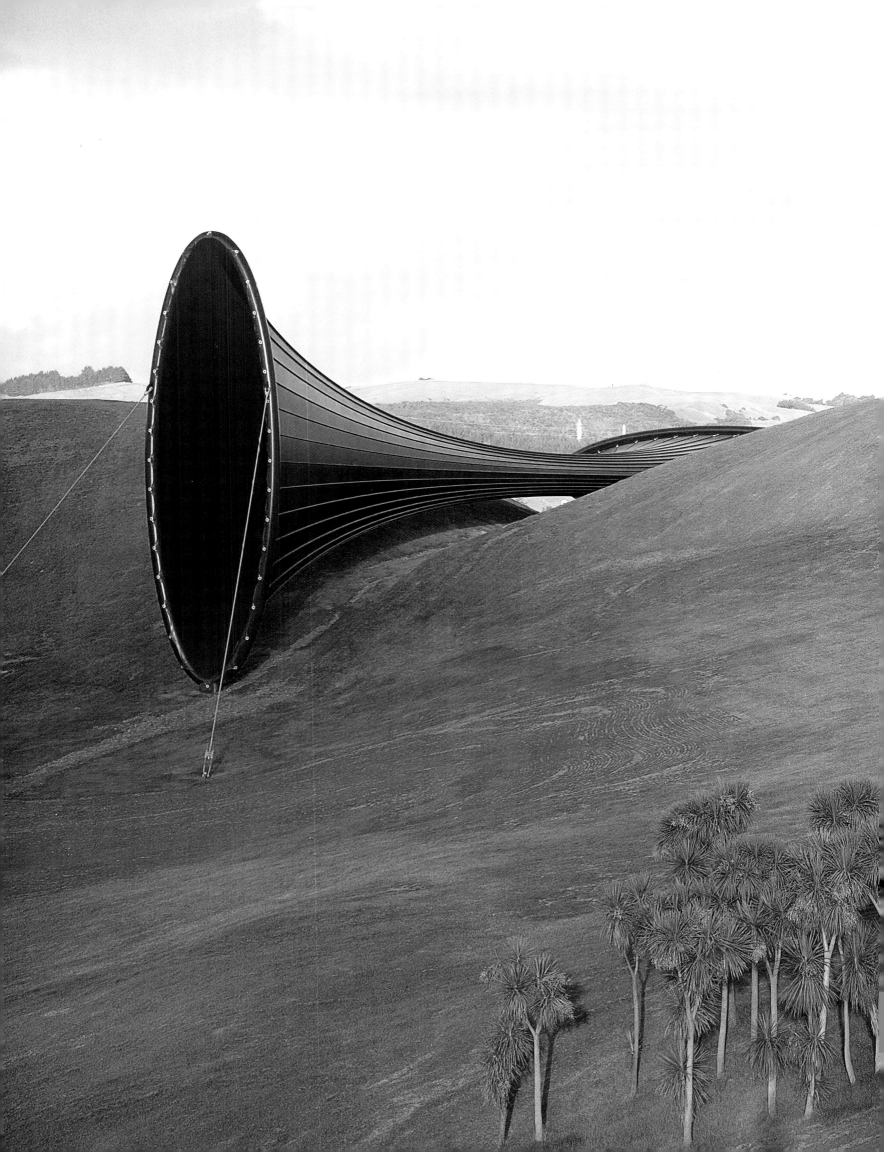

Anish Kapoor's *Work at the Farm*, erected in Kaipara Bay in New Zealand.

pp. 6-7 Toby Melville/PA Photo, p. 8 Karel Prinsloo/AP Photo, pp. 10-11 David Cheskin/PA Photo, p. 13 Toshihiko Sato/AP Photo, p. 14 Brian Hendler/Getty Images, pp. 16-17 Richard Vogel/AP Photo, pp. 20-21 Efrem Lukatsky/AP Photo, p. 24 Oliver Favre-Bulle/AFP, p. 29 North Wales Police/PA Photo, p. 33 David Cheskin/PA Photo, pp. 36-7 Eric Draper/AP Photo, pp. 42-3 Dan Loh/AP Photo, pp. 44-5 M. Scott Moon/AP Photo, p. 47 Jean-Philippe Ksiazek/EPA Photo AFPI, pp. 52-3 Shane T. McCoy/AFP/Getty Images, p. 55 Joerg Sarbach/AP Photo, p. 56 Awad Awad/EPA Photo AFPI, p. 57 Jerome Delay/AP Photo, pp. 58-9 Jeff J. Mitchell/Reuters, p. 61 NASA/jpr/EPA Photo AFPI, p. 63 David Longstreath/AP Photo, pp. 64-5 JIJI Press/STR/fl/ EPA Photo, p. 67 David Cheskin/PA Photo, p. 68 Miguel Vidal/ Reuters, p. 69 Kai Pfaffenbach/Reuters, pp. 72-3 Kirsty Wiggles-worth/PA Photo, p. 77 Rafael Perez/Reuters, p. 83 Jerome Delay/AP Photo, p. 87 Chris Hondros/Getty Images, p. 88 Anita Marie/News Team International, p. 89 Hasan Sarbakhshian/AP Photo, p. 94 Jon Sohoo/EPA, p. 95 Toby Melville/Reuters, p. 96 Christophe Simon/ AFP, pp. 98-9 Thomas Coex/AFP/Getty Images, p. 101 Karen Ballard/ Pool/Reuters, p. 102 Sergei Dolzhenko/EPA, pp. 104-5 James Quinton/Wireimage.com, p. 107 Luis Sinco/Los Angeles Times, p. 109 Awad Awad/AFP, p. 110 Arko Datta/Reuters, pp. 112-3 Frederic J. Brown/AFP, p. 119 Matthia Hiekel/EPA, p. 123 Peter MacDiarmid/ Getty Images/Pool/PA, pp. 124-5 Dallas Morning News, Smiley N. Pool/AP Photo, pp. 126-7 Dave Martin/AP Photo, pp. 134-5 Kennan Ward/Corbis, pp. 140-41 Oded Balilty/AP Photo, pp. 142-3 Maximil-ien Brice/Cern/Gamma BRICE/CERN/GAMMA, pp. 146-7 © David Hockney, courtesy Juda Fine Art, pp. 148-9 Peter Lawson/Eastnews, p. 153 Brennan Linsley/AP Photo, pp. 154-5 Nigel Cook/Reuters, pp. 156-7 Akintunde Akinleye/Reuters, p. 161 Andrew Milligan/PA Wire, p. 165 Kevin Sanders/AP Photo, p. 166 Paul Faith/PA Photo, pp. 174-5 Daniel Berehulak/Getty Images, pp. 176-7 Andy Rouse/Shell Wildlife, p. 178 Carlos Barria/Reuters, pp. 200-1 Gary Hershorn/ Reuters, pp. 206-7 Goran Tomasevic/Reuters, pp. 214-15 Peter MacDiarmid/Getty Images, p. 217 Muhammed Muheisen/AP Photo, p. 220 Steve Bloom/stevebloom.com